Movers and Shapers
Irish Art since 1960

Vera Ryan

The Collins Press

Published in 2003 by
The Collins Press
West Link Park,
Doughcloyne,
Wilton,
Cork

Vera Ryan has asserted her right to be identified as author of this work.

British Library Cataloguing in Publication data.

Ryan, Vera
 Movers and Shapers : Irish visual art since 1960
 1. Art, Irish - 20th century 2. Cultural animators – Ireland
 – Interviews 3. Artists - Ireland - Interviews
 I Title
 709.4'17'09045

 ISBN 1903464382

Printed in Ireland by ColourBooks Ltd

Typesetting by The Collins Press

ISBN: 1-903464-438-2

Contents

Acronyms and Abbreviations

AAI	Association of Artists in Ireland
AIB	Allied Irish Banks
AICA	Association International des Critiques d'Art
ATC	Art Teachers' Certificate
BA	Bachelor of Arts
B Comm	Bachelor of Commerce
BFA	Bachelor of Fine Art
CAD	Computer Aided Design
CCAD	Crawford College of Art and Design
CIE	Córas Iompar Éireann
DOE	Department of the Environment
EEC	European Economic Community
ESB	Electricity Supply Board
EU	European Union
ev+*a*	exhibition of visual+ art
GATT	General Agreement on Tariffs and Trade
GI	General Infantory
HEA	Higher Education Authority
IAP	Irish Academic Press
ICA	Institute of Contemporary Art
IDA	Industrial Development Authority
IMMA	Irish Museum of Modern Art
IPA	Institute of Public Administration
IT	Information Technology
LCGA	Limerick City Gallery of Art
LLB	Legis Legendae Baccalaurus
LSAD	Limerick School of Art and Design
MA	Master of Arts
MD	Managing Director
MFA	Master of Fine Art

MIT	Massachusetts Institute of Technology
MOMA	Museum of Modern Art (New York)
NCAD	National College of Art and Design
NCEA	National Council for Educational Awards
NGI	National Gallery of Ireland
NIVAL	National Irish Visual Arts Library
NSF	National Sculpture Factory
NSPC	National Self-Portrait Collection
NUI	National University of Ireland
OPW	Office of Public Works
PRHA	President of the Royal Hibernian Academy
RDS	Royal Dublin Society
RTÉ	Radio Telefís Éireann
RHK	Royal Hospital Kilmainham
SSI	Sculptors' Society of Ireland
UCC	University College Cork
UCD	University College Dublin
UCG	University College Galway
UK	United Kingdom
UNESCO	United Nations Education Scientific and Cultural Organisation
US	United States
VEC	Vocational Education Committee
V&A	Victoria and Albert Museum
YBA	Young British Artists
YMCA	Young Mens Catholic Association

Titles and abbreviations in the text:
The Crawford Gallery is an abbreviation of the Crawford Municipal Art Gallery. The Crawford College is an abbreviation of Crawford College of Art and Design.
The Hugh Lane is an abbreviation of the Dublin City Gallery, the Hugh Lane. It was formerly the Hugh Lane Municipal Gallery of Modern Art. The Municipal Gallery is an abbreviation of this.
The Irish Exhibition of Living Art is abbreviated to *Living Art*.
The Playboy is an abbreviation of the title of J.M. Synge's *The Playboy of the Western World*.
The Ulster Museum was formerly the Belfast Museum and Art Gallery.

Acknowledgements

I sincerely thank the interviewees, who were so generous, patient and co-operative throughout the interview and editing process, and also most helpful in providing me with photographs. I particularly thank Sarah and Simon Walker for their kind co-operation following the sad death of their mother, Dorothy.

Esther Murnane and Irene Stevenson at *The Irish Times* were very helpful with photographs. Warmest thanks also to Caroline Walsh and Eoin McVey. At the Arts Council Sheila Gorman and Fiona McMahon were of great assistance in sourcing images. Dorothy Cross kindly lent me the photograph on page 214. I made every effort to ascertain and seek copyright of the photographs included and I regret those instances where I did not succeed. The scanning in of the photographs was done by my colleague at the Crawford College, Noel McMorran, and to him I am deeply indebted.

The Cork Institute of Technology gave financial support towards the publication and my earnest thanks go to Dr Patrick Kelliher, Brendan Goggin and Una McCarthy. I wish to thank colleagues at CCAD: Geoff Steiner-Scott, Mags Kenneally, Francis Moore, Charles Clarke, Mary Cronin and Triona Crowley in particular. At the Crawford Gallery I thank Peter Murray, Colleen O'Sullivan and Joe Murphy and the staff in the Ballymaloe Café.

Mary McCarthy and Elma O'Donovan at the National Sculpture Factory were most supportive. Thanks also to Patrick Murray, Stella Coffey, Tim Goulding and Catherine Marshall.

Thanks to Geraldine Murphy at CopyCats for her warm professionalism. Thanks also to Marion Lynch (NCAD), Elaine Fallon (RHA), Marie Sheehan (Abbeville), Marcella Senior (TCD) and Noreen King (Galway).

At Fenton Gallery I thank Ita Freeney and Sineád Dennehy. Friends and colleagues Nuala Fenton, William Gallagher and Hilary O'Kelly were enormously helpful in every possible way. Thanks! Special thanks to Tom P. O'Byrne for his help and constant encouragement thoughout.

Finally, I thank Willie Smyth to whom I am so much indebted.

Introduction

A rt history and cultural history are based on many sources; images, documents, voices. How do the voices of those who did not make the images, the non-artists, those who worked for the arts in the broader process of cultural formation, sound? Does their accent give precision to perceptions of their achievements? Can we catch the accent? What is their memory of the inevitable frustrations? In the process of synthesis necessary in writing history, achievements are often noted but voices muted. This series of interviews came about in an effort to present a kind of oral history of some aspects of the wider story of the visual arts (as traditionally understood) in later twentieth-century Ireland. The intention was to ask some significant participants to talk about themselves, their ideas and their memories. For the purposes of the construction of this record memory, motivation and perception were more important than factuality.

While it was a period of 'firsts', in some ways it took the whole of the twentieth century to fulfil and sustain some of the aspirations declared at the beginning of it. Sir Hugh Lane was vigorously advocating a museum of modern art in Ireland before the First World War. But it was not until the last decade of the twentieth century that the Irish Museum of Modern Art opened, with Declan McGonagle as its first director. It was that last decade, too, before we had a ministry for the arts, even though in 1922, however briefly, there had been a ministry for the fine arts. An institution like the RHA, doing well at the beginning of the twentieth century, was in near decline by the 1970s. New energies revived it over the last twenty years. The present exhibitions director, Patrick T. Murphy, is making a constructive contribution to this process of reinvigoration.

As is indicated by Patrick J. Murphy's account of going to

Rathmines Library to read Bodkin's *Four Irish Landscape Painters*, then out of print, in order to learn about Irish art, by the early 1960s publications on Irish art were at an all-time low. Several participants – Anne Crookshank, Brian Fallon, Dorothy Walker – have been involved in the writing of the history as well as the making of it, and it is hoped that these interviews will complement and illuminate their writings.

Many of the interviewees touch on the role of education in art. Just before free secondary education became available to Irish citizens in 1967 the first art history degrees were started in Dublin. In TCD, Anne Crookshank was the first professor of art history. In the art colleges, student activism in the late 1960s brought change and expansion here as elsewhere.

Some anomalies still lurked; for example, to be eligible for full-time studio lectureships, Irish applicants had to, from the mid 1970s onwards, have fine art degrees, but there were no such degrees available in the Republic until the 1980s.

If Irish-trained artists for a time thus did not play pivotal roles in third-level art education, artists have made enormous contributions to the arts above and beyond the making of their work. It became inevitable and correct that artists' voices would be heard in this compilation, even though the original editorial intention was to talk to non-artists. Noel Sheridan creatively negotiated his double vocation of director of NCAD and artist; his voice attests to the complexities of the issues involved in trying to interweave system and individual creativity. Specifically artistic perceptions were brought to bear on their projects by artists Paul O'Reilly and Vivienne Roche also, ensuring that artistic vision played a first-hand role in arts management in Ireland. Artists in co-operation with local authorities frequently drove important initiatives that facilitated creative participation in the arts outside Dublin.

The period was one of professionalisation in the visual arts, as in many disciplines. When Colm Ó Briain became director of the Arts Council in 1975 he was the first full-time salaried director of the Council, which had been founded in 1951. Interviews with him, with

former exhibitions officer Patrick T. Murphy and also with former Council members, Vivienne Roche and Patrick J. Murphy, give varied insights into this centrally important organisation. Legislation currently being debated in the Dáil may bring to an end the important phase in the history of the Arts Council in which these interviewees participated.

During the second half of the twentieth century successive governments saw responsibility for the arts as a State concern. From different positions within government and from rather different perspectives, Charles J. Haughey and Michael D. Higgins, both interviewed, made outstanding contributions to the advancement of the arts in Ireland. The huge development in buildings for the arts, among other things, reflects their leadership and the overt benefits of European partnership. By the end of the century formal planning for the arts was a part of government policy. This planning includes provision for access to the arts for those who are not economically privileged. Commitment to an inclusive cultural democracy is evident in many of the interviews.

Histories tend not to be collaborative. Although the interviewees here did not know who else was being interviewed, the compilation of different voices creates a kind of contrapuntal collaboration, authentically reflecting different stances, spaces and memories.

Memory has its own shades of beauty and truth, and I think that the interest of these interviews may often lie in the evocative detail remembered as well as in achievements outlined. Images like that of an old lady wearing a cross-over apron with her great house collection of paintings stacked in the attic of a small street house in Wexford, or of Patrick Collins in his new cravat when he won the Guggenheim prize can have as great a power to stimulate the imagination as the recollections of great events.

VERA RYAN,
July 2003

Noel Sheridan at the NCAD Conferring 2002 (photograph Liz Sheridan).

Noel Sheridan

Noel Sheridan was born in Dublin in 1936. He was educated in the Christian Brothers' School in Synge Street and in Trinity College, Dublin. He later took a Masters Degree in fine art at Columbia University, New York. He is married to Liz Murphy and they have five children. He is an artist. He has lived in London and New York, and between 1971 and 2002 was involved in art education in Australia (Sydney, Adelaide, Perth) and Ireland. He retired as director of NCAD in 2002.

VR: *Noel, you're director of the National College of Art and Design and an artist. What are the problems of being an administrator and an artist?*

NS: You cannot do art at the weekend, then just get into a suit on Monday to deal with pension schemes and academic councils. They are two different versions of reality. It is difficult to deal with this paradox, this contradiction. The institution aims to be rational; to have clear criteria of assessment for courses and educational policy. And this is correct. The criteria should be transparent so that staff and students are reading from the same script. Tax payers pay us to teach and they are entitled to know what we are doing and how.

You strive to demystify something that is inherently mysterious, so that what you are seeking is seen to be reasonable. But sometimes there is a price for this reasoning. Trying to find the geniuses, or making a manifesto with the ten commandments of politically correct practice is useless. Art should be oppositional to certain versions of reality. Art should interrogate the status quo, not accommodate it. This is the contradiction.

VR: *What leads you to think that?*

NS: I am conscious of Adorno's theory of how institutions may reify art: package and make 'a thing' of it. In that art is to do with chance, risk, the unknown, etc., it is difficult to lodge this level of unpredictability within an opposing system. Difficult, but that's what you must try and do. You must learn to speak the same language as the funding system to have an art school at all. It's a matter of trying to understand the other system but never becoming it. And that's hard because the other system seems logical and, in opposing it, you can appear febrile. But you need to get it right.

VR: *How do you do that?*

NS: Put a sound administration into place and then employ good practising artists and designers and get those two to work. Give everybody clear ideas of what to do, so that they don't start doing each others' jobs. That is when it will go wrong. For some

reason that's what everybody loves doing – the other person's job. A democracy, directing through consensus, brings a particular kind of stress – but dictatorships don't work for art – so you've got to get a balance. The moment you go into the academic world all that is venal about humanity, including yourself, comes in. Listen, listen, listen, but then you must make decisions. If you are trusted it will be OK. That's what takes all the time. Establishing trust. It cannot come without consensus. It can't come down in a canonical way.

VR: *And what about your art practice?*

NS: I worked at art all the time I was director of NCAD although I didn't exhibit, except for a show I did at Taylor's in 1985. This was in conjunction with a set I did for *The Playboy* at the Abbey Theatre. I just like to be in the studio and oil paint is such an addictive medium that I'm happy to do hours just watching what it can do. It is mesmerising and can be painful because too often it just goes wrong. John McGahern talks about searching for the pain and it's only then you begin. I've found that it's only when you get there that anything of interest happens. It's like going to the dentist.

　　The reasons I did not exhibit are complex. I understand that there is an urgency and focus that comes from having an exhibition deadline whereas just working from curiosity, without any set purpose – although I think this is what art is – may bring you all over the place; like having a great holiday, but no slides. I could work on the same picture for years. If you don't have a reason to stop, to have work to show, then that's what you end up doing. Very 1950s that. That's the down side of having a job; you don't have to exhibit. Sometimes being public is an essential characteristic of art. It's not art if it is not public; it's the social side of the equation that we can deceive ourselves about.

VR: *How do you mean?*

NS: It's no good if it stays in your head. And even if your public is just one other, it must be seen. I have to keep reminding myself

of this because I can 'enjoy the day', i.e., be thinking of everything as art; be amazed at the world. I did a performance at the RHA last year that tried to deal with these art and life issues. It emerged from the idea of the 'readymade'. Why are things in the world not enough for us? That's one of the questions behind the installation, *Everybody Should Get Stones* that I made over 30 years ago and the question continues to intrigue me.

Does art clarify or distort; does it expand or restrict consciousness? Does writing about it do that? These ideas, which were central to much conceptual art of the late 1960s, continue to interest me. I thought of a great deal of conceptual art as a clearing exercise to give painting a fresh start. It just didn't turn out like that.

VR: *Nevertheless, you did have a retrospective – Missing It – at the RHA in September 2001.*[1]

NS: Yes, I did. Mostly it was an attempt to have a look at myself, at what I'd done from the 1950s to the present. I'd been putting this show off for a while. Initially Ciarán MacGonigal at the RHA asked me to do it, but it seemed very final.

Then Pat Murphy came in and wanted a yes or no. I said OK let's do it. The document I thought was perhaps more important than the exhibition. In the RHA I did the installation *Stones* and a video and some current work. It was interesting to see the earlier work, the paintings from the 1950s and 1960s. My response was polarised – I felt 'I know now how to fix it' or sometimes I saw work and I couldn't imagine how I did it – I couldn't do it now. I think you can do certain things at certain times. It isn't like you get better at art. It's always the first time and sometimes you get lucky.

A great difficulty I suppose was the work from the 1970s – so-called conceptual work. The sort of work that I did was deliberately ephemeral – part of its stance was to work against the museum as a mausoleum – there was something that was wrong about that politically. So a great deal of the work was intended to be disposable or to be cheap. *Stones* was originally written as

a little book that you gave away. I had installed it in the 1970s and then it got reinstalled at the RHA and it just completely changed. It was so well behaved and elegant and minimal. Not at all what it was supposed to be in 1971, which was, you know, to be very abrasive. It wasn't dangerous but it was very uncomfortable and that was part of it, part of the idea. And it got transformed as it was re-presented. And that's interesting about art. How time changes it. How does it travel in time?

And the final piece was just to install my studio. I had been working all the time and things had accumulated. You do an edit and you pick out the good stuff and you bring it in. But everything in the studio seemed to me to be part of the total action. What would it be like to simply bring all of it in, including the mistakes and the cigarette butts? It's funny to be anti the institution at this time when there only is the institution – there isn't an alternative thing. The paradox of trying to bring what you're trying to do into this highly managed, curatorial self-conscious kind of world that now constitutes how we see art – I suppose that's an echo of my modernism. I don't know how important a problem it is any more but artists have to deal with it and everybody has to get on with it. So that was my stab at it.

Essentially what the installation was was a setting for a performance that I did called *Missing It* and *Missing It* was about missing it in relation to trying to make authentic art, I suppose. But also missing painting in a way, missing a period when it all seemed to be clearer. The performance was essentially an address to that. It was only small numbers of people, maybe 40 or 50 people at it, mostly from the art world, painters and so on. You just tell these stories and talk about art making and either people get it or not – some people liked it. But that was it. It's all part of that 'how do you take risks, how do you try and be truthful'. And what fiction is that?

VR: *You support sabbaticals, Noel, and hope your staff will sustain their own art and design practice. You say you didn't want people to get caught in 'the diploma loop'. What's that? Are you*

referring to the late 1970s requirement to have a degree to get full-time jobs in art colleges, but there were no degrees in the subject available in Ireland until around 1980?

NS: Well, I think it's an historical thing. When I came, the highest award you could get was the diploma, and most of the staff probably had diplomas. Yet we were moving to degree and post-graduate work and in order to supervise that, you know, everyone needed to be better qualified. What we have now is a policy where staff can do post-graduate work. We are totally supportive of that.

I am not making a big deal about academic awards and certainly there is a lot of cynicism about that in the art world. Nevertheless you have to be realistic. In the beginning, the criteria for students to enter here were two honours and four passes. I did away with all of that on some understanding like 'Picasso didn't have the Leaving Cert'. However, the result was that we would have thousands of applications. And so even I had to come back to ask for those criteria. I even notice too when jobs are up, I am going to the back page to see who has the post-graduate awards. It's just the way the system is. So it's very important (a) that the students can go to the highest level and (b) that the staff have the opportunity within it.

We are actually talking about the structure as I found it when I came here. Partly to do with this academic qualification issue, you found that you had had a Welsh director, an English assistant director, a Polish head of design, and then all the troops, the lecturers and assistant lecturers were mostly Irish; it really was a colonial model and that had to be changed. But it went very deep. I had difficulty with some academics who couldn't believe because of my accent that I was the director. It was too deeply ingrained in them that it must be an English voice that's giving us these instructions, which made me go even more Dublin than I am. I think it's critical that we own ourselves, we are going to do this without permission. So although sometimes I suppose people think I'm a little bit over

the top nationalist, at the same time I just think it's hopeless and useless to look to England for a model and think that that's the solution. I should also say that any art made in the name of nationalism is usually bogus. That's a different issue!

It took six or seven years to validate the degree. The NCEA was really finding its footing. It wasn't expert in this, it knew very little about art, but it knew that, unlike the Department of Education, who thought they knew something. They knew everything that was wrong. At least the NCEA did try to appoint external experts but for the most part they went to England. I just had to get these courses validated and I didn't spend a great deal of time in conflict. But what I did do was make sure that the end of year external examiners, and so on, came from a broader spectrum, if you like, than just the mainland. Artists like Brian O'Doherty, Sean Scully, et al, came to the College.

But then what system was better that anyone would pay money for? The best art school I ever taught at was 'The Tin Sheds' in Sydney. These were science research sheds discarded by Sydney University and 'liberated' by artists and students in 1971. They became home – a squat, I suppose – to a group of political and conceptual artists, who were then employed by the Department of Architecture to teach architectural students art. That was the deal. It was up to the artists to work with groups of students in whatever way they thought it best to do it. We got paid for an hour or two but ended up doing the whole day as it was so interesting. But that couldn't last. It was a particular time, a particular moment in art. But I keep that memory in my mind. Whatever the course document or paradigm, getting real life and art into it is the goal. How to know if it's working? Well, you see people smiling and doing surprising, interesting things. You look forward to coming in.

VR: *What brought you to apply for the job of director?*

NS: It had something to do with what was happening in art and at that time working out my own stuff. Also the accident of coming back after twenty years to see my folks and meeting up with

friends, many of whom were working at NCAD. The position of director was advertised and they encouraged me to apply. I did, and almost a year later – there were all sorts of delays – I had an interview and decided to do it. I spent time thinking through it. The reasons for not doing it were as strong as the reasons for doing it. But once I had argued everything through in my mind I made a total commitment. I'm stubborn and I had a fairly clear idea of where the College should be in ten years. This bond sustained me, especially through the 1980s, where the cuts were deep and it was difficult to move things forward.

VR: *You started in 1980. The 1980s were difficult in education in general.*

NS: Yes. The Tory model in England came to Ireland. Peter Brooke sold art to Mrs Thatcher as a subset of the tourist industry. High profile and money generating. It's not good that we must promote education and art along these lines. But that is what can happen and it trivialises the source of what may help make culture. We celebrate the finished items: writers, filmmakers, musicians, artists, but there is still the belief that these just pop out of nothing. I think things are changing. I think we are beginning to cherish the talent and bring it along.

VR: *Did the job originally have imaginative appeal?*

NS: Why I did this job in the first place probably goes back to issues that were live in the art scene in the 1970s. The question of what constituted creative action in the world was no longer limited to hand painting in oil or objects on pedestals. If art is about changing consciousness, if it's about society, what alternative ways were there of engaging those ideas? What did it mean to be a citizen? And the College in Ireland, that had gone through such traumas and now needed to get well, seemed to me a good thing to help rebuild. Helping get NCAD strong and functioning was part of an answer to that broad socialist question, for me, at that time. Devoting energy to help to bring a new generation of artists and designers through to professional status and to help to put in place the support system that would do that

seemed worthwhile to me.

VR: *Did you find that your work as director influenced your studio practice?*

NS: Well, in a way it was an extension of it. I came out of art practice into education because that seemed to me a better choice than getting into that whole world of exhibiting and having a practice. I just had queries about that. But it is a contradiction. There is a space between art education and art practice. I did a video, which was shot in Australia for a *biennale*, called *Why Be An Artist?* It was just a list of questions (a) to ask myself and (b) to ask students, like 'why are you doing this?' 'Do you know what you're doing?' 'If you think that you are going to be able to deal with this, maybe you're wrong'. And of course the education, certainly in the first year, is usually involved in trying to rearrange the way people think about what art is. So that was work that came directly out of the problems of (a) having a practice and (b) to do with students.

VR: *Was the RHA show linked to those ideas?*

NS: In a way, yes. I read *Athena* by John Banville which is a novel; part of which is to do with these little fake, possibly forged, paintings from the seventeenth century. What intrigued me about it was the precision of the writing and the way from reading it you could see it in your mind. I wanted to go back to that very early thing of how do you represent something, literally if you like, as you see it in your mind and can you do it in that seventeenth-century style, and, well, you can't because you can't go back in time. Those works look like that because that was the total political, social, cultural context they were made in. So – *Missing It* – that's one of the things you miss – you can't go back. But I think it was also about an interest in utopias and certainly Poussin and Claude were about arcadias. They were projecting backwards towards Greece and where Greece was coming from. And because it's difficult at the moment, with the collapse of institutions, churches, politics, there is a deep lawlessness. People are just consuming things and getting on

Performing Missing It, *RHA Gallery 2001 (still from video by Noel Sheridan).*

with it. Nobody is projecting forward, but the clarity of times past when things were clear is very evocative.

Recently I was engaged in the College in bringing in information technology – we put a media course together that had to do with computers, video, etc. It's a paradox in that it's cutting edge technology but the deep structural processes it uses are fifteenth century. If you see a video game it's a Brunelleschi landscape. Nobody has dealt with what is computer space. Not only do they not use the shallow space of modernism, but what is this other pixelated space? The course may address that. But I did use the software programme Photoshop, which is structured along this grammar or syntax of the fifteenth century so you can get effects. I worked for a year by hand with tiny brushes and you had to wait for things to dry and you had to research how you get glazes. With this technology you can do it in ten seconds. And you have the question, 'what is it if you don't accept that, what are you doing? Is it some sort of puritanical idea like boy scouts getting badges for achievement?' You know if it's expressing the thing. Partly the work was to do with that.

What I did in the RHA was bring in the entire studio, including the mistakes, the wretched attempts at trying to paint by hand as if it was the seventeenth century and the grotesque, failed works, then using the technology, which in a funny way got closer to the seventeenth century. So there were all these contradictions in *Missing It.* It was missing the seventeenth century if you like and the nostalgia for a bygone time but also

not quite getting it as art. I also did a drawing live that didn't work, and talked about that.

VR: *You're very interested in the relationship between art and life.*

NS: It's interesting to me that in so-called advanced art, we still have this separation between people and the art. It does seem to be very specialist and those who get it, get it, and you can't simplify it because it is complex. But if you sit down and describe the complexity and take the risk of being as honest as you can be, maybe there is a bridge. This is the guy who has got the paints and he's sitting at the table and he has these pictures and he is talking about what he was trying to do. And you do try to say it in such a way that people might get it. And I think that's the educational thing. Most artists don't care; in fact, the more enigmatic it is the better, because people will write about it and this will build up discourse. And maybe the social role of art is to generate discussion. That's how the art permeates into the society and I'm interested in that. However, I don't have a big manifesto on this. I have no epistemology of art. In fact I suppose my take is linked to the last great modernist, Beckett. You can't go on, but you go on; you know, I am cynical about the whole activity 'art' but I love this activity and I am going to go on. In trying to do it and failing to do it somehow or another, if you fail again and fail better, something may come out of it. That is a shared thing with humanity because that is the way our lives are. That's why art has sometimes had to say instead of that confident 'this is the masterpiece', if you say 'look, I am in trouble with this', then maybe people will say 'that's interesting because that reflects life'. The big thing is how to do that with some kind of excellence. The trick that Beckett does is that he is about boredom without being boring. How do you show failure but somehow or another make it look like a success. That's the problem.

VR: *Given the layered and prismatic nature of your thinking was it difficult to work with bureaucrats?*

NS: I was impressed with the excellence of the Higher Education

Authority. I know I have had a lot to say about the difficulties of bureaucracy and art, and my instinct, when I first went to meet with Jim Dukes, the Secretary, was not good. He spoke to me for a long time. He told me how important it was to provide education for technology; IT. He was a genuine public servant, with the nation's well being at heart and he turned me around. I accepted what he said. Art was not on the top of the agenda, but he did have an agenda and it made sense. And he was dedicated to the idea of advancing 'the nation' and how that might be done. I was very impressed. That culture continues at the HEA. They are people who do a really difficult job with no fuss and great modesty. This was a revelation to me. It gave me a new take on what it was to be 'a citizen' – a public servant.

In Ireland I found there is no such thing as not being political. And certainly I knew C.J. Haughey and I knew people in the Fianna Fáil party although I never, partly through this meeting with Dukes, went over the head of the HEA.

In Kildare Street, the College was in an old building; they had attendants at the top of these marble stairs, and it was almost like they were going to take your cloak and hang it up. Like, waiting for Orpen or somebody, it was very old fashioned. And clearly it was in terrible disrepair, it was deeply neglected. It must have been totally intolerable for the students and the difficulty was that it was administered from the Department of Education and everything was forms. If you needed a hammer and chisel you put in an order form and three or four months later if you got lucky it would arrive. Everything was just locked into this kind of nineteenth-century way of doing things and it was intolerable.

What happened was there was an act passed in the Dáil.[2] That certainly was a fantastic achievement by the students – it was due to their political pressure. The National College of Art and Design Act constituted it as the National College and clearly there was a blueprint there for it to be a really important college. The permission was there.

The only thing is the resources weren't coming in. So you had an Act but you didn't get much action. In Kildare Street the tunnels run in directly from what was the College basement in Kildare Street into Leinster House, the Dáil, and Rose Dugdale, through the Students Union, got onto the balcony of the Dáil, luckily enough just to distribute a manifesto. It was for that reason, plus the fact that a new party, the Progressive Democrats, had come into existence and there were no rooms for them, that on the basis of safety we were evicted. That is the fact. Nobody said 'let's make a great art school and convert Powers distillery in Thomas Street and give it resources'. We were simply evicted. Now that was very abrasive and very difficult to manage. On the one hand you were going to get better premises – the old distillery converted – but on the other you had to do it on the hoof. Kathy Prendergast, who is a terrific artist, graduated from here on a building site. It makes you wonder what is possible.

The other thing was the Board. At that time – 1981 – they were told to go to Thomas Street and they didn't want to go. They ideally wanted Earlsfort Terrace, or they wanted a green field site out at Morehampton Road. Everything is a matter of working with boards and committees and so on, but for some reason when the old Board went out, a new board wasn't appointed for six months. I was working directly with the HEA, making these decisions and they said 'OK, you don't have a board but if you agree we'll go to Thomas Street.' The one thing I did know was that the right place for this College was Thomas Street, in the middle of the Liberties. There is nothing worse than art schools on green field sites. You're looking out the window at sheep and you're graduating shepherds. This is the place to be. You come out and you're directly hitting life and that's very important.

VR: *Yes.*

NS: In the 1980s everything stopped and there were cuts and we couldn't get staff. The HEA was the agency and I accepted that. I didn't try to override that or second guess it. However, I may

have been wrong. I think there's no question but, for instance, when Niamh Breathnach was elected from Dun Laoghaire as Minister for Education she put about twenty staff into the college of art there and big plans for expansion. You realise that was a political move to satisfy that constituency. I don't even know who represents us in the Liberties.

It isn't that sort of place. That may change now that this is going to be Silicon Alley, they are bringing all these media labs from MIT and so on. This area is now going to be an extension of Temple Bar. If the plans come through, although already they are starting to be in great doubt, this could be a very exciting project, bringing in all the new media and I think the NCAD should be a very important part of that.

VR: *What kind of student comes here?*

NS: This is still a very middle-class operation unfortunately, and there's nothing I can really do about that. One day I saw a lot of kids going down the stairs and they were out on a project and I said 'Where are you going?' They said 'We're going out to draw poor people', and I said 'Come back, come back'. I called all the academics together and I said, 'It's very important that you do projects that relate to this area. I don't want anything patronising. This is us and I want it represented but I don't want to see that distance'. And now I think we are accepted into the community. I usually take a very low-key position, in that I am from this area. But now I think it is the time to celebrate the College. I think the community likes us being here.

There were difficulties in the move. We actually were among the last people to pay disturbance claims. People were paid money to come up and that was OK. I did have staff who were nervous and I think maybe understandably too. It can be a tough enough area, this. We back onto Oliver Bond and it's difficult to secure. There's a lot of drug addiction and stuff around. I was sympathetic and we did put on extra security. But I was aware too that they were going to miss Bewleys. People were talking about the National Gallery but essentially it was

because the College was so close to Grafton Street and the shopping! But I never had any doubt that this was the place to be.

A big difference between twenty years ago and now is the new attitude of parents. Parents used sometimes come to see me because they had a problem. The problem was that their child wanted to come to art school. What was wrong with the child – they're asking me this! I'd counsel them, saying it wasn't all that fatal; it was a good course and that they should support their child. Now when I meet parents I am likely to be told their child was successful in gaining entrance and they wanted to be assured that the kid would learn Photoshop, Quark Xpress, video editing, web design and other IT and CAD software programmes currently so much in demand. The answer now is 'yes' – we now have a policy that every future graduate will be computer literate. I wonder will we have artists twenty years from now, because there are so many opportunities out there for those computer and visually literate graduates within the IT industry. I put the media department in place, which is grounded in the history of art. So whatever the new technology, as long as that continuity is sustained, they will have powerful tools to represent the world. The postgraduate course is called 'Virtual Reality' not because this is a recent buzz-word but because that is what art always was – virtual.

VR: *It took ages for the College to fully move from its premises in Kildare Street and all over the city – City Quay, Princes Street, Leinster Lane, etc., to this campus.*

NS: It took seventeen years to get from the brief of the new building, the new Design for Industry building in John's Lane, to having it built.

The master plans for the new Ireland featured science and technology. Art didn't feature. What turned it our way was the visit of the Swiss bankers who came over. We got £6,500,000 from the EU in about 1991/92. Then we had to go over to the Department of Education, who told us how to spend it. We had to spend more money drawing up a document proving to the

Department that the figures we were submitting were right. Dublin was just exploding with building then. All the time it took to convince them, the building figures were inflating. The problem was we couldn't spend the money fast enough to avoid the inflation. The money you had in 1992 wouldn't do the same building in 1994. So the Design for Industry building – that's what we had to call it to qualify for the EU grant – had to be cut back.

VR: *Design is very big here, isn't it?*

NS: This is the largest faculty at NCAD, and it may well be that it is Design that will lead the College in the future. I don't find art and design distinctions useful. We may have to have these discipline distinctions but there may be a price. And no, I'm not suggesting that you jumble everything up. One has to edit, to make both art and institutions work – you can't do everything – but be aware that there is an 'everything' and you've got to be open to it. A great garment, or a book, bowl or industrial product can be art, just as a hand painting in oils, which is just a copy of someone else's style, is design or craft (as a more accurate definition). I think in the future these distinctions will blur. Just as popular culture has invaded the world once thought of as High Art, so our ideas of what counts in visual culture will change.

VR: *How do you adapt art education in a post-modernist context that is different in its thinking from the world of modernism?*

NS: Cultures that embrace deconstruction and such post-modernist agendas are in themselves, usually, strong, i.e., there is something to break down. But NCAD at that time, 1980, was broken down – there was nothing coherent to dismantle. So the task was to build it up; give it form. It may be that it will be reconstructed at some future date and there will be a coherent model that can be verified or falsified along the lines that Karl Popper recommends. When something is in flux in art it is a good thing. When something is in flux in an institution it is not so good. Everyone gets on the case and the hysteria builds, confidence is drained until even those who know what they are doing begin to doubt themselves. It's a nightmare. On the opposite

hand, the problem for 'rational' systems is how to prevent them becoming inflexible and autocratic.

The important thing is to stay flexible and open to change. Art changes and you have to absorb new ideas within a core of traditional skills. You can establish a core of full-time teachers and then inject change through part-time projects and visiting lecturers. This is difficult when the unions want all posts permanent and pensionable. I'm ambivalent about this; I am for unions; I have started them and served on them, but this policy of permanent posts has problems. How to avoid inflexibility and be progressive, or at least sympathetic to the changing needs of art, is the task. Part-timers lift and shift and change the whole thing. Part-timers are much more than just the pepper and salt of art education.

VR: *Have we moved from a degree of chaos in art education to a degree of rigidity?*

NS: One senses things becoming more corporate. This is true of both the art and the institution. When I came it was the beginning of the end of the RHA influence on the College. It was the revolution by the students, in the late 1960s that made it happen. I was concerned that the baby – especially that 'drawing baby' which is central – might go out with the bath water. Performance and video and issues from conceptual art were displacing painting in an unforgiving way, and I don't think that was the best thing for students. The task then was to continue to offer options – the image of the smorgasbord rather than the set lunch gets the idea. Choice.

VR: *How is this done?*

NS: You try to appoint staff with a wide range of skills and beliefs. It makes management more difficult, but this tension enriches the students. It shows them that all answers to the art question are provisional and it encourages them to make themselves up. Students will always be looking at the magazines and they will try to be up with their contemporaries in the art of their time. As long as this is grounded in a real knowledge of the history

and theory of art – and not just getting 'the look' – then this is how it should be. Art colleges will always be off the pace anyway, but you must know what's going on. You can't freeze.

VR: *Out of that late 1960s chaos in Kildare Street many good artists emerged – including Charlie Tyrrell, Gene Lambert, Mick Cullen, and Brian Maguire, now Head of Fine Art at NCAD. The dynamic between the students can be the thing.*

NS: A quarter of the education happens in the canteen. I look favourably on that.

How contemporary or how traditional must an art college be? If you can come up with a definite answer to this – you're wrong. So what you try for is a coherent support system sufficiently flexible to handle change.

VR: *How do you mean art and art education institutions are becoming more corporate?*

NS: Modular systems and quality assessment procedures are all administratively neat, but the paperwork they require, and the time lost to students, who can't get access to staff, is no small thing. Art, too, is becoming corporate. 'Branding' has replaced 'style' – not a good way to go anyway – so the aim now is to establish 'a name' that will register: Hirst, Emin, YBAs (Young British Artists) etc., and this is tough for students who look to these models. Neo conceptualism is the same work as the 1970s with more expensive production factors. One can't make important work now for under $100,000, it seems to me, and one can see students try to mirror this, so their end-of-year shows end up being more expensive. So you have a generation of artists with greater freedom than ever but they have a more difficult task in many ways. It will change, but at the moment it is tough.

But what won't change is the talent and the growing confidence. I believe that some time, in the middle of this century, we will have the visual equivalents of the Joyces and Becketts. But you have got to roll with the blows and put things in place for them. You need to burn a lot of lumber to get a good fire. If you're just kicking the ball around you can't be Premier League,

you can't win.

VR: What do you think about an art scene where the State – the Arts Council for example – and wealthy patrons, vying for star art, set the agenda?

NS: One thing I think about it is that it doesn't matter what I think. It happened and a new generation of artists will have to deal with it. With the death of modernism it may be that we are going back to an earlier model where the State rather than the Church is patron and corporations or wealthy individuals, in competition for status art, set the agenda. Great artists in the past have made great art in what might be called barbarous conditions. I think in many ways it's becoming more like the Renaissance now than modernism. It's very complex and I'm interested in how artists deal with it. Art is no longer underground, it is hugely popular, so old strategies no longer apply. Art's got to make itself up again. If I knew how I'd tell you – or better still I'd be doing it – but it must come from the bottom up – from artists.

VR: How did you begin? You did a night degree at Trinity and you were an actor before you started painting.

NS: I went to Synge Street Christian Brothers' School. When I left they gave me a reference which said I was, 'to the best of their knowledge, punctual, honest and amenable to discipline'. I was stunned. And this was deemed a good reference. I couldn't help thinking it was more like something you would write about an animal. But that was the 1950s – not exactly cherishing. It was a wake-up call, but I didn't know what to wake up to. I just felt lost.

VR: What did you do? You didn't go to art college until much later, in America?

NS: Well, I tried to do nothing. I failed CIE, the ESB, and all the insurance jobs we were prepared for at Synge Street, but my father got me a job in the Circulation Department of Independent Newspapers. I think I went crazy. The people there were nice, but I just couldn't hack it. I knew I had to be better educated. I went to school at night on the only course available

in Ireland. BA, B Comm at Trinity. It was not exciting but I got to write for the Trinity Players – revues – and out of that I got a job writing material for a morning show that the actor Joe Lynch did. And I began painting, and that was a revelation. And I had enough stamps to draw the dole so I left this job.

VR: *What got you onto painting?*

NS: The art class in Synge Street was for losers; those who didn't get chemistry. One day Brother Gillroy brought in a big illustrated book on the history of art. He showed us the cave paintings – Byzantine – Medieval – and then he stopped. He said he could not show us 'The Renaissance' because of the images. Nudes. I made straight for Rathmines Library. I was shown to the reference section – you couldn't take these books home – and there they were. Amazing. Very sexy, but there was something else. And I began reading about art. They had a book on modern painting which you could take home. I couldn't reconcile the critical text with the images, which were wonderful and I felt, I'm not getting this. Then I got a catalogue of Nicolas de Staël's paintings – and then I got it. No need for text; no need for anything but the work; this was it. I worked backwards from de Staël. I began to get Matisse and then back to Cézanne. And I was into it. When I met painters I entered into the strange language of broken, inadequate English that was their way of talking. I loved that.

VR: *What was strange about this language?*

NS: Well, it presumed telepathy for a start. It's looking and pointing in the belief that each one is working from the same set of beliefs, which need no explanation. It has lots of 'see that' and 'look at this' and 'that doesn't work for me'. It's mostly to do with 'how was it done?' Very businesslike. I got intrigued with this language, which I still love – I like talking to artists, especially painters, about the work, and I know it was from this interest that I made *Everybody Should Get Stones* which I think is about painting. These were exercises to clarify for myself certain issues to do with representation and the role of language in

seeing. It's the problem of ostensive definition that opens Wittgenstein's *Philosophical Investigations*.

VR: *Theatre was very important to you.*

NS: I wrote a show for Chris Fitzsimons and John Molloy about the time RTÉ was starting up. Chris got a job at RTÉ so I performed it with John. I did various bits and pieces in revues which were popular at that time. James McKenna, who was in the *Independent Artists* with me, wrote a play *The Scatterin'* and I played in that. It was a good play about unemployment and emigration. It featured 'Teddy Boys' and rock and roll and it was a hit with an audience that was ready for this representation of Irish life. Very gritty. You could feel change in the air. Also the revues were a way into this change. That was 1960, I think.

VR: *Why did you stop acting?*

NS: Well, I wasn't that good. Also my father, who was in theatre, held strong views about what it was to be a professional – a pro. You couldn't have a second job if you were a 'pro'. That was amateur and it took work from 'pros'. I was raised up in that culture and because I was painting and exhibiting at the time I always felt amateur and that I had to make a choice. Leo Smith, my dealer, was also keen that I decide. It's different now. If you want to use other forms it's OK – film, video, performance, painting, whatever – the permission is there. It's good that these distinctions are blurred now, but it had to wait for the collapse of formalism in the 1960s to open things out. So my timing was off.

VR: *Does your acting experience assist your performances?*

NS: I suppose so. But in so-called 'fine art performance' you are working against technique. You're trying for real time, between the audience and performer; and you try to get everybody into that unique time and make that a self conscious act for both performing sides, because people are performing as an audience. The formal issue is the same as in modernism; to show how something is happening while you make something happen. It's not that different from acting, but it's just a particular focus. I can't explain it and it's this uncertainty that I work to represent.

It's that place in art that most painters I know talk about. I'm trying to represent that. It's risky and you can only do it once or twice, because then you know what you are doing – and then you are acting. When is one not acting and what might that look and feel like? But I've done that and I need to do something different and I'm working on it.

VR: *How did you get your first solo painting show?*

NS: I got lucky. I left some works in with Leo Smith to be framed and he sold them. From that he offered me a show and that went well. Everything was going great. It sometimes happens, in the beginning, that the Muse smiles on you and gives you everything. It just flows. Then it changes, and for no understandable reason, the giving stops. You spend hard time trying to get back in. And sometimes you do and, because you can remember that first time, which is not a style or a look – it's more a sense of discovery – that sensation is all you want. But now it's work. The honeymoon is over. Now you must do anything it takes to stay connected. I have done that. I have always been about art. If sometimes it seemed peripheral to the main action, it nevertheless was in the vicinity, waiting. I hope to move to a state of 'not waiting'. I did a performance examining exactly that state recently – *Pushing It*. Now I'm looking for the next move.

VR: *What was the art scene in Dublin like when you began painting in the late 1950s?*

NS: It was a very small scene relative to today. But it was intellectually rich and it was generous and idealistic: Norah McGuinness, Patrick Collins, Gerard Dillon, Barbara Warren, Pat Scott, Cecil King, Nano Reid, all showed at *Living Art* and once you got to exhibit there you were accepted into this band of avant-gardist bohemians – or at least that is how they looked to me. And they would talk about art and help you. It was easygoing, but you got a sense of a dedication to art or to the idea of modernism that was an alternative to everything in Dublin at that time. I was ready for that; I was looking for that.

I got that show with Leo who became my dealer. I was

aware that I was the first working-class Catholic to enter what, in many ways, was an élite – a minority really. Maybe it wasn't, but it felt like that – an ascendancy that sustained art. I did not see this as a political issue – maybe it was, but I did not see it that way. I just wanted to paint. When I agreed to be a founding member of *Independent Artists* [in 1960] with the idea that this would give more opportunities for artists to show work, we surfaced issues that were a surprise to me.

VR: *Like what?*

NS: Well, *Living Art* had a jury system that selected whereas *Independents* was more like a co-op with each artist showing four works with two painters and one sculptor, drawn from a hat, showing ten works. First year the painters were Barrie Cooke and Camille Souter and the sculptor was James McKenna, none of whom had ever shown that many works before. Amazing really. Also I felt that Leo and the *Living Art* people didn't want it to happen. Leo warned me against it, for career reasons, but I had agreed to be secretary to the group and I went ahead. Leo, not for any bad reasons – it was business – had warned his artists off the project. But Gerard Dillon, as a favour to me, sent work and he convinced Nano (Reid) also to show. They were the established names and they took a chance, because Leo could be a hard man if crossed. We had Noel Browne, who was quite controversial at the time, open the exhibition. He did a really good job. There was something in the air – change – but I wasn't politicised until the later 1960s so I had no analysis and for me it was just about art. Later *Independents* did become political and that early start was erased from history, but people like Owen Walshe, who was one of the main movers in setting it up, should not be forgotten. Owen worked from anger at being rejected by *Living Art*, but then many interesting things can come from disorderly passions. Like art.

VR: *What are your memories of Patrick Collins?*

NS: He was handsome. He wore cravats, drank wine and he smoked Gauloise. I thought he was the real deal. He took himself very

seriously. When he won the Guggenheim[3] he got a wonderful cravat. I can remember listening to him talking about his painting. He had a 'three stage rocket' theory of painting. First comes a 'lumber burning' to get lift. But you are not there yet. You've got to find a second gear in the knowledge that everything might blow up, but maybe you will get another lift. And then comes the lift into that space you were trying to find. Everything here is delicate. He would speak for hours about this place and I can remember him in his room, I think in Parnell Street, with a small painting on the floor between his feet, sitting, looking at it, talking to it and to me. He was coaxing it to emerge with small movements of his hand in the air. And that image, that memory, stays with me. It was more than the talk; it was the total immersion in the work.

This is one of the reasons I think it's so important for students to see artists making the work, and it's great when artists let you in to see that. Not just talk about it. But it is not easy to get agreement from artists to do this, because how you behave at these times could have you certified.

VR: *You got the Macaulay award in 1961 and the prize for painting in* Living Art, *so you were on your way as a painter.*

NS: Yes, the Macaulay was for £1,000. I got married on that and went to London with Liz. I painted my second show there. I saw a lot of art and my work began to change. I tried to work against the grain of what I had done in my first show.[4] This had problems for Leo – what a dealer wants is consistency – but I was 24 and held the firm belief that habit was the enemy of art. I still think that, but I also believe, from Wilde, that 'everything you say about art, the opposite is also true'. I do know you don't get better at art. Every time is the first time and you just have to keep working.

VR: *How did you get to New York?*

NS: When I went back to Dublin in 1962 I did a revue, *Tate at Eight*, which was taken to New York. I stayed there for the duration of the 1960s, painting, teaching, doing various part-time jobs and

trying to make art. I got a scholarship to Columbia in 1966 at the time of the Vietnam war. A lot of the protest came from Columbia – it was a good course and what with the famous visiting lecturers: Noland, Stella, Guston, Smith, et al, plus the political sit-ins, it was a real education. There was real change for me. My work changed and I got involved with conceptual art. It was difficult for me, as much of this art was anti-painting and I had been painting for twelve years by then, so the break was not easy. In fact, I decided to make a clean break at that time, 1971, and we went to Australia.

Noel Sheridan, New York, 1967 (photograph Francis Keavney).

VR: *Why Australia?*

NS: I had met some Australian artists in London in the early 1960s and I liked them. I went initially with the idea of giving up art altogether, doing something else in a new place. Art can be alienating and I just wanted to be a human being and get a different kind of life. But I did get back into the art scene. It was a good time in Australia. Whitlam's Labour Government was in power. It was progressive on all fronts, including the arts and I wanted to be part of that. I worked in Sydney for five years and then went to Adelaide to direct an experimental art foundation which was a venue for alternative art; conceptual, community, political, feminist and all the shades of practice that flourished under that heading at that time. By the end of the decade this work was going to *Documenta* and the various *biennales* and was no longer alternative. It had run its course and the main action moved back to the private galleries. Of course, it was at

this point that the alternative spaces got more funding from the State. They became respectable; major players in the culture industry. They bred their own particular style of art making. It's within this new landscape that artists must work out their stuff.

VR: *You retire as director at the end of this academic year. What will you remember?*

NS: I have been clearing out my office; five filing cabinets of documentation. I must have written over one million words. I look back sometimes to earlier years. All that writing. I can't tell how much of it made any difference. It just seems such a lot and I don't think it's going to get simpler. One large section of documents has proved worthwhile; the various EU schemes – EU documents are something to behold – that allow students to move around Europe to study. I remember when going to Skerries was an adventure but now to see so many students move so easily across Europe, being part of that idea, is wonderful. European cities are educations in themselves and it is essential that students gauge their practice in this larger context. We also do exchanges with North American institutions. We have raised private sponsorships for these through 'The Friends of NCAD'.

VR: *What is the biggest challenge for the next director, do you think?*

NS: The next person primarily needs to raise 50,000,000. That's the price of the next development for NCAD. We have a strategic plan for the next ten years and a model of how it might look. It's wonderful and it will take some doing by a very special person. More telling than a knowledge of art and design education, these days, is a capacity to raise money. And maybe this is right for NCAD at this time. The platform is there: good staff and professional structures – it's better not to meddle too much with those – but the primary task is to raise everything to the next plateau and this requires more space than we have now. It's very exciting and different from what I had to do. If I was fifteen years younger I would love to be given this to do.

On the other hand all of this building and capital develop-

ment is incidental to art education. It doesn't guarantee anything. Students still have to walk the walk to be artists, but the buildings, the framing or containers for art, these will affect the way that art walks. It can give confidence.

VR: *What will you do?*

NS: I'll go back to the studio. I'll try again. I have some ideas, but what I need to do is work and work. My time is getting short. I'm aware of that. I am aware that the days when I could do fourteen hours straight in the studio with ten cups of coffee and a ham sandwich are over. I've got to work out. Just get in again, some way. That'd be good.

VR: *Will you stay in Ireland?*

NS: I don't think so. Dublin has changed so much, so fast; I feel like I'm in a movie and it's about something else. It's for someone else; a new generation. In a way it's what I had wished for. But beware of making wishes – they come true but not the way you figured.

VR: *Your association with the College has been extensive. What do you think of that time?*

NS: I didn't get to go to art school in Ireland, so maybe I was a believer. Many who got to go will say it was a waste of time. But they got the experience, so it's easy to say. I think more of our people should get the chance – it really can be magic – and I'd like to feel I was part of setting it up so that those who think they might be artists and designers can really find out. That's what it was about. But that was that. What's next is what's interesting, I hope.

Interviewed on 18 October 2001, 14 December 2001 and 4 July 2002

1. Sheridan, N., *On Reflection*, Dublin, Four Courts, 2001.
2. National College of Art and Design Act, 1971.
3. Patrick Collins won the Guggenheim National Section Award for Ireland in New York in 1958, with *Liffey Quaysides* (now in the NGI).
4. Noel Sheridan's first one-person show was in 1960 in the Dawson Gallery, Dublin.

Declan McGonagle watches a US camera crew filming in Derry for the Leon Golub documentary, July 1987.

Declan McGonagle

Declan McGonagle was born in 1952 in Derry and educated in Francis Street Primary School, the Christian Brothers' 'Brow of the Hill' School, and St Columb's College. He attended the College of Art and Design in Belfast from 1971 to 1976. He is married to Moira Carlin, and they have two children. He has worked as a curator for over 25 years in the UK and Ireland, was shortlisted for the Turner Prize in 1987 and served on its jury in 1993. He was director of the Irish Museum of Modern Art from 1991 to 2001. He was Commissioner for Ireland for the Venice Biennale *in 1993 and for the* São Paolo Bienal *in 1994, and is the chair of the board for the Liverpool Biennial. He is currently working as director of the City Arts Centre's Civic Arts Inquiry in Dublin.*

VR: Maybe the solemnity of contemporary art mitigates against understanding it?

DMcG: I think that's true. Contemporary art can be very intimidating for the general public because they are not now familiar with the codes used in art, which many contemporary artists have turned upside down, especially in the second half of the twentieth century. But it is interesting how, even with the group of artists known as Art and Language, who were pretty formidable in their deconstruction of narrative and subjectivity in art, one can now see that humour and cultural play was part of their process. I remember working with Terry Atkinson, a founder member of Art and Language, after he had left the group and realising that a north of England humour mixed with a sort of puritanism was woven into his practice. The point is that as an artist he was a real person in the real world. People often see art and artists as if they came from nowhere, from the ether, whereas a key point of my work as a curator has been to explore artists and their art in the world, as products of the world, not coming from some other zone, governed by rules of its own – disconnected.

In the general media, artists are regularly represented as strange and eccentric or, if they live long enough, venerable. These presumptions, from the solemn to the ridiculous, are real impediments to what I believe could be a much fuller engagement between people and art, and contemporary art in particular.

VR: Do the institutions contribute to this distancing?

DMcG: Oh absolutely. It's a very big issue with museums now. Lots of museums are reacting to what museums were in the past, moving away from the idea of the temple towards the idea of the forum, which is a space where social transactions take place. Many new museums represent a mix of the two. But in doing this they are in danger of moving in one direction only and adopting a shopping centre model, which can define visitors simply as consumers – the consumer model of the museum is

becoming celebrated because it provides very easy answers, usually in numerical and economic terms. The focus moves from the content, its value and meaning, to the vessel of the museum building – hence the overwhelming focus on new museum building which is now rampant across the world. The Tate Modern is a brilliant example of this. It's a great project. It represents the beginning of a whole new debate on what is a museum, and because it has succeeded brilliantly in creating signature architecture in a great cityscape, repositioning the Tate Gallery and capturing the media and public imagination, it actually allows us address the next set of questions for public cultural institutions dealing with contemporary art.

I would have concerns about what is in the museum being relegated to a secondary experience, and not being presented as the reason for going to the museum in the first place. That isn't to say museums shouldn't be wonderful buildings. Of course they should. But when their primary function is to assist urban regeneration or institutional leap frog without considering programming and for whom, then there are dangers. Public institutions must play a part in their place over the long term and the consumer model is unsustainable over the longer term.

With the consumer model the pressure is on to have thousands of people coming through, with shops and admission prices, and a huge revenue-raising process. I think the consumer model operates in ever decreasing circles and if projected as the only valid model – the only game in town – can be dangerous culturally. It disenables people. If you're a consumer, consuming what someone else has told you one way or another to consume, you are on someone else's script. I would say that our task as curators in the public sector is to create experiences that give people space to enable themselves to negotiate meaning in art. The challenge is to do that without diminishing the art. Some artists today develop their practice around that whole issue of participatory rather than signature practice.

Our society has come to expect quick, short-term returns

and instant gratification. If you think of it in investment terms it's a quick return society. The imperative is to turn a quick profit – I don't believe this is any way to run an economy, never mind a culture. Culture is long. Art is long and the structures which nourish and support it should be operating with a thoughtful, well-planned strategy with identifiable goals and benefits, over the long term.

VR: Are you talking about politicians or curators or critics taking responsibility? Do different kinds of institutions have different responsibilities?

DMcG: I'm really talking about everything, the culture of politics, art and business, the economy. Long-term, strategic processes at the national level do not preclude shorter-term strategies in other areas of the culture. The City Arts Centre is an interesting example. An organisation born in the 1970s, it was committed to giving people access to the arts as part of a wider community arts sector. It has succeeded in foregrounding issues of access and is now facing into a period of radical change. As an independent organisation it can do that and hold its core values – people can and should have access – either to making or experiencing the arts. As an independent organisation it has remained capable of changing itself, or morphing, into a new entity, and that's what I am involved with now.

But national institutions, and especially those which have been in existence for a while, don't have this kind of freedom. They often have statutory responsibilities, given by government, to provide a cultural memory, to document it, to keep that memory safe and make it available to society. They can surround contemporary activity with an understanding of memory and have a responsibility to be capable of functioning 50 years or more into the future. Again I would emphasise that art is long. Even the fastest looking contemporary art is still connected to long lines of descent. National cultural institutions also have to be long, they shouldn't be put in the position of looking for 'short-term profit'. Beyond national institutions, other organisations will

emerge, change, disappear and reappear over time.

However, when the consumer model is applied to long-term projects, there is pressure to have short-term returns and that produces tensions which have the potential to destroy the institution.

VR: *Why is the consumer model so ubiquitous?*

DMcG: In many ways it's a simple mechanical thing. If it's easy to measure it's easy to manage. If you have millions of people coming through the door, you can turn to government and say we deserve funding and they can see why it should be given on the basis of a head count, as it were. If you have smaller numbers coming through, an institution can less easily be described as successful. Yet there is often no debate or research about the nature of the experience those millions of people have or the quality of that experience.

What's happening is that an economic system is being applied in an entirely simplistic way to a cultural process. Somebody recently said we in Ireland seem to be living in an economy rather than a culture but this is not exclusive to Ireland, it arises because perception in Western societies is not considered to be scientific and perception is key to art. The scientific, the economic, is associated with intelligence and visual perception is not. It is presumed, on a societal scale to be subjective.

Activities that project themselves as dealing with facts, sciences, economics, occupy elevated positions in our society. And you can speak to power through facts, through objectivity, not through personal experience or subjectivity. As C.P. Snow argued in the 1950s, there are two cultures – one of the arts, one of the sciences – in our overall culture.

The idea that truth is only accessible though reason is a construct of the Enlightenment which has dominated Western Euro-American culture for more than a couple of centuries. We know now that progress towards universality is not the whole story. We're now clearly at the end of the period begun in the

Renaissance which continued though the Reformation and the Enlightenment to Industrial Capitalism and into the twentieth century, to a world which is now globalising economically while fragmenting and localising culturally.

There was a view that the universality of modernity was desirable and possible, everyone could be an 'Englishman' in the sense that the Amish community uses the word 'English' to mean 'modern (ist)'. I think the events of 11 September (2001) have shown, finally and brutally, that this is not possible. The Western view of modernity is clearly not accepted by whole areas of the planet. Many people are reacting against Western values, at the same time as more people than ever are drinking Coca Cola. But culturally and politically there's a fundamental rejection in sight and I think September 11 represented that sort of rejection.

VR: *And what are the culture-related questions we need to ask now?*

DMcG: The questions now are about how we nourish culture in that sort of world without becoming inward or defensive or fascistic. Ronald Reagan was once asked what would he do as president if there was a foreign affairs crisis and is reported to have said, 'I would draw the wagons in a circle', referring to his own background in movies and the mythic Hollywood image of the American West. But in my view having a healthy, confident culture means not having to draw the wagons in a circle.

VR: *You've used the cultural model of the museum as forum, as a centre for artistic debate.*

DMcG: We also have the model of the agora in Athens. Both places, Roman forum and Greek agora represented the importance of socially and commercially interactive, transactional, space.[1]

Within a universal belief system, anyone can deal with sophisticated art codes and make them part of life. The peasant could walk in from the field and 'read' the Gothic cathedral or the *Adoration of the Lamb* altarpiece, and get its value. All that was mediated, of course, by priests but there was a seamless culture at points within our European history. I'm not a Pre-

Raphaelite and I am not simply nostalgic for some medieval golden inclusive age – people were generally more brutalised and disempowered than now, so I am not arguing for a return to anything but I do believe in continuities and coexistence of ideas. We inhabit culture at any time. As humans we are fed by it and we feed it. But the consumer model of culture says that it is outside the person and the person has to 'buy it' somehow in order to value it; that culture is something we can possess rather than something we inhabit. In a particular period of the nineteenth century these separations emerged between history and the present modernity, and between the artist and society.

That opposition needs to be recast as a continuum within larger societal processes. But you are what you eat and what we, in society, have been eating since the early nineteenth century is a societal model based on production and consumption, which I would argue disempowers the artist and the potential for people to engage with what the artist does.

VR: *And what about the primary producer, the artist, how do they do?*

DMcG: Middle men have done well out of that producer/consumer model. Art administrators and art historians are middlemen and I would say the primary producer, the artist, actually occupies a very marginalised position. Analysis shows that many contemporary artists in Ireland make less than £3,000 per annum from their art. That alone is disempowering. It's a measure of how society regards the art producer. Also I think the deal is clearer with a plumber or bricklayer and is therefore measurable, and payable, by the hour, as it were.

VR: *Is it because art isn't essential in our society that artists are marginalised?*

DMcG: We operate with a definition that art is frivolous, that it's extra, that it's beyond society. That is, until, as a country or nation, we find ourselves presenting ourselves to the world, and then we fall back on our culture and usually our heritage in order to say who we are.

VR: *Are you most interested in issue-based art? An exhibition you curated,* Irish Art Now: From the Poetic to the Political, *might suggest that.*

DMcG: It is not as simple as that – I am interested in exploring the full range of what artists are doing now and creating ways for people to assess the value of that. *From the Poetic to the Political* should be seen, for the sake of discussion, alongside the William Scott retrospective or the Alfred Wallis/James Dixon show at IMMA – it is the space between so-called issue-based work and more traditional approaches that I feel gives people the point of entry for them to consider what is of value.

There are many artists who are not focused on issues directly and I would argue that this tension is clearly represented in *Irish Art Now: From the Poetic to the Political* if you look at Ciarán Lennon's or Fionnuala Ní Chiosáin's work in that exhibition. If looked at openly I think the exhibition actually contains the range and the debate, the tensions I am talking about.[2]

VR: *Are you more interested in the reception end of art than in the production end?*

DMcG: I don't think the two elements can be disconnected. I think it is a total process. In my view art is social. It involves self and other and that is a social process. I do not mean Socialist when I use the word social – that mistake is often made, sometimes wilfully, by commentators. I mean social in the sense of a conversation which can be large or small, simple or complex, to which you can contribute according to your capability or take from according to your needs. It may sound Socialist to characterise it in such terms but that is only one among many ways of reading the 'cultural conversation'. All cultural processes, making and seeing, occur within society anyway.

VR: *Which artists do you most admire?*

DMcG: I admire those artists who take responsibility for their art in the world and don't see their responsibilities ending simply with the successful production or realisation of a work or project. I

believe that art is, at root, a social process because, as I said, it involves a transaction between self and other, the self of the artist and the other, the viewer. So I tend to value art and artists who address the world, especially when the realisation of their ideas depends on public resources. This has nothing to do with a preference for any particular medium or style or subject and it does not just mean art which is socially or politically descriptive. It includes artists like Donald Judd or Sol Lewitt or, in Ireland, Ciarán Lennon, for instance, who are not 'descriptive' artists but persuasive advocates for the implications of their practice in the world. I also admire people like Marina Abramovic, Leon Golub, Stephen McKenna and Shane Cullen, among others. The whole area of what is called 'Outsider Art' represents a deep well of meaning for me. It is really impossible to bring it down to a few artists because I admire different aspects of an artist's practice at different times but, fundamentally, it is the idea of artists taking responsibility for their work, rather than some kind of connoisseurship which underpins my admiration.

I remember showing the work of Stephen McKenna in Derry – his first one-person show in Ireland in fact, in 1981, in the middle of the riots about the Hunger Strikes. Although Stephen McKenna's works are figurative they are not political at all, in a contemporary sense, but they do draw heavily on history, particularly the history of European painting and I actually came to like his work, I think, because it stood its ground in a very difficult context in Derry in 1981.

There are all sorts of different reasons for responding to different artists.

VR: *How do we achieve the necessity of art?*

DMcG: That's the question. How do you make it integral, without making it melt into the social ground? I remember being taught in art history that Giotto's achievement was to separate the figure from the Byzantine ground, and that this achievement was consolidated by Renaissance perspective, which is dependent on

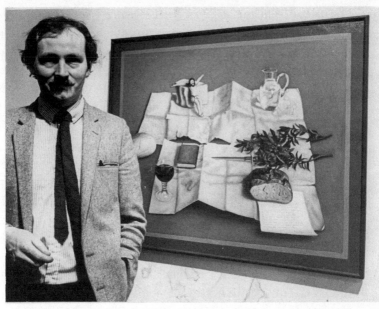

Declan McGonagle at the Stephen McKenna exhibition in the Orchard Gallery, Derry 1981.(photograph W. Carson).

the fixed single point of view. In Byzantine art, for instance the figure was in the ground, within the collective. Just as in the religious and cultural mindset the individual is subsumed within the collective. The Western modernist position is that this is a pre-modern and therefore a 'primitive' idea, something that has its place in the past as preparation for the 'real thing'. Yet 11 September has taught us that the 'pre-modern' state of mind co-exists in the present with the modernist and post-modernist states of mind.

What would be most interesting would be to hold figure and ground in negotiation, in a sort of tension without detaching figure from ground or letting the figure disappear into the ground. This would also be true of art and society, and artist and community.

I believe it is possible to create an active dynamic, not a static institutional model which holds that process of negotiation,

that sort of tension in play. That is what I was trying to do in the Museum – in IMMA. I was trying to create an environment where that sort of negotiation was possible. Projects done by local people were shown alongside high modernist practice, participatory work alongside signature work. This process is certainly the subject of debate but I believe it is a successful model.

Now at the City Arts Centre I have an opportunity to take that process further. I believe it's a responsibility to add something that isn't there in society. I am not talking about storming the barricades. I mean some way of valuing human experience and for that a long view is essential.

An interesting illustration of that is that there are only 27 companies in the world which are over 100 years old. Analysis shows that these have a number of characteristics in common. One is a conservative attitude to finance, another is tolerant management, another human community and the final one is about profit.

Those companies are not in business to make profit but make profit to stay in business. Staying in business requires a long view. The Celtic Tiger does not take a long view and neither does the consumer model of museums.

VR: *What about Matisse's idea of 'an art of balance, of purity and serenity, devoid of troubling subject matter ... for the business-man as well as the man of letters ... something which provides relaxation from fatigue and toil?'*[3]

DMcG: If that is what he set out to do – to create comfortable beauty – and succeeded in doing that then that is fine but no other claims should be made for it. Neither is it the only view.

VR: *Did growing up in the North make you into a questioning kind of person, do you think?*

DMcG: The Troubles in the North forced a set of questions on people that may not have surfaced otherwise. I think the Northern situation only became resolvable when it was addressed culturally. Writers in particular constructed a vocabulary which then

allowed politicians to use a different language in terms of identity from the mid-1970s on. Difficult times allow other questions surface.

It is interesting that the Koran is now a best-seller in America. People are always trying to understand the world and their place in it. Culture was a way of asking questions which politics was unable to ask, without threat. As things developed in the North we had to ask what does being a Catholic/nationalist/republican mean? Did it mean you have to approve of people being blown up in shops. And of course it doesn't. Culture provides the means of articulating your own identity without attacking other people's. Culture is not about defensiveness, it's about self confidence. There's a generation of artists in Ireland who explore identity, artists like Alice Maher, in terms of male/female or Willie Doherty, or Maurice O'Connell, among others, who treat the word Irish as a question, not a statement.

VR: Your wife is from the North also.

DMcG: I first met Moira in the Gaeltacht in Ranafast in County Donegal. I was fourteen or so. Later on, during my last year in St Columb's College in Derry, Moira's brother Tony was a good friend, and I met Moira again. I finished school and in my first year in Foundation Studies in the Belfast School of Art I asked her out. We've been together ever since. We both come from very extended families. When I was working in the Orchard Gallery in Derry quite a few of my family and Moira's happened to come to one opening. The artist who was showing there, having been introduced to them all, said that it was less of a marriage and more of a tribal alliance. That's a characteristic of Derry families like ours. The archaeologist Brian Lacy, who used to work in Derry, published an essay once saying that Derry was one of the last places where the Celtic idea of the family, the extended rather than the nuclear, was alive and well. I remember when I was working in the Institute of Contemporary Art in London in the 1980s I said something to someone there about my second cousin. They were puzzled about how I would be

aware of a second cousin – what is a second cousin anyway? But knowing all your cousins is part of being in an Irish family. I have four brothers and a sister and I'm the youngest and we have lots of cousins.

VR: *You attended the same secondary school, St Columb's, as many of the eminent people of the previous generation – Seamus Heaney, Seamus Deane, John Hume?*

DMcG: That was the grammar school you went to at that time if you passed the eleven plus and I went there with a lot of my friends from the Christian Brothers' school. It does seem that quite a few ex-pupils of the school have become very prominent recently but I was not a very good academic. I got by and then towards the end of my time there decided that I wanted to go to art college. All my family are involved in art and music. They all teach art in school or at third level but I decided not to go into teaching.

VR: *You worked in London in the 1980s?*

DMcG: I was appointed exhibitions director of the Institute of Contemporary Art in 1984 and worked there for over two years. The ICA worked at an extraordinary pace and it was a great opportunity to gain, in a very concentrated way, extensive international experience. It was a very interesting period in Britain – it was the beginning of a process which led to the boom in British art in the late 1980s and a period of change in the basis of arts provision in general there. So there was a lot going on. I learnt a lot and was also able to create a series of major public art projects in London which were provocative but successful. There was also a very busy gallery programme. It was interesting too going from Derry – the edge, as it were – to London, the centre, to see close up just how small even the national (and international) art world is and to realise that, in fact, challenging work can be done anywhere.

My first son was born in London at that time but I decided to go back to Derry, since the City Council had said I could return to work there, if I wanted, at the end of the first ICA

contract period. I was also drawn back by the political changes which were under way in the North at that time and felt that culture/visual arts could have a role in that process.

It was also interesting that I felt I couldn't 'feel' the audience in London. Audience for the ICA was a sort of abstract idea and the programmes were very dependent on media responses, whereas I personally preferred to meet audiences face on and this was something that I tried to do in Derry and also at the Museum here in Dublin. Even with its national status it was possible at IMMA to have a sense of the audience, especially through the extensive community projects. This aspect makes the work of curating very real, rather than abstract, and I value that.

VR: *So you came back.*

DMcG: So the decision to return to Derry was a mixture of a personal and professional decision and it's true that my own curatorial practice seemed to go from strength to strength following my return to Derry, to the Orchard, and the development of a whole range of new programmes – education, community, public projects and publishing.

I think if you think of yourself as being in the world then you can be/work almost anywhere. Now, for me, the deciding factor will be as much personal – the family, etc. – as professional. I have always found it useful not to be a trained curator or art historian as I don't see myself being on that sort of career ladder in the art world and can be very flexible or lateral in my work.

VR: *In 1987 you were nominated for the Turner Prize for making Derry an international centre for the artist.*

DMcG: Although I did not get the award, I was really pleased about that, because it validated the Orchard Gallery and Derry as a place where significant work could be done, and also, of course, my own curatorial practice in relation to place and community, while still being effective internationally.

VR: *You were back working in Derry when the directorship of the Irish Museum of Modern Art came up?*

DMcG: Yes, I was working in Derry when in late 1989 it was announced that the Irish Museum of Modern Art would be established in the Royal Hospital at Kilmainham. I was aware of the discussions – was the building suitable? was the Government doing it on the cheap? and so on. From my position in the Orchard I had no sense at all of being on a curatorial ladder which would take me to a new position, so I wasn't on the lookout for a major position, but I inquired. I decided initially not to go for it but I was persuaded to come for an interview. I was impressed by the chairperson, Gillian Bowler. I saw that although there were not going to be millions to acquire works of art or a programme, it could be a unique opportunity, because the building was a point of discussion rather than celebration. Gillian was clear that the Museum shouldn't be based on an imported model. I'd seen *Rosc* there in 1988 and had thought it was a fantastic building. One of the things that interested me was the potential to deal with contemporary identity in an historical context. It was the chairperson declaring that it wasn't intended as a parachute model that made me very interested.

When I started I was really excited at starting from scratch, starting a national institution which could have implications for the country as a whole.

If you do something properly in a smaller country it will have implications for the culture as a whole. The first annual budget in 1990/91 was just over £800,000 to cover all costs and that included a one off figure to begin collecting, of £200,000.

But then in 1992 we had a zero figure for collecting.

We established the acquisition process by donation and loan as well as by purchase and were able to sustain the process without an actual budget in 1992. We made deals with artists. The idea was to acquire strategically in a way that would eventually unlock donations. I had an image of the Museum as a train with the programming and collecting process like the locomotives with more and more carriages being added over time.

VR: What an opportunity ...

DMcG: It was a remarkable opportunity, probably unique in Europe. For a city like Dublin not to have a national institution of modern art and then start a national museum with a direct line to government was unique, at that stage. One of the spurs was Dublin becoming the European Capital of Culture in 1991. I think Glasgow Capital of Culture spent £30,000,000 in 1990. Dublin spent a fraction of that, maybe £3,000,000. But the Museum became one of the main projects for the Capital of Culture year.

At that time the Taoiseach held responsibility for the cultural portfolio. In *The Irish Times*, I think it was Christmas 1990, Charles Haughey came out with a very forthright defence of the building being used as a museum of modern art. He was very positive. A full Ministry for Arts and Culture with a full cabinet position wasn't established until 1993. It was very important for the Museum, therefore, that the Taoiseach of the day would be supportive. But, of course, that meant that the Museum had to prove itself straight away.[4]

VR: Did its location make that difficult?

DMcG: I never saw it as far away or really out of town. The Royal Hospital building had been restored extensively in the period 1979-1985, using a combination of State and European funding.

Before that it had been semi-derelict for about 50 years. Up to the late 1970s the National Folk Collection from the National Museum was stored in the buildings. Now that the National Museum is in Collins Barracks, very near the Royal Hospital, and both so close to Heuston Station, it makes the location of the Irish Museum of Modern Art more accessible nationally.

After Independence there was a sense in which the building was rejected by the new Irish State, along with many other buildings throughout the country, which were defined as English. They were seen as untouchable for the public in the new State.

Topographically it's a very hidden building. It was a

military retirement home with no public function but was not militaristic, it didn't really carry the sense of oppression of other buildings. In fact architecturally, it's a French building.

VR: *Yes, it's based on Les Invalides, isn't it? Like the Chelsea Hospital.*

DMcG: Yes. There were two processes in the 1970s which I believe allowed the State to reconsider the Royal Hospital at Kilmainham and other buildings like it, and bring them back into our history. Firstly, the Troubles in the North had made many people question the one-dimensional myth of nationalism and the idea that Irish was good and English was bad. Secondly, Ireland in the early 1970s had become an enthusiastic member of the EU, or Common Market as it was called then. By the late 1970s there were the beginnings of a sense of European-ness about Irish identity.

In that context it became possible to spend public money on a building that had previously been unacceptable. When the idea came to establish an identity for a museum of modern art in that building, it was very important to connect it to other European examples of historic buildings, used for cultural purposes, such as the Picasso Museum in Paris, reconnecting the historic RHK building to a European and not just an Irish heritage. The building itself was begun in the seventeenth century and sits in a 67-acre site, including stables and other houses originally used for a variety of purposes by elements of military administration in Ireland.

VR: *Does the Museum occupy the whole RHK site including all the other buildings, under the lease with the OPW?*

DMcG: In 1992 we developed a forward plan which projected a number of uses for the buildings and the site alongside the core galleries in the main building. Over the first decade we established studios, working spaces and living accommodation for up to sixteen artists. In 1999-2000 we restored and brought into use an important historic building known as the Deputy Master's House. It now serves as a series of environmentally controlled

galleries – as a 'house' for special collections.

It was important in the first stage of development after opening, to provide space for working artists on site so that the public could have access to and experience of the working process of making art, in direct contact with living artists.

When artists are on this programme they are encouraged to be available to the public on a day-to-day basis. Leaving it to the artist sometimes didn't work. So we formalised that process over time into studio visits, panel discussions with artists and open days.

We saw the studio programme as one of the programming elements in the Museum's overall identity. The Museum funds the presence of artists on site, by paying them weekly sums to cover living expenses, with working and living space provided free.

VR: *The artists are from all over the world, at all stages of their careers?*

DMcG: Yes, it is an international programme, though a majority of the artists who have been on it are Irish but we always tried to make sure that there was a mix of Irish/non-Irish and a range of media represented. A lot of younger artists have benefited from the programme over the years but we also included established figures to create a dynamic.

VR: *IMMA has a National Programme which brings works in the collection to venues around the country.*

DMcG: The National Programme is something which has worked very well and been run very successfully as a way of dispensing the skills, assets and resources of the Museum. It is structured as a means of facilitating people through curatorial and technical support contexts of any kind, with or without galleries or exhibition spaces, to have direct access to works from the collection, but in their place. The National Programme has a non-'colonial' relationship with those local situations and that empowering role for a publicly-funded institution is very important.

VR: You yourself lived on site.

DMcG: The Board decided that it would be very useful, firstly in the building phase of the project, and then in the opening and development phase for me to continue the tradition of Royal Hospital staff living on site. We lived in one of the houses. It was an amazing context in which to live and work but it meant there was very little separation between my normal and my working life.

My children felt they were in heaven in terms of the scope they had from a very young age. Declan was six and Paul three when we moved to the Museum.

VR: How did they feel when you left?

DMcG: One of the main issues for the boys in the recent controversy 2000-2001 was the fact that we would be leaving the house in which they had spent their formative years. For them this was more crucial than any career problems I may have had. While I was dealing with the controversy every day I had the means to get it out of my system to some extent. But it produced a lot of unreasonable stress for the family. I think the central issue in the controversy was to do with the mission which ran through the Museum in its first decade; that is, connecting artists and non-artists, developing a very strong community dimension, without diminishing the quality of the programme – a sort of 'joined up' approach rather than a stacatto, trophy exhibition approach. It was not clear that this was understood or valued by the new board appointed in 2000, which contained twelve new members out of fourteen, including a new chairperson. Because I was so associated with that programming strategy I must have been perceived as an impediment to any change, though none was openly proposed. The Museum mission statement was to foster within society an awareness and understanding of and participation in the visual arts through programming and policies which were excellent, innovative and inclusive. That mission statement was defined and adopted by the Board and senior staff in the review process in 1995-1996. While it

represented the founding principles of the Museum in 1991 it was only formally articulated following an extensive audience review in 1995-1996. This mission statement and all the thinking that went into its definition, the development of associated strategies and objectives for the Museum as a national public institution were enunciated for the Board which came into place in 2000, and included Marie Donnelly as the new chairperson. It appeared to be accepted by the Board as a basis for a new period of development at a series of strategy meetings.

I think the recent controversy in the Museum raises issues about the relationship and the understanding of the roles of the executive staff functions and the non-executive functions of the board. This issue is becoming a feature of cultural life in Ireland. In my opinion there needs to be some sort of assessment of the relevant skills and experience that board members bring to an appointment and for what purpose they are appointed. Any institution needs different skills at different stages of its development but continuity, especially when things are working, is also crucial.

VR: *Were you surprised at the conflict?*

DMcG: I was taken by surprise when the issue came out of the blue in November 2000. There had been ample opportunity at a series of board meetings, during the first months of the board and the new chairperson's tenure, to raise questions, to discuss, to challenge existing strategies and propose any changes. This didn't happen and no questions were raised about my own or anybody else's performance, quite the opposite. In fact, at a series of meetings the existing mission statement was discussed and accepted with only one amendment ... one word added at a meeting in July 2000. Strategies around exhibitions, education and community collection programmes were discussed and were not contested. In fact they were accepted as the basis for the next stage in the Museum's development. What was discussed and accepted, by Board and staff, was that more resources would be needed, naturally.

VR: Now that the controversy is settled and you can look back, which exhibition did you most enjoy curating at IMMA?

DMcG: I think the single most significant show I personally curated was the Andy Warhol retrospective.[5] I initially embarked on that exhibition without a particular enthusiasm for Warhol, thinking that it would be interesting to do it as a 'blockbuster'.

As I researched his work I began to feel that Warhol was not the maverick trickster that he is often projected as, but that he was actually one of the most significant artists of the late twentieth century. What I learnt was that by addressing subjects in his life and his work, like fame, money, celebrity, commodities and violence, he was as much an artist of this time as Bruegel was of his. The title of the exhibition, *After the Party*, was taken from one of his prints. It was intended to reflect the need for a reconsideration of Warhol, based on a rigorous rather than a showbusiness approach to his working methods and subjects. By covering the whole spectrum of his work from illustration to film to paintings and prints and also including a series of ink drawings by his mother, Julia Warhola, we tried to get behind the mask which Warhol himself presented to the public. The inclusion of Julia Warhola's work was very important in revealing that Andrew Warhola invented the persona of Andy Warhol as surely as his prints of Marilyn Monroe represent an artificial persona.

I was particularly pleased by this exhibition because the Museum had the credibility by then, 1997, to borrow works from the Warhol Museum in Pittsburgh, the Warhol Foundation in New York and important public and private collections elsewhere.

As a result I was able to create a coherent argument about an artist who is important, not because of his media presence but because of the way he dealt with some of the most enduring ideas in art – the nature and meaning of human experience.

At the same time as the Warhol exhibition another exhibition, created by artists and women from St Michael's Family

Resource Centre in Inchicore, dealing with violence against women – *Once is too Much* – took place. It was curated by the Education Department and was easily one of the strongest manifestations of the power and quality of participatory culture I have seen. These two exhibitions along with the Kiki Smith mini retrospective represented a very clear summation of the Museum's identity, capability and values at that time and were also extremely popular. I believe it is possible to create that sort of empowering dialectic between exhibitions.

VR: How do you see the role of curator?

DMcG: One thing which I think is storing up problems for the future of curatorial practice is the ever-increasing numbers of what I would describe as disconnected curators. It is especially evident I think in Britain at the moment. The courses from which they emerge are not bad courses, quite the opposite, but what has developed is a whole generation of itinerant curators who always seem to be on their way to somewhere else, who, as a result, do not invest in 'place' to the degree which I feel makes a difference. I don't see this as a good trend. It is right to professionalise the practice and people should be as good at administration as they can be – but with a purpose beyond themselves or a closed art world. In other words curators in training should be confronted with questions about why as well as how to curate.

I have always tried, even when involved in heavy administration, to maintain a curatorial role, most recently at IMMA, and have taken and argued for an opinionated curatorial position. I have always seen this as part of a director's responsibilities and I think it is noticeable that those museums of modern art internationally which have become significant are all directed by a curatorial rather than a business orientated director. Of course a director must play a key role in any fundraising process but I think a curatorial vision is the key determinant for a director's position. Fundraising skills can be bought. Vision cannot.

VR: It was a fruitful ten years at IMMA.

DMcG: Ten years after opening or, at least up to that point in 2001,

the Museum had developed from what was initially an ad hoc organisation to become a credible public institution in Ireland with a strong, effective international profile which has contributed significantly to the arguments for 'participatory' culture without diminishing 'signature' culture and the development of new models of institutional thinking. That achievement also involved a lot of other people and I am proud of my part in it.

Interviewed on 9 November and 14 December 2001

1. McGonagle, D., 'New Transactions' in *Decadent: Public Art, Contentious Terms and Contested Practice*, Glasgow, Foulis Press, 1997.
2. *Irish Art Now: From The Poetic to the Political,* Independent Curators International NY, in association with IMMA, London, Merrell Holberton, 1999.
3. Flam, J.D., *Matisse on Art*, London, Phaidon 1984, p. 49.
4. IMMA, *Inheritance and Transformation*, Dublin, 1991
5. IMMA, *After The Party: Andy Warhol*, Dublin, 1997.

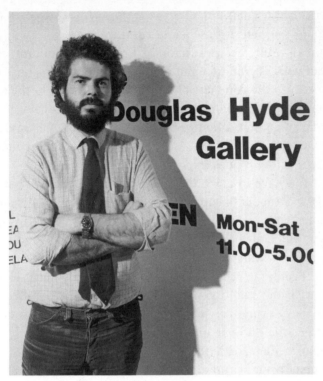

Patrick T. Murphy, August 1984 (photograph John Kellett).

Patrick T. Murphy

Patrick T. Murphy was born in Wicklow in 1956 and was educated in St Lawrence's College in Loughlinstown, and in Trinity College, Dublin. He was exhibitions officer at the Arts Council from 1980 to 1984, director of the Douglas Hyde Gallery in Trinity College from 1984 to 1990, and director of the ICA at the University of Pennsylvania, Philadelphia USA from 1990 to 1998. From 1994 to 1998 he was adjunct professor in the Department of History of Art at the University of Pennsylvania and is now the exhibitions director at the RHA Gallagher Gallery, Dublin. He is a curator. He is married to the artist Susan Tiger and they have one daughter.

VR: Patrick, as exhibitions director of the RHA Gallagher Gallery how do you perceive the job of curator?

PTM: Part of your job as curator in Ireland is to inform yourself about what is going on and that means not waiting until the art comes into the commercial gallery but getting into the studios. What happens in Europe is that the art gets to be seen in the public arena first, admitted by the curator, and afterwards in the commercial galleries. In America it goes into the commercial system before it goes into the public system.

You have to go to the studio to find out what's happening and what's about to happen. As a curator you have to make yourself and your knowledge available to artists. It's a two-way street. I'm as vulnerable as the artists when I go and look and talk.

I don't think enough curators in Ireland are out in the studios. People get concerned about committing themselves – if you visit the studio you have to do a show. That's like saying you marry everyone you date. You don't. You stand somewhere between the studio door and the gallery door. It's not the artist's job to mediate with the public. It's yours. It's an interesting dilemma being a curator. At one stage you facilitate, at another you curate; you adopt different strategies for different exhibitions. The curated exhibition is almost like an academic thesis, you have an argument, a hypothesis. The danger is you could start illustrating the idea with the work and the work then becomes subservient to the idea. There are not enough well-curated shows in Ireland. I don't do enough. In the last four years I've made two shows that I see as curatorially conceived.

I did *The Sea and the Sky*[1] in June 2000, that was a show I curated in collaboration with my American colleague Richard Torchia. We put together a group of artists who used the subject of sea and sky in various media. Coming off the very theoretical 1990s we wanted to see how the sea and sky fared, looking at them as subject and as an abstraction, a set of subjectless subjects. It had 21 artists: European, Irish and American.

In a show like that you have a preconceived notion of

where you're going and you support it with an argument. It takes a long time to develop, you need time to research it. An easier show is the one-person show which you see a lot in Ireland.

In terms of Irish art I loved the worker's show in IMMA. It had a theme, it was a great way to look at Irish art.[2] It's not good enough that art is tagged with a national brand anymore: that's not a compelling armature for the twenty-first century. We need deeper investigation. The material is there.

A Yeats show with Kokoshka and Corinth would suggest a European and broader context for him, and save him from becoming the 'most famous Irish artist'. A fame, by the way, that hasn't impacted globally.

VR: *Who do you do the shows for, who is your public here in the RHA?*

PTM: They are people I don't know. I work for an imaginary being, someone intelligent and curious that comes to see everything we put on. If they have seen what has gone beforehand, how will they react to this ... In ways what I'm trying to build is a matrix of comprehension. The person I work for has the willingness to look, in good faith, and curiosity and intelligence. The public I work for is quite specific but faceless. As a director you have to combine a number of different aspects, and for me the most crucial one is curiosity. Subjectively, it's my own motivation.

That answer would not suffice to satisfy the criteria for getting public money. When people are allocating public money they want to know who that public is, who is benefiting. So you have the measurable, sociologically defined concept of the public, the objective idea of the public.

There are different publics. At the Douglas Hyde Gallery in Trinity when I worked there we had a vast public. At that time, in the early 1980s, there were very few options. It was extraordinarily well attended. Everyone went to everything. There was what I would call the trade public – artists, art students, art

administrators. There were the College students, then there were adults interested in art. I don't have a demographic on who those adults were, you didn't need it in those days. You need it now.

In the Institute of Contemporary Art in Philadelphia when I worked there it was a specialist public. There were very few uninvolved art people coming to the gallery. It was an art public. It was an experimental platform for contemporary art. The broader servicing was provided by the Philadelphia Museum of Art. It had 1,000,000 per annum attendance. We'd have 12,000 people at the ICA. They were a recurring public. As we did seven shows per annum one would allow for a core public of 3,000.

The Academy is different again. In the RHA we have a traditional public, often well heeled and often conservative. The public question is one we're working on. The Academy is at a point of dynamic change.

Rather than saying who is your public you could say how are you valued by your public. One of your barometers, only one, are your members, people who write cheques for you because they believe in what you're doing.

Who is your public is a loaded question.

I'm an egalitarian. It is about access. It is my public responsibility to encourage access for everyone but I don't believe it's my responsibility to have an attendance that reflects the socio-economic demographics of Ireland. The truth is that white educated middle classes come. But I don't believe in the Victorian idea that the public morals can be improved by people seeing art. We have to be sure that political and social concerns are not the responsibility of art. The moment art accepts them it tends to get into a quagmire of trouble. Leon Golub's art would be seen as political. Yet he said the most political thing an artist can do is vote. His subject matter is highly political but he has no illusions that his art does anything political.

Elizabeth Sussman curated a Whitney Biennial exhibition in the 1990s that was full of issue-based art. You had Hispanic, black, Latino artists, and the good old white middle-class public

coming to look at them. Poverty was partly exotic for that kind of person. It's the new orientalism, it's the people who live down below as Tom Wolfe phrases it in *The Bonfire of The Vanities*. There's a conscience salve in showing their work. Art isn't going to stop people living in damp flats. Building better flats is.

VR: *What are your views on public art?*

PTM: I don't get involved in public art projects. The Gallery is a public space. I don't have a feel for art outside the public space of the Gallery. It's too missionary for me. I feel art isn't for everyone. You don't have to put it into a public space for people to stumble on it without wanting to. Architecture is the art of the public place. It creates a physical fabric of our cities. Raising awareness of it is important. Frank McDonald does a lot more than public art for raising awareness. The concept of public art is zealous, it says art is good. The art and morality debate is still the Plato and Aristotle debate. I'm not sure art is moral. Is it good in itself or is it good in the social sense is the debate.

Dorothy Cross's *Ghostship* (1999) was public art I suppose – it was a public art project – but it was a private art in a public realm. It was a massive personal act, it was great. To conceive of this idea of a ghostship was to conceive of something already embedded in popular myth. It was a miraculous manifestation that just happened to be on the sea in Dun Laoghaire. It was gentle, it wasn't aggressive.

That's what I love about Christo. He's one of the better artists at projecting his individual aesthetic in a public space. And his pieces are not publicly funded, they are privately funded. But the percentage for art schemes, they're a lot about the panel, the public representatives, the professionals. Artists who like to negotiate around these groups, and who know how to work with specialists and bureaucracies succeed within that frame.

VR: *As an egalitarian what do you think about community art?*

PTM: There's a terrible connotation around the term community art. When we think of community art, the image presented is of the

lower socio-economic groups at workshops. In America a lot of community art projects are interventions of artists into specific communities. In 99.9 per cent of cases, poor black communities. It's a sustainable, fundable programme. The more challenging, less näive concept of the community is the cultural wasteland of the bourgeoisie. We all live in community and all art is for various sections of any community.

VR: *You worked in America for ten years.*

PTM: The Institute for Contemporary Art in Philadelphia was a vital experience. It was surprising to end up there. It is an art institution of international importance, there are few institutions of its scale with its profile in the States. It was a great responsibility. My ability to run it was based on running the Douglas Hyde Gallery in Trinity College. When I got the job I thought 'The skills I learnt in Ireland serve me well internationally'.

VR: *Was there any comparison in scale?*

PTM: They were on a different scale. You went from a budget of £160,000 to a budget of nearly $1,000,000, from 3,000 square feet to 10,000 square feet of gallery space, from a staff of three and a half to one of fifteen. The differences were vast. But the enquiry was the same. They were both university spaces. The rigour of the enquiry which I honed at the Hyde served me well at the ICA.

VR: *What were the biggest challenges at the ICA?*

PTM: One of the big challenges was to create an identity. Philadelphia was 90 miles from New York. The heat of the New York scene was very seductive. A lot of programming throughout America was dictated by it. New York was the arbiter. I was very determined to create a different identity for the institution and its role within Philadelphia. I did that in two ways. One was to overfly New York in developing an international programme and the second was to include Philadelphia artists for the first time in the programme. They'd been shown under a flagship called 'Made in Philadelphia', which happened every two to three years. That in American curatorial code is 'I am

now fulfilling my local responsibility'.

I started doing credible shows of Philadelphia artists, not flagging them as Philadelphia artists. I did a series of shows combining Philadelphia and European artists.

The shows indicated that the Philadelphia artistic practice was concurrent with artists in London, Zurich, Seoul.

On the international side, and avoiding the parameters set by Soho, we presented the first museum shows in the US for a number of artists including Rachel Whiteread, Marlene Dumas, José Bedia and Vanessa Beecroft.[3]

VR: What were the biggest differences in the curating?

PTM: In the ICA I was operating in a continental collegial culture and I had a whole array of fellow curators to talk with. I was isolated in Dublin. The negative side of the States is that the curatorial structure is very hierarchical and very career driven.

VR: Were your fellow curators impressed by shows like the Whiteread, Dumas and Beecroft shows?

PTM: When I started curating the Rachel Whiteread show I couldn't get another venue in America to accept the exhibition, she was unknown, so I worked with the Kunsthalle in Basel. By the time the show was open I could have sent it to five major American museums because she'd had international attention. She'd done the House project in which she had taken a cast of an actual house. Art curators are very much an establishment profession in America. Young curators are very interested in being seen to make correct decisions, to get up the ladder. There's an incredible conformity in the American museum culture. That's why there's so much radical art – there's so much excluded. It's a great country for consensus. I wanted the ICA to be a venue that made comment and commitment before consensus.

VR: Did the Board share your aims?

PTM: I had a marvellous Board. The ICA was a settled institution, 35 years old. It had had three directors, each had about a decade at the ICA. The Board's ethos, a commitment to identifying and presenting new art, was formed around the accolade that it had

been the first public institution to organise an Andy Warhol show. (Andy never forgot that, he was very supportive of the venue throughout his life.) Another formative characteristic was that in 1988, the year prior to my getting there, it had organised *The Perfect Moment,* an exhibition of Robert Mapplethorpe's photographs. A section of the exhibition had the XYZ portfolios, explicit images of homoerotic activity. It became a cause célèbre for the right wing in Washington. They attacked government funding for the arts through the federal agency, the National Endowment for the Arts and also the ICA. During my first year there I had to deal with Congress and the Senate. An Act of Congress had singled out our institution, and said that grants to the institution had to be posted on Capitol Hill for 30 days before being awarded.

VR: *For named projects?*

PTM: Yes. The culture wars in America in the early 1990s were an example of right-wing fascism. The private sector rallied around the ICA to provide resources. There was a moral imperative to deal with work that was controversial. Following the Mapplethorpe, I did a mid-1990s survey show of Andreas Serrano.[4] No one else was working with him, he was too controversial. The show travelled to the New Museum in Soho, New York and to the Museum of Contemporary Art in Chicago. I also worked with Sally Mann whose photos of sexual self-consciousness in children, her children, had caused a great deal of debate.[5]

VR: *In working with these artists whose photographs were so controversial were you trying to be polemical?*

PTM: We weren't trying to be polemical, we were trying to show art that was formally successful as well as provocative and say that within a democracy that was OK. An institution like the ICA depends on a kaleidoscope of funding sources and the great fear is that you'd offend any part of that spectrum. I go back to the idea that America can be a fairly conformist society in which to operate a museum.

VR: *Did you spend much time fundraising?*

PTM: One of the most important things to realise is that America is a country in which philanthropy is deeply embedded at an individual and private foundation level. I would be dependent on such sources for something in the region of 85 per cent of my funding, the rest coming from federal bodies such as the National Endowment for the Arts and The Institute of Museum Services. All taxpayers' dollars. The individual tax laws are incentive-based for donating to institutions. You have a positive atmosphere in which to raise money. In America, government is but one aspect of the leadership of the country. In Europe centralised government provides the leadership. America is a market driven culture, it was interesting to be engaged with so many collectors and to realise that most American museums are dependent on collectors to provide them with funds, and indeed, acquisitions. You need a huge array of support around you in the American museum system. I was tutored in the European idea of the public institution standing apart, maintaining a critical distance from the market. In America it's all right to get into bed with the market and still claim this critical distance. The ICA was marvellous. I spent ten years playing with the American art/fashion industry. It's interesting to think that I am now committed to working with the once non-fashionable Academy. But it's forcing me to ask meaner and better questions about what constitutes art. I want a healthy, inquisitive atmosphere at the RHA.

VR: *You were saying that the Academy is quite market driven.*

PTM: The annual exhibition at the Academy is a selling exhibition. We have people coming to buy art and I would hope to encourage people to buy as broadly as possible. If we create a broader collecting practice, it will create a greater market interest in artists here.

I'm interested in getting money into artists' pockets. There are two main points of commerce in the RHA, the annual exhibition and the Ashford Gallery. The remaining exhibition programme is non selling. We take 25 per cent commission on

sales, the Ashford takes 40 per cent. The RHA is a barometer of interest. Some may say that the interest is conservative. But it's up to the public institutions like the RHA to lead those collectors into more exciting areas of the art market. In order to develop you have to begin with the conservative and the safe; without a healthy establishment you cannot develop support for more radical art.

VR: *Did you show any Irish artists when you were at the ICA?*

PTM: I showed Dorothy Cross in 1991[6] and John Kindness in 1997. To me they were members of the most innovative generation in Irish art. The first ones that had concurrency with what's going on anywhere, with a healthy self absorption in issues of identity, gender, etc – it was that generation that came out of the art colleges in the late 1970s and early 1980s, interestingly a generation of great women artists like Dorothy, Kathy Prendergast, Eilís O'Connell, Alice Maher and Marie Foley. They were absolutely confident. That generation wasn't laboured with responsibility for the nation. They were just making work.

VR: *What about the younger generation, the recent graduates?*

PTM: One purpose of museums and institutions should be to identify and support emerging artists. We are proposing that question with our *Futures* shows. Places like Draíocht and Temple Bar Gallery working with younger generations are great. Artists must be supported and documented and contextualised in an international context.

Up to the late 1960s or early 1970s Irish art was in a fairly provincial relationship with art in general. Jellett can be a fine painter, but let's not surround her with hyperbole that would dissolve if you put her beside a French painter 30 years her senior. She was 30 years late. Much of the late 1960s art was a mimicry of what was going on elsewhere – we were still playing catch up.

We did have a native school of expressionistic painting that was there all the time and got vindicated when 'new' painting came back in the 1980s. Rather than visual imitation, there

was a case of critical alignment with what was going on abroad. Artists like Michael Kane, Paddy Graham, Brian Maguire, Patrick Hall were disenfranchised until figurative painting came back, flooding in from Germany via England and later taken up by America. All of a sudden there was a critical coup, whose rhythm was set from elsewhere. The *Independent Artists* had been set up as a salon for painters getting less and less presentation within the modernist criteria of the *Irish Exhibition of Living Art*. But *Living Art* was the premier show, *Independents* was in a secondary position.

VR: *How do you evaluate the Irish situation now?*

PTM: What we are lacking in Ireland is healthier established art and art institutions. To strengthen the innovation and experimentation we need a stronger establishment. You won't strengthen innovation by having it alone. When you have artists like Richter in MOMA, Gentileschi in The Met. and Hopper in the Whitney, it allows a fringe to develop. I think there's dwarfed development in Ireland. A lot of the time when we look at innovative art from Europe and America we're looking at art that is contextualised by a huge church of orthodox art. There's less experimental art in Ireland. Major institutions can become intermittent platforms for innovation, but innovation is the purview of smaller, more radical organisations. By its nature innovation cannot always be successful. It's not until it's proven that it should cross over to more mainstream institutions – the old chestnut of quality.

The Academy is a conservative institution with an innovative edge. For 70 per cent of the time the audience are seeing art that doesn't challenge their notion of art, for 30 per cent they are seeing art that does. The Gate Theatre is a place which for the most part gives a good imaginative, well-produced production from the canon and from time to time creates/produces innovative plays. So you have an audience for your fringe. There's no point in having an edge with six people in the room. It goes nowhere.

VR: You're very interested in contextualising Irish art. How important are the biennales?

PTM: I did two *biennales* and approached them as trade shows for the artists I was promoting.[7] Presently as national projects they are under resourced. There is no sense in going to a *biennale* unless you can afford to do it absolutely right. Grace (Weir), Clare (Langan) and Siobhán (Hapaska) all produced excellent work for their participation. My idea is to use the *biennales* to get other curators to see the work, so that the artists would get many more opportunities to show abroad. It's going to be the Department of Arts that gives the money from now on. We had to raise £150,000 for the Weir/Hapaska show in Venice. The Cultural Relations Committee of the Department of Foreign Affairs gave £50,000. That curtailed the original vision the artists and I had shared about how to use Venice for the best effect. You need £250,000 as a core grant and on top of that you can fundraise.

VR: What's the system?

PTM: The original method was that artists were nominated by a range of arts professionals and a subcommittee from the Cultural Relations Committee chose the artists and then a commissioner.

I asked them to let me choose the artists from the nominated list and they did, for which I am very grateful. It's a second job and when you're acting as a commissioner, if you're not completely impassioned about the work you're dealing with, I don't know how you would endure. Also, I was insistent that work shown abroad would be shown here. Home audiences haven't always seen the work that represents their country at these festivals and I think it's important that they do.

São Paolo is a more concise and cogent effort than the *Venice Biennale.* It's in one venue, the support on the ground is better. Because the show is less vast, you get to see everything – unlike in *Venice* where it's all over the city and there's a lot of searching to see it all. The response to Clare's work in *São Paolo*

was very good. The work looked fresh and vivid in comparison with other video projects. It's important to know what context you're showing artists in. I'd visited the *São Paolo Bienal* twice, before showing Clare. We're not doing badly for a country of our size as regards showing Irish artists abroad. Looking at the young British artists, I don't hanker after that type of presence for Irish art. I think it's totally media based and I'm not too sure how enduring it is.

The greater production values that new art media are demanding need to be challenged. Twenty-two year-old artists are being enslaved into the materiality of presentation and not addressing content. If you understand your content you may not need six different projectors digitally synchronised, you may have a different means to realise your project. Try funky. Funky was hard to find when I got back to Ireland three years ago – artists using poor materials that stand up against the higher production values so often seen in museums. You don't have to have what's now the contemporary conventional equivalent of the gold frame. I'm looking for that type of challenge to come from artists, the employment of differing strategies to make art.

VR: What is the Royal Hibernian Academy *about?*

PTM: The Academy was about artists gathering together for the artists' good. In the nineteenth century, it was their guild, effectively. The aspiration was firstly to secure the role of the classical ideal in the artist's training, and secondly to have exhibitions with a monetary return for the sale of work. The RHA's first building was lost in the 1916 Rising.

Our academy lost the school in 1942 due to lack of government funding but continued with the annual exhibition as its identity. Academicians can show six works each at the exhibition, associates two. With 30 academicians, that's 180 works of art, and then with the associates, 200.

From the 1940s on, the function of the academicians was to adjudicate what went onto the walls. Many of the members

did their teaching of the life class over at the National College of Art, in the absence of the RHA schools.

When I started working in the arts in 1980s, the Academy represented to me the bastion of traditional painting. It stood in vitriolic relationship to anything else. It progressed its own irrelevancy. It was taking a nineteenth-century stand. Academicians were ageing or dying off. But then in the late 1980s, early 1990s, a new breath of fresh air came, with artists like Conor Fallon and Liam Belton and Martin Gale gaining the ground within the Academy.

If you look at the membership now it includes the 1969 College of Art revolutionaries and the teachers they revolted against. That's a sign of a mature institution, one that can encompass dissenting differences within itself. Gene Lambert, Martin Gale, Liam Belton are academicians now. It's interesting to me to sit at that table and see artists who were arch enemies of the art establishment sitting within this parliament of art.

VR: *Is there any significance in the fact that they are figurative painters?*

PTM: That's the perpetuation of tradition in the Academy. These artists are not ideological about their style, as the academicians of the 1960s would have been. They welcome different approaches. It's only a matter of time before we see the academy elect a non-figurative artist. There is no revolution to be fought for that to happen. The Academy for the last three years has understood that its function is no longer confined to the annual exhibition. It has had a broader remit within Irish art, as is stated in its original charter in 1823: 'The promotion of academicians and other artists.'

Following the Act of Union in 1800 in some ways the establishment of the Royal Hibernian Academy was establishing Home Rule for artists in Ireland.

VR: *As exhibitions director of the RHA Gallagher Gallery, what is your relation to the Academy?*

PTM: Affairs of the Academy, elections, issues of membership, by-

laws, etc., are the responsibility of Academicians. Operational issues are my remit. The academicians are an entity unto themselves, for all matters relating to their own members. They are also the fiduciary trustees of the operation I run. We do talk policy. We do talk vision. We do talk money.

The velvet revolution of the past five years means that we are the institution that deals with artists who make objects. We don't want to be fixed but we will preference artists who make objects and add to that more ephemeral media from time to time. The other galleries/museums are 80/20 conceptual/art object approximately.

VR: How do the new art developments in Dublin influence the RHA? Is the Merrion Square area still a centre of energy?

PTM: Dublin is fracturing now, the northside/southside divide is over. Artists are under extreme stress because of real estate prices. If you look at the exodus out of the city to rural affordable areas, you're talking about people living a two and a half hour journey from here. As the city gets more expensive art spaces – studios – become unattainable for younger artists.

As all of Dublin gentrifies I'm not sure what's happening. Maybe we're realising we're a small island and it's OK to be living two and a half hours from Dublin. Dorothy Cross is now in Galway. Ronnie Hughes is in Sligo. Charlie Tyrrell is in Cork. Micky Donnelly is in Laois. There are a lot of reasons you need to travel to see artists now. You need, as a curator, to travel to see artists; no more hopping up to Henrietta Street or Mountjoy Square. It's all about shoe leather.

There are artists' collectives, but they may be only there until the real estate becomes desirable. The idea that as an artist you can do some odd jobs, maybe be on the dole and have a flat and a studio is no longer possible. The city was centred in the late 1970s and the 1980s. You had the Hendriks, Taylor and Dowling galleries within five minutes walking distance of the Douglas Hyde in Trinity. You had Tobin's in Duke Street, where everyone drank. You'd always meet someone. Now you make a

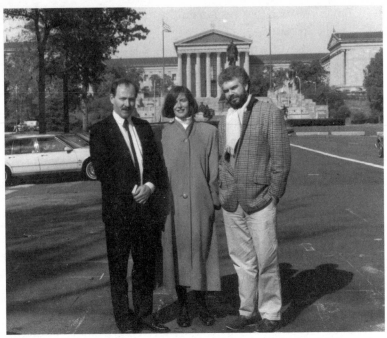

Right to left, Patrick T. Murphy, Vera Ryan and Declan McGonagle on lecture tour in America, October 1988.

selection of what you want to see. The city is more like a city. Now you have areas where you go for certain things. Twenty years from now where IMMA is, in Kilmainham, will be good for IMMA. IMMA may not be very suitable architecture for 1960s, 1970s and 1980s art but it may be a great museum for art of the twenty-first century. David Hickey was talking about New York in the 1950s and 1960s recently. It was a small community of people working and drinking together. He saw Pollock's paintings in small flats, where they looked big. Then they made big spaces and the work began to look small.

In Dublin, at the beginning of the 1980s there were so few people involved in the arts, everyone knew and rubbed off each other.

George Dawson, the professor at TCD,[8] was interested in making the Douglas Hyde Gallery happen. He made sure that

when they were putting up the new arts block in the 1970s that they would create an art gallery. For the first five or six years it operated as a university gallery, run by academic interests. In order to secure its Arts Council funding in the early 1980s a company was formed. Trinity had the chairmanship. That company employed me in 1984. The Arts Council wanted the Gallery to be for contemporary art. We presented fairly eclectic programming. We did Bill Viola in 1985. We made a series of generational shows, Eilís O'Connell and Brian Maguire and Dorothy and Kathy Prendergast. It was the first time Irish artists of such a young generation were documented. There was a trans-national standard in catalogues and writing and so on. I think it helped artists. It was done in an international context. Kapoor, Richard Deacon, Judith Barry showed. Guston and Lichtenstein exhibited drawings – they were very established. I wanted people to look at Irish artists the same way they looked at them.

At that time the Hugh Lane was a fairly inactive space. It was steeped in the dowdiness of municipal and corporation bureaucracy. The big contribution was *Rosc*. It was a way of getting oxygen into the country, but only every four years. So the Hyde enjoyed an exclusivity. There was no IMMA. There was no Academy premises. It was just a site. Matt Gallagher, the developer who took down a lot of Georgian Dublin wanted to do something for culture in the city and agreed to build a new Academy. Raymond McGrath designed it. The concrete was poured in the 1970s, and then Matt Gallagher died. It languished all through the 1980s. Tom Ryan and Charlie Kenny and Ted Nealon secured money from the Government, sold off some of the site, and raised the rest. The Academy didn't really come on line until late 1980s.

VR: *What is the best way to give the public what ought to be given to them, whatever that is?*

PTM: The best way to service the public is to have all the institutions strong. We should all be challenging one another. Barbara

(Dawson) is doing a good job in the Hugh Lane, John (Hutchinson) is in the Douglas Hyde. IMMA awaits a new director.

When I came back to Ireland after ten years away I saw that there was a remarkable amount to be done in Ireland. There are three areas I note.

One is dealing with the neglected generation of Irish art, the Academy. A senior academician like Tom Ryan, a past president of the Royal Hibernian Academy, is one of an entire generation of Irish artists who never had a public gallery exhibition in their lives. There's no documentation on them. We are presenting Imogen Stuart and Barbara Warren this year, and next.

Then there's the mid generation of painters who haven't had enough interest in their work. The Martin Gales, the Barrie Cookes, they haven't had a museum treatment for years. Barrie Cooke last opened in a public space in Dublin in 1987! There's an incredible provincialism in Ireland, a reluctance to embrace its own story. If we don't understand our own story how can we comprehend other stories? We have to understand it, be as truthful as possible. It's important because it's our story – it's not always good, but we mustn't turn our back on it.

The third thing is the *Futures* exhibitions and a series of one-person shows of young artists' work. I'm trying to support the young generation. That's contextualised by showing international art. I tend to notice artists that use innovative forms to ask traditional questions. It's all right to do that. I'll exhibit new work dealing with traditional issues.

I'm playing with the idea of the stylistically driven progression of the twentieth century being over and the implications of that. Conceptualism has been around since the 1970s, it was about the supremacy of the idea above object form. It admitted a lot into art, a lot was licensed by it. The innovation of post-modernism was not a studio innovation, it was a critical one that came out of French philosophical and literary theory absorbed by art critics. Theory so dominated practice that people came out of art school making work based on critical

concepts. It was heralded as stylistic innovation but I think it was the end of stylistic innovation. There is no next big thing.

We have been freed from the notion of a dominant style, all styles have collapsed into an equality. It requires us to be discerning as viewers, we no longer can see style as value. Style is there to service what the artist is intending.

VR: Can you do an international programme on your budget?

PTM: I'm ambitious to develop a bigger budget. Presently it's about £750,000. The Arts Council grant is £240,000 this year. We raised the rest. We have a real public/private partnership. That gives us a self-reliance.

We probably present about ten shows per annum. There are, however, a number of shows I can't do, major international thematic exhibitions. I want to do a major show on mortality. We all understand mortality. There's an access point. It would probably cost £75,000.

I would like to explore what small-scale painting is doing now but again I am curtailed by resources. Scale is now the dominion of photography. I have noticed that the issue of scale is receding from painting.

VR: Do you use guest curators?

PTM: The idea of a guest curator is important. But I want to put a codicil on that. It's good when it's to do with a show you'd do yourself. Sometimes museums get guest curators in because they don't want to handle a particular issue. But the institution is curatorially responsible for what you show, irrespective of who authors it.

VR: You started work in the visual arts with the Arts Council?

PTM: Yes. I didn't deserve to get that job – Colm Ó Briain took a great risk giving it to me. He was director of the Arts Council then, in 1980. I was elated to get it, I wanted it, but I felt inadequate.

The Arts Council's central role then was grant making, but as visual arts officer for exhibitions I was the one person who was not involved with that function. I knew that I needed to use

this opportunity to educate myself. I seconded myself at one stage to the Scottish Arts Council and at another to the British Council in London.

In the Arts Council, I inherited the *Delighted Eye* show, curated by Frances (Ruane)[9] It went to London as part of *A Sense of Ireland*. It toured to Cork, Limerick, Galway and Sligo. With the exception of Cork, which had Der Donovan as curator at the Crawford, there was no professional arts administrator in any of the galleries. In some cases we would mail the invitations from Dublin, organise the wine, hang the show, and change into our suits for the opening. It was great fun, John Hunt and Ruairi Ó Cuív were employed to work on the shows, and our friendship continues today.

I sensed we needed to create an intensity of activity. Once we had five shows going to eight venues in a year. That was 40 'ups' and 40 'downs' ... we lived on the road.

Triskel (in Cork) was a tiny place, the Belltable (in Limerick) hadn't opened, there was a small gallery in UCG.

There was the Yeats Society in Sligo, the Butler was run by the Kilkenny Art Gallery Society. There was a small group of committed people, but there was no supporting infrastructure. The art centre phenomenon hadn't developed. It was really raw and it was great fun. That was 1981 to 1983. Ten years later there was a professional circuit. There was extraordinary development in those years.

VR: *You did the Patrick Collins and Tony O'Malley retrospectives?*[10]

PTM: There was a lot of work to do at the time. Tony O'Malley was obscure and living in Cornwall. George McClelland brought his work to my attention and from that we organised the exhibition *Places Apart – Work from Kilkenny and the Bahamas*. By the time the show opened Muiris MacChongail was making a documentary on Tony. That was 1982 and when I made the retrospective in 1984 Tony was moving to his central position in Irish art.

I remember being in Paddy Collins's studio off Harcourt

Street, full of painting and smoke and not much else. Collins wasn't an eater, we used to visit the GP once a week together to ensure he got his vitamin shot. His health wasn't the greatest over the period we worked together.

I learned a lot from them, they who once had been a bank clerk and insurance clerk, respectively. They shared generously what they had learned about painting. It was quite an education. Other artists I worked with were Robert Ballagh, Conor Fallon, Martin Gale and John Kelly. Michael Warren was really formative for me at the time. He was living by himself then and I would arrive in Wexford with a bottle of whiskey and we'd stay up all night and talk about art. Because he trained in Milan he had a different perspective on many issues, and opened many debates for me to consider.

In 1983, on behalf of the Department of Foreign Affairs, the Arts Council organised an international touring exhibition. I was adamant it was it to be a show of artists from Ireland and not Irish artists. Six were chosen, all well established. It travelled to Athens, Rome, Ljubljana, Aachen and Copenhagen. I learned much from seeing these artists literally and figuratively in the different lights of the various venues. Some art can translate, some cannot. There is a level of engagement that is specific to a particular culture and in a different cultural circumstance certain art cannot behave as intensely. There was no consistency, one artist would look good in Rome, the same might not do so well in Germany. I suppose it raised in me an awareness as to the artificiality of the concept of internationalism. There is none, just a series of communities bound by shared values. Those values tilt slightly differently from one place to the next, requiring an attentiveness to comprehend. Everyone is from somewhere, no one is from everywhere.

VR: Did you document much?

PTM: No, making slides wasn't done. A sense of history was beginning then. It was a proto-history. Brian Fallon, Dorothy Walker, Frances Ruane wrote for the catalogues. They provided important primary

material that will be further utilised in years to come.

That's something we still have to develop – the whole writing thing needs to be looked at. I'm not a scholar-curator, I'm a curator-art writer, probably. You need various voices and interpretations. One voice is journalistic, one is curatorial. Somewhere between scholarship and journalism there's the curatorial voice. And then there's the theory based writing. We need a bigger ground swell in Ireland. Not enough curators here write. *The Irish Times* provides a visual arts journalism equal to anywhere. Aidan (Dunne) is a good writer. But too much is expected of him from many different quarters. *Circa* provides a niche for a certain kind of criticism. We probably don't have enough scholarly treatments in exhibitions. That's down to the lack of a curatorial profession in Ireland and down to a lack of ambition to create one.

VR: *You don't come from a visual arts background?*

PTM: I'd done philosophy and psychology in Trinity. I was working for the National Rehabilitation Board. I got a job on the Hospitals Board. In 1978 they were closing down obstetric units. It was politically hot. Charlie Haughey was Minister for Health and didn't reappoint the board. I had a job but no work, so I went back to Trinity to do the diploma in European Painting with Anne Crookshank. I had the time. Before I completed it I got the job in the Arts Council. So I had really no formal education in art history.

Trinity was a great place to go to college. I'd been to secondary school at St Lawrence's in Loughlinstown. It was an American school. John Charles McQuaid, the Archbishop, had invited the Marianists to Dublin to open a school. They weren't then exam orientated. But we were reading Vatican II papers when we were fourteen! The school was a circular building, the library forming the centre. The classrooms were slices of cake coming off the library. It was very liberal. We did art history throughout the five years. Similarly, we had musical appreciation. I was one of the few who went straight to college, most of

my peers needed to repeat. It was a fairly unusual secondary education.

We lived in Bray. Bray was still small then, about 5,000 people were living there. When I began to try and understand where my interest in aesthetics came from I looked back on growing up in Bray. I thought it was natural that every wheat field had a mature oak in the middle. There was the Kilruddery estate and Powerscourt. We lived in between. I thought these estates were native. When I realised how ragged raw nature was I appreciated how deliberate the planting of these estates was.

I grew up in a family of women. There were four sisters of my mother's on the road on which we lived. You could go into any house for lunch. One aunt was widowed, two had husbands who remained in England, one was unmarried and was a great knitter. My father was one of the few males around.

I had three sisters older than me. I was the only son. My uncle had six daughters. I'm the last of the male line. The Murphys were from Bray, and my mother's family, the Byrnes, were from Bray also.

Bray is now unrecognisable. By the time I was in my late teens it was beginning to be. We grew up outside the town, then it was all subsumed. The house my father grew up in is still there. It was a farm but is now in the middle of the town. North Wicklow has changed, Kilruddery has sold off a lot, there are now industrial estates and motorways.

But the topography is so distinctive, the valleys between Bray Head, Little Sugar Loaf or Big Sugar Loaf still dominate. There are great lines, interlocking diagonals. I used to keep a horse in Kilmacanogue. I'd cycle over every day to tend her. Now that pasture is a motorway. We'd be riding horses on frosty mornings through Powerscourt. The Slazengers were there. At one stage a man from Louisiana bought Charleville, and fenced it. There was outrage. Parish paths ignored. Now Powerscourt is a golf course. They were still working estates when I was growing up and it was from the eighteenth-century idea of

what constituted a rural landscape that I probably got my first, albeit unconscious, lesson in aesthetics.

Interviewed on 30 November 2001 and 17 May 2002.

1. Torchia, R., and Murphy, P.T., *The Sea and The Sky,* Pennsylvania, Beaver College Art Gallery, Glenside and Dublin, The RHA, 2000.

2. IMMA *Labour in Art. Representations of Labour in Ireland 1870-1970,* Dublin, 1994.

3. Kellerin, T. (ed.), *Rachel Whiteread, Sculptures,* Basel, Kunsthalle, Boston ICA. Philadelphia ICA, 1994.
 Marlene Dumas, Land of Milk and Honey. Bonn, Produzentengalerie, Hamburg, Bonner Kunstverein,. London, ICA. Philadelphia, ICA.
 José Bedia, Where I'm Coming From. Philadelphia ICA. 1994/5.
 Vanessa Beecroft, Are You Talking To Me, Conversation Piece II. Philadelphia ICA, 1996.

4. *Andreas Serrano, Works 1983-1993,* Philadelphia ICA, 1994.

5. *Sally Mann, Immediate Family,* New York Aperture 1992.

6. *Dorothy Cross, Power House,* Philadelphia ICA 1991.

7. Siobhán Hapaska and Grace Weir showed in the *Venice Biennale* in 2001, and Clare Langan in the *São Paolo Bienal* in 2002.

8. 'The collection of G.W.P. Dawson, former professor of genetics, dates from the 1950s ... George Dawson's enthusiasm for the visual arts has permeated Trinity College ... In 1959 he set up the College Gallery, the picture hire scheme for students and staff. He founded the college exhibitions committee which during the 1960s and 1970s put on some memorable shows ... including the Picasso exhibition of 1969 ... He was instrumental in setting up the Douglas Hyde Gallery in 1978.' Scott, D., *The Modern Art Collection TCD,* Dublin, TCD Press, 1989 p.13.

9. Ruane, F., *The Delighted Eye, Irish Painting and Sculpture of the Seventies,* London, Roundhouse, 1980.

10. Ruane, F., *Patrick Collins,* Dublin, the Arts Council, 1982. Fallon, B., *Tony O'Malley, Painter in Exile,* Dublin, The Arts Councils, 1984.

Right to left, Declan McGonagle, An Taoiseach Charles J. Haughey and Gillian Bowler at the opening of IMMA, RHK, May 1991.

Charles J. Haughey

Charles J. Haughey was born in Castlebar, County Mayo, in 1925 and educated in St Joseph's Christian Brothers' secondary school, Fairview, Dublin. In 1946 he graduated from UCD with an honours B. Comm. He qualified and practised as an accountant and was called to the Bar in 1949. He married Maureen Lemass in 1951; they have four children. He was first elected to Dáil Éireann in 1957 and over the next 35 years held office as Minister for Justice, for Agriculture and Fisheries, for Finance, for Health and Social Welcfare and as Taoiseach. During this period he gave high priority to enhancing the artistic and cultural life of Ireland.

VR: *Of the eleven Taoisigh we have had since Independence many would say that you have done the most for artists.*

CJH: I believe that an enlightened proactive policy for arts and culture must be an integral part of modern government. It is necessary for the ultimate well-being and fulfilment of a people that they should be aware of their cultural identity and heritage and that public policy should favour the fullest expression and flowering of that identity in all its aspects. The approach should be comprehensive but in my view, to encourage, support and sustain individual creativity is, in the long run, by far, the most important. Secondly, of course, there is the need to facilitate and encourage public access, by means of public performances, theatre, music, opera, galleries, exhibitions, festivals and so on. Art education, particularly in our schools, is also very important.

The introduction of the tax exemption for artists in 1969[1] and the establishment of Aosdána in 1981[2] in particular were both directed toward the first of those objectives.

In Ireland we have had a sad history of our creative people going abroad either for economic reasons or from what they felt was an unsympathetic or even hostile climate. I felt that it was necessary to radically change all that. I wished the modern Irish State to make a positive gesture to our creative people. I wished it to say to them, in effect, 'you are valued members of our community. Your contribution is of unique importance. We wish you to stay and work here at home'. That was a very important aspect of the tax initiative.

However, the actual financial provision was very significant also and a number of artists have said to me from time to time that without it they would not have been able to continue to devote themselves to their art.

I hoped also that by creating here a favourable creativity climate we would attract eminent poets, writers, sculptors, painters from abroad who would help keep our Irish artists in touch with new trends and influences taking place elsewhere.

The tax exemption and Aosdána were important initiatives

and I think unique in a modem parliamentary democracy.

VR: *Yes, Rubens for example, had had tax exemption in the seventeenth century.*

CJH: In former times rulers and Church leaders would bestow their patronage on their favourite artists. Today that role must in the main be filled by the State. The State must through appropriate agencies act as an impartial, objective patron, supporting and facilitating creativity but not attempting to intervene or to influence or restrict artistic freedom. Given the circumstances in which democratic governments must perform and the need at all times for public accountability, this is not always very easy. You must, however, try to create a political climate where such a policy has full public acceptability and support.

VR: *Do you do it through education?*

CJH: It is certainly desirable that art be taken seriously as a normal part of the school curriculum. The National College of Art and Design is a very successful institution. It was formerly housed in a very unsuitable premises which adjoined Leinster House. We succeeded in having it transferred to the old distillery in Thomas Street. This was strongly opposed at the time as impractical and unsuitable.

However, the staff and students were keen to go there because of the ambience and the challenge it represented. The conversion of the old buildings was in itself an artistic achievement and it has all worked out very well.

VR: *City centre locations are valuable to art students in that they can visit galleries and museums easily during the day.*

CJH: Yes. One of the advantages of being based in Leinster House was that the National Gallery was next door and it was easy to slip in and wander around. George Bernard Shaw did that as a student and I think that is how he came to donate the royalties of *Pygmalion*, later *My Fair Lady*, to the Gallery.

Following a review of the National Gallery in 1984 a major programme of refurbishment and modernising was carried out by the OPW on what is now called the North Wing and then the

Board itself undertook the major task of the Clare Street extension which has been universally acclaimed as a triumph. I had a very illuminating experience when I was involved in the private fund-raising aspect of that project.

Approaching the chief executive of one of our major, successful, commercial corporations, I spoke about the desirability of large profitable corporations making a contribution to the community in which they operate. I was quite horrified to hear his response – that his only interest was in the bottom line: in maximising the profits of the corporation and nothing else. He was, of course, the exception. The great majority responded to our overtures in an exceedingly generous way. And, in fact, in doing so they reflected a new and increasing trend in corporate business.

It began in the US where corporations are now expected to produce a new type of balance sheet for their shareholders which, in addition to the financial results, sets out a broad profile of the corporation's activities, indicating its performance in regard to the well-being of its staff, customer satisfaction, the environment, the local community. These are judged by an annual 'social audit'. This is a development which could bring enormous benefits to the arts if properly encouraged by public policy.

VR: *Can we come back to the living artists and how you envisioned them in our society.*

CJH: It was always central to my policies that the primary focus must be on the creative artist living and working in Ireland today. This is not being insular or indicating in any way that we should not be fully aware of and in tune with the world around us, or that we do not facilitate access to the fruits of other cultures and the great treasures and masterpieces of the past. Of course we must not do that but it is crucially important that we recognise and support the contribution made to our cultural life today by the creative people in our midst. There is a story, probably apocryphal, that when the editor of *The Irish Times* phoned WB Yeats to tell him that he had been awarded the Nobel Prize for literature Yeats's reported immediate response was 'how

An Taoiseach, Charles J. Haughey visits the Knowth excavation. Behind him stands Tony Cronin and to his right, Professor George Eoghan.

much is it worth'. Poets must live!

VR: You appointed Anthony Cronin[3] as your cultural adviser.

CJH: Yes, we had been at UCD together and kept in touch. He was the ideal person for me to have as cultural adviser and he was, I believe, brilliantly successful. He has a comprehensive knowledge of the cultural world, past and present; he was full of ideas and enthusiasm and determined to bring about a radical improvement in Ireland's place in the world of arts and culture.

VR: And Aosdána?

CJH: The establishment of Aosdána was a major innovation and a very significant element of my policy of enhancing the status of creative people in our society. It was intended to be their own independent academy, elected by themselves. I suppose the role model was the Acadamie Française. Tony Cronin was charged with the task of setting it up and for its successful development.

We were fortunate to have James White[4] and Colm Ó hEocha as successive chairmen of the Arts Council at the time. Their enthusiasm for the concept of Aosdána was of crucial importance.

VR: Did all this fit in with the spirit of the age?

CJH: Not really. You must remember that in the 1980s, unlike today, the country was in a very depressed state, with massive unemployment, high emigration, huge deficits, crushing borrowings; a generally pretty bleak outlook.

In these grim circumstances economic development had to take priority; the provision of jobs and sorting out the nation's finances. It was not very easy to find money for culture and the arts but we managed to lay the foundations for a brighter future.

I believe that today in Ireland we have a vibrant cultural life; a great flowering of creativity right across the artistic spectrum; writing, poetry, drama, music, and the visual arts.

VR: Were you influenced by your European experiences?

CJH: Probably – I knew that De Gaulle for instance had appointed Malraux as his Minister for Culture. De Gaulle was very proud of French culture and like many of his country men and women believed that the French had a duty to bring French culture to the rest of the world! It was his 'cachet' that made Malraux so influential. I met Malraux once when he opened the Galerie Maeght in the South of France.

Mitterrand whom I got to know very well had a very definite concept of the role of the French president in cultural affairs.

VR: Your interest in heritage is very strong. What about Discovery Ireland?

CJH: I was always interested in our archaeological heritage particularly in the earlier era, the Stone Age and the Bronze Age. I was fascinated by the great mystery of it all. It is, I believe, very important for a nation's self-confidence that the people should know as much as possible about their past and cherish their heritage.

The National Museum was an excellent repository of artefacts from the past but most of them were the result of accidental finds and our general approach to archaeological discovery

had been minimal and haphazard. Brilliant work had been carried out by individuals on some important sites like that of Professor Eoghan in Knowth but we lacked a comprehensive coordinated programme of exploration. The Discovery Programme was designed to provide such a programme, properly funded, covering the whole country through each succeeding era.

The programme would be directed and managed by the archaeologists themselves who would take all the decisions in regard to exploration, priorities and publications. I believe that it has been very successful and in fact the envy of archaeologists around Europe. Here again I decided that the State's only role would be that of impartial, objective patron.

VR: When you were Taoiseach there wasn't a Ministry for Arts and Culture?

CJH: I brought responsibility for policy for culture and the arts into the Department of the Taoiseach. Before that politics and culture, the visual arts especially, were estranged. There was mutual suspicion. First of all I wished to give it the enhanced status that this would bestow on it and secondly because the Taoiseach's department was the only one with sufficient clout to secure the increased state funding that was required, and thirdly because it facilitated my taking personal initiatives in this area.

There was also, of course, the added advantage that it was a highly talented, committed department headed by that urbane, cultivated public servant, Padraig O h-Uigínn.

VR: When Dublin was European Capital of Culture in 1991 your office was in charge.

CJH: Yes, but we didn't handle it very well. It didn't have the impact it should have. It was a bit hit and miss.

VR: How do you see Temple Bar?

CJH: I was very conscious of the fact that most of the great cities of the world have at least one area which is different, where creative people congregate, where there is an atmosphere of relaxed non-conformism, with theatres, studios, galleries, cafés, pubs, restaurants and a general dedication to 'joie de vivre'.

I wished to see such a place develop in Dublin. The whole process began during an election campaign when at a public meeting I was questioned about CIE's acquiring property with a view to establishing a bus depot in Temple Bar. This was opposed by a number of bodies and individuals who wished to see something more worthy of this old part of the city put in place. I gave a public undertaking that the bus depot proposal would not go ahead. And so the concept took shape.

Paul McGuinness, representing U2 who were very keen to see something special done for Dublin, came to see me and promised support for the proposal. I also spoke to Fergus O'Brien who was Lord Mayor at the time and he fully approved and promised the support of Dublin Corporation.

Special legislation was needed to implement the concept: establish the appropriate bodies, lay down their objectives and powers and deal with the town planning and other aspects of this first-time project. I introduced the required legislation in the Dáil and it was passed by the Oireachtas with very little opposition.

VR: Were you involved in the Tyrone Guthrie Centre?

CJH: Yes, Tyrone Guthrie came to see me and very generously offered his house in County Monaghan as a centre in which creative people could spend periods of time working in peace and quiet. I gratefully accepted it on behalf of the nation and it went on to become a very successful part of our cultural landscape and a little haven of creativity. He was a lovely man, delightful to meet and talk to.

VR: You had Government Buildings done up.

CJH: Yes. The situation in regard to the seat of government had been totally unsatisfactory for years. The obvious location for the Taoiseach's office and Government Buildings was the site of the College of Science on Merrion Street which was part of UCD.

A number of events coincided which facilitated such a proposal. The students and lecturers in the College of Science were being moved out to the new campus in Belfield and a terrace of houses opposite the College, in one of which the Duke of

An Taoiseach, Charles J. Haughey, Anne Madden and
Louis le Brocquy, at Anne Madden's exhibition, in the RHA,
July 1991, © Lensman.

Wellington was born, were being sold by the Government. They
were in a very dilapidated condition and would not be suitable
for conversion into modern offices. The funds realised by the
sale of these houses was earmarked toward the cost of the pro-
vision of the new Government Buildings. The outcome was a
great triumph for the Office of Public Works who did a magnif-
icent job in transforming the old College building on Merrion
Street into a centre of government in which everybody could
take great pride.

VR: *You also had a number of other public buildings restored and
adapted for different modern purposes.*

CJH: Yes, Dublin Castle, the Royal Hospital Kilmainham, the Customs
House and the National Concert Hall being the more important ones.

Dublin Castle was transformed into a splendid centre for official entertainment and also an international conference centre. Again, the Office of Public Works and its team of architects and design staff did a wonderful job.

By a happy combination of circumstances, the Royal Hospital Kilmainham became the home of the new Irish Museum of Modern Art. The restoration had just been completed and the question of its future use was being discussed. At the same time we were seriously looking at the question of establishing a new Irish museum of modern art, the absence of which represented a major gap in our cultural institutions.

This was given an impetus by the fact that Gordon Lambert, who had a very fine collection of modern art, was anxious to have an Irish museum of modern art established and to donate his collection to it. It got off to a very good start. An excellent board under the chairmanship of Gillian Bowler got it up and running smoothly and with the appointment of Declan McGonagle as director, it was immediately catapulted into an institution of international status and significance.

I think I should mention that the Office of Public Works by this stage had developed into a modern, efficient, public body capable of successfully undertaking major projects of construction, restoration and preservation.

Under the inspiring leadership of Chairman John Mahony it had shed its old-fashioned traditional image of inertia and delay and was actively engaged in initiating and completing a variety of high-quality projects all over the country.

I recall, for instance, visiting the Céide Fields site in Mayo when excavation was in its early stages. John Mahony and some of the members of his staff were present and we discussed with Dr Caulfield the future of the site. John Mahony said, in effect – 'This is an extraordinarily important site of international significance. It must be properly handled. Give us the job and we will provide what is necessary and appropriate for such a site'. We did and the result was an award-winning centre of

the status and quality such a unique site so richly deserved.

There is an intriguing aspect to the story of Céide Fields. A local teacher who was a keen observer of the world around him noticed that as the farmers cut turf they were constantly exposing rows of a similar type of white stone. He knew they must be of some significance and brought them to the attention of the Royal Irish Academy. In one of those coincidences that one comes across from time to time, in due course, the teacher's son Seamus Caulfield, a professional archaeologist, supervised the excavation of the site which revealed it to be one of the most important Stone-Age remnants in Europe, as it provided us with an authentic picture of how a farming community of that era lived. These were probably members of the same community that built Newgrange and Knowth.

VR: *Your portrait has been done several times.*

CJH: Well, there are quite a number but the majority of them were not actually commissioned by me.

For instance this one here by Peter Deignan was commissioned by a friend who was so impressed by this very powerful portrait opposite, of Seán Lemass[5] by Seán O'Sullivan, that he wished to have one done of me, also in Dáil Éireann. You will notice the presence of the microphone in the latter.

In that context I have noticed that many artists like to identify their work by some subtle little personal gesture. For instance this is a painting of Croagh Patrick by Patrick Hennessy. He finished painting it the evening the Americans landed on the moon and so he put in this little crescent moon here to relate the two events.

A few days after I acquired it I noticed that it was not signed. By arrangement with the Hendriks Gallery Patrick Hennessy called here one evening to sign it. We spent the evening talking and having a drink and around midnight Patrick departed for home. When I looked at the painting the next morning I realised it still hadn't been signed!

And Eddie McGuire who was really a portrait painter of old

master calibre would always do a portrait his own way; placing the subject within a framework of his choosing like in this brilliant portrait of Tony Cronin.

This is a Blackshaw, it's of Flashing Steel. You need to know the anatomy of a horse to paint one. Stubbs knew horses, anatomy and all. Blackshaw rides, breeds and races horses and that's shown in the work.

That's Chú Chulainn standing there on guard. It was carved by the sculptor Joan Smith from a fallen elm.

1. 1969 Finance Act, Tax Exemption Scheme for Artists, now Section 195 of the Taxes Consolidation Act, 1997. Artists may apply to be exempt from tax on their art work.
2. Aosdána is an affiliation of artists established by the Arts Council in 1981, to honour artists whom colleagues believe have made a serious contribution to the arts in Ireland. Membership consists of not more than 200. Aosdána members resident in Ireland are eligible to receive an annuity from the Arts Council. It is called the *cnuas* and is valued in 2002 at around 11,000. It is funded by the Exchequer through the Arts Council. Aosdána is a self-regulated body, with ten members, *Toscairi*, elected every two years as a supervisory board. Aosdána means 'poets of the tribe' in Irish.
3. Anthony Cronin has written novels, biographies, essays and poems. 'Art for the People?' in *Letters from the New Island*, Bolger D, (ed.), Dublin, Raven Arts Press, 1991, pp, 148-88 is an interesting compilation on his ideas about art and society.
4. Dr James White (1913-2003) was chairman of the Arts Council from 1978 to 1983. He did not have a formal education in art but encouraged and wrote on artists such as Nano Reid, Oisín Kelly and Gerard Dillon. In 1960 he became curator of the Hugh Lane. He and his family lived in the building. Then and when he was director of the National Gallery from 1964 to 1980 he was tireless in his efforts to encourage art appreciation among all Irish people.
5. Seán Lemass, Taoiseach from 1959-1966, was C.J. Haughey's father-in-law.

Patrick J. Murphy, third from the right, outside the main office block, Guinness, Ghana Ltd., January 1973.

Patrick J. Murphy

Patrick Joseph Murphy was born in New Ross, County Wexford in 1939. He was educated at the Christian Brothers' School in New Ross, the College of Commerce in Rathmines, Dublin, and Trinity College Dublin. He married Antoinette Cummins in 1964 and they have four children. He worked in brewing, first with Guinness and later (1973) became Managing Director of Irish Malt Exports Ltd. He was President of the European Maltsters Association from 1989 to 1991. He retired from malting in 1999. He was appointed Art Adviser to the OPW in 2000. That year he was also appointed chairman of the Arts Council. He is a member of the International Council of the Museum of Modern Art, New York.

VR: *Patrick, you became chairperson of the Arts Council two years ago. You're a noted art collector, among other things.*

PJM: I suppose I started chairing in February 2000, but it had started for me the Christmas before when I got a call inviting me to a private dinner with the Minister, Síle de Valera. In the event, Síle missed the dinner. I was given no hint by her staff as to what she wanted at it. I'd already done two terms in the 1980s, on the Arts Council, as a member. There was a number of high profile people present, however, and I had the feeling of being looked over for something or other. In the middle of it, I got a phone call from the Minister. She apologised and said she had flu, and hoped we'd meet soon. Was there any possibility I'd come and see her in the near future? I was mystified.

Liam Belton and I are two of the trustees of the National Self-Portrait Collection in Limerick and we were in the Royal Hibernian Academy, the day of the opening of the *Artists' Century*[1] exhibition, putting the finishing touches to the hanging. Liam, John Logan and I did that show for the millennium, in the RHA in co-operation with the National Self-Portrait Collection. The NSPC wanted to exhibit the recent additions to the collection, and I said 'Why don't we do the self portraits and masterpieces. Rather than include all 400 self-portraits, why don't we select; pick major figures of the century – say have 100 self-portraits and three masterpieces each by those 100 artists'. This was initially agreed to be a good idea.

In brewing you'd assess the quality of a vat by taking top, middle and bottom samples; maybe that's where I got the idea. Patrick T. Murphy came back from Philadelphia about that time to be director of the RHA. He wasn't so keen on historic shows but we thought it was important to have one to mark the millennium.

Four hundred works wouldn't fit anyway. We couldn't have the entire RHA as the back rooms were booked for Tom Ryan's retrospective show. So we scaled it down to 100 self-portraits and 100 masterpieces.

VR: *Did it travel?*

PJM: It did travel, to the Ormeau Baths in Belfast. Hugh Mulholland took about 150 of the works.

Ironically, it turned out to be one of the best attended shows in the RHA. I did the introduction to the catalogue, and the essay was written by Paula Murphy. Ruairí Ó Cuív did the administration. Patricia (Moriarty) was there before that, but she went to Limerick to a new career. Ruairí did do a great job. Sadly, we only printed 1,000 catalogues. I haven't even got one myself. If we'd printed 2,000 we could have made some money.

My idea was that the work should mainly come from private collections, not public ones. There were some people who promised us work but in the end didn't give it. I loved the Tuohy we borrowed. I'd researched Tuohy. I was able to borrow the *Girl in the Striped Dress*; I knew who had it from following the auctions. I refrained from taking paintings from my own collection but there was one I did put in; *Henrietta in a Pink Hat* by Mary Swanzy. She painted it in her nineties, in 1974 or 5. James White considered it as good if not better than the Van Dongen in the National Gallery of Ireland.

Anyway, the morning of the hanging of the show I got Síle's call. I left the RHA and went down to the Dáil. She said, 'Brian Farrell is resigning as chair of the Arts Council. I'm wondering would you take it on'. I looked at her straight in the eye and said 'What?'.

I then said I'd do it, and she asked if I needed time to consider it, but I said there and then that I would do it. I saw there'd been a lot of trouble. I believed it to be in the national interest to do it. I'd retired from malt exporting at Christmas and had other plans but I decided to do it. I'm enjoying it. I hope I've made a contribution. I'd been offered the chair by C.J. Haughey, the Taoiseach, in 1981-2. I didn't know him, but I'd been president of the Irish Exporters Association, as Managing Director of Irish Malt Exports Ltd. The Irish Exporters Association had been founded in 1951, the same year as the Arts Council. It's a strong federation, a kind of a club of exporters promoting Irish trade

internationally. It goes well.

I was one of the youngest presidents, then. At the end of the two years' presidency the 36-person Council turned to me and said they would nominate me for the Senate. They said they'd campaign for me.

It was very onerous. Antoinette and I campaigned, in the evenings. I was still MD at Irish Malt Exports. But I failed to be elected. Forty-five public representatives had promised me their first preference vote, but only four actually gave it. That told me a lot about politics. I went to C.J., to Garret and to the leader of the Labour Party, and they all said 'No, you're not in the party'.

After that C.J. rang and asked me to come down to his office. I did. He said 'I see you're interested in the arts. There's an opportunity arising, I'd like you to take it'. It was the chair of the Arts Council. It would involve two days a week, I knew. He said, 'I think you could do it on your ear'. So now when things get difficult I lean over, hand on my ear, and say to myself 'can I do it on my ear?'. When I said I couldn't do it due to business commitments, he asked if I would agree to become a member and I said I'd be honoured, so I became a member. Robert Ballagh joined then, also Proinsias MacAonghusa, and Arthur Gibney a few months later, I think.

Later on I remember Proinsias saying, 'we three came in together'. Colm Ó Briain was director, James White who had been director of the National Gallery was chair. Then there was a change of government, and Garret re-appointed me. James said, 'you are on the Council solely on your merits. That can't be said for everyone'. I was a bit chuffed. Leo Smith had been championing me down the years. He thought I had a good eye. Leo of the Dawson Gallery. I got to know him very well over the years. He said to me one day, 'what are you going to do for masterpieces now that I'm going to kick the bucket'. I didn't believe him so I said, 'I'll find my own'. He was soon gone, through a sudden heart attack. I'd cut my teeth as a collector with Leo.

My first significant art purchase was from Desmond

Carrick. Before Antoinette and I were married in 1964 we went to Desmond's studio, he worked in Guinness's by day, and we chose a painting called *Bulls*. I really liked *Bulls*. Antoinette preferred a still life, but we couldn't afford two.

In 1988 I was not re-appointed by C.J. Haughey to the Arts Council. Proinsias was, his speciality was the Irish language. So was Arthur.

VR: *Were there many Arts Council chairmen who came from the private sector?*

PJM: I think the Arts Council has been very well served by its chairmen. Máirtín McCullough was an excellent chair,[2] very conscientious, very good, from McCullough Pigotts, in 1984. In 1989 it was Professor O hEocha,[3] President of UCG. He was said to be very good too.

Colm Ó Briain retired during James White's tenure. He was a dynamic director. As the late Máire de Paor said he had a new idea every day. The day he was retiring he rang me on James White's suggestion and asked me if I would like to apply to be the next director. But I had no ambitions for that position as the business sphere suited me very well. I was later asked to sit on a subcommittee to recommend an appointment as Colm's successor. We interviewed a short list and recommended Adrian Munnelly who became director.[4] He was a well respected education officer at the Arts Council at the time. At the interview, he was outstanding on the day. My crusade all my life has been that everyone should share the arts. Adrian had that. Like him I was a country boy. He was from Claremorris, County Mayo, I was from New Ross, County Wexford.

Professor O hEocha served his full term, and then died shortly after, poor man. After him Ciarán Benson[5] was appointed, Professor Benson from UCD. He was the youngest chairman – he continued up to 1998 – then Brian Farrell[6] was appointed. I was slightly surprised at his appointment because he wasn't that visible in the arts. He had undoubted skills, a well-known broadcaster, a professor from UCD and so on.

On the steps of the Arts Council on the day I was appointed they said to me, 'what are you going to do? They're all fighting'. I said 'there are too many, seventeen (Council members) is too many'. I believe moving towards a board of directors approach is more appropriate. And it says in today's *Irish Independent*, in Síle's press release (2 April 2002) that it is to be eight plus one, in the new arts bill. The text will be published within a week.

VR: *Having a smaller Council sounds like a return to the situation before the 1973 Arts Act?*

PJM: Not really. The reduction in the number of Council members reflects trends in public sector governance, and this change should streamline the efficiency of the Council. In 1951, when the first Council was appointed, there was only a tiny professional executive, whereas today there is a highly qualified, highly trained professional staff in place at 70 Merrion Square to support the Council.

From the day I went in I needed to get harmony, as there had been in the 1980s. The harmony I wanted was between Council members and staff. Council members give time and expertise freely. It needs fairly focused leadership. The ideal is that the chair and the chief executive should get on. I would always aim for a good relationship with the chief executive, which I hope I have with Patricia Quinn, the director.[7] That is not to say I wouldn't point out something if I thought it wasn't right.

I brought a fair amount of expertise and a fair measure of enthusiasm to the job. The arts are to be enjoyed. It's a privilege and a pleasure to plan for the Council. There's now a unity of purpose. We've prepared an exciting new plan, a five year plan, which is with Government. I hope it will be approved before too long. I have to praise Síle de Valera. She delivered £100,000,000 for the current *Three Year Plan*, 1999/2000/2001 – the second three year arts plan which finished at an average of £33,000,000 a year. It's incredible, compared with the £5,000,000 back in the 1980s, when we were arguing, some of us, for £13,000,000. She's delivered. I'm confident she will deliver on the five year

plan. Although this Council won't see it through, because we only have till next year, I took the view that the longer view would be better.

I'm all for new ventures. At our planning session we took the map and said that no region should be more than twenty miles from an arts experience, a centre, whatever, music, visual arts, theatre.

VR: *The* Arts Plan, 1995-1997, *the first arts plan, was strong on getting art to everyone, wasn't it? To the dark corridors of the midlands and so on.*

PJM: The whole arts scene has expanded since the 1980s. New venues have been built with capital funding from the Department of Arts, Heritage, the Gaeltacht and the Islands in recent times. So in the Arts Council, more revenue is required to sustain these developments. I officially opened An Grianán in Letterkenny, I like it very much. Draoícht in Blanchardstown is terrific. The exhibition of State art was great there.[8] In Portlaoise I opened a show from IMMA at the Dunamaise Arts Centre. Carlow is developing a new arts centre.

VR: *Are theatre spaces often more successful than the visual art spaces in art centres?*

PJM: Possibly. I want the arts to extend to everyone. As chair of the Council I go around the country. I opened the Clifden Arts Festival this summer. Also *Íontas*, in Sligo – the *Small Works Exhibition*.

Festivals have become very important to Irish people. The visual arts are sometimes not shown at their best at festivals, maybe, and our next plan will seek to address this. While chairman of the Arts Council I have a policy to open only group shows, but not one person shows, except in special circumstances. I want to be fair and to be seen to be fair. I can't open all the one-person shows I'm asked to open, so I think it's fairer not to open any. I do believe in not having conflicts of interest.

If I were Minister I'd choose people (to sit on Council) who didn't have vested interests, by that I mean a direct interest in getting substantial grants from the Council on appointment.

I resigned as chair of the Contemporary Irish Art Society, since the society was in receipt of a small Arts Council annual grant. At Council meetings, when there is a vested interest people declare it and leave while Council decisions are made on their particular interest.

VR: *You're interested in public collections.*

PJM: I advise the OPW on their art purchases now. They have about 6,000 works. Recently we bought art for the Dáil, we had £100,000 to spend. The State is now a big patron.

When the Arts Council was set up in 1951 collecting was a very important part of its activities. No one was buying much in the 1950s. People needed the imprimatur of the Arts Council. The Arts Council collected strongly right up to the 1980s, when some of the collection was sold off. It's a source of sadness to me that the Arts Council has reduced purchasing in recent years, other than under the Joint Purchase Scheme, which isn't used much these days.

At the end of 2001 when Aer Lingus had to sell off their paintings, there were six which had been purchased jointly with the Arts Council under the Joint Purchase Scheme. They were Louis le Brocquy's *Isolated Figure*, a large George Campbell of Connemara, an Arthur Armstrong also of Connemara and Patrick Collins's *Rain in Connemara*. There was *Dublin Streets* by Séamus O Colmáin, Eamon's father, a painter by day and a baker by night. There was an oil by Anne King-Harman, she was friendly with Mainie Jellett and Evie Hone. The paintings were already in de Vere White's catalogue when they were brought to my attention. I immediately contacted John de Vere White and Aer Lingus. Aer Lingus had written to the Arts Council to point out that they were selling their collection. They were very good about it. I negotiated with them to take the six paintings at half their pre-auction value on the basis of the Joint Purchase Scheme. The OPW then took them at cost, and they are going to go to a new public building in construction in the Glen, Waterford. The Arts Council had no financial benefit but the

paintings were kept for the nation, which I was very pleased about.

In the early 1980s buying was still very important for the Arts Council. I loved going to the exhibitions. My judgement might be useful when purchases were being made. The growth of patronage since then has been phenomenal.

When I first went to an opening at the Dawson Gallery in the 1960s there were only nine or ten people present. That was at 4 Dawson Street. They all looked at me. They were elderly, from my point of view. They were the nucleus of the Contemporary Irish Art Society. There was (Sir) Basil Goulding and Gordon Lambert, and Leo of course, Leo Smith, James White, Stanley Mosse from Kilkenny, Cecil King, Terence de Vere White, Michael Scott, possibly Dorothy Walker. And George Dawson. Maybe Patrick Scott. They were the establishment. There were no young people of my age. I was so unsure about how things worked then. I remember asking Leo had the Arts Council taken their pick yet when I was buying a Nano Reid. He laughed. So I went ahead and bought two, the dearest and the cheapest. Later he told me the artist said I'd bought the two best works and wondered why I'd bought them. I told Leo I bought them because I liked them.

Patronage was confined then mainly to the Arts Council and a few other groups and those establishment people. Later two other big buyers were the Bank of Ireland and AIB. I think the Bank of Ireland started before AIB. When Ronnie Tallon built their Bank of Ireland Headquarters in Baggot Street he put aside some money for art. Now some people are saying the building is just a pastiche of the Seagram Building in New York. According to Michael Scott, Ronnie was the power house of Scott Tallon Walker, the architectural partnership which did so much for the arts in Ireland.

The Dawson, and later the Hendriks were the main, the only commercial galleries then, when I started collecting in the 1960s. There are about 30 now in Dublin and they all seem to be doing

Antoinette and Patrick J. Murphy at Kilgobbin, Co. Dublin (photograph Ivan Murphy).

fine. There are also many about the country nowadays.

VR: How did you rate the Arts Council's collection?

PJM: I was hoping the Arts Council collection would be the nucleus of a museum of modern art. It would, in my view, have been a fine, if not perfect nucleus. In the late 1980s, I was on the steering committee for the new museum of modern art, the Irish Museum of Modern Art. Gordon (Lambert) thought I should be chair of the Board, but I wasn't appointed to the board. He was campaigning for me but it didn't come about. Subsequently I was asked to donate some works to the fledgling museum under the tax incentive scheme. You could set off donations against income tax, under certain conditions. I picked out fourteen works. I put a value on them, in 1991, of £90,000. They included a major Mary Swanzy, because they said they wanted one. I was going to give them an exceptional futurist composition by Swanzy. There was a major Barrie Cooke, the Síle na Gig that later represented him in Holland, an important cracking box by David Nash, the only one of its kind in Ireland I think, and a large landscape, a mixed media piece of the Burren also by David Nash. It was about 4'x8'. I later gave it to my son Bryan, who works in the Peppercanister (Gallery) with Antoinette. I had a print, inscribed

to me, by Sandro Chia, a work by the Czech artist also in one of the *Rosc*s, Jiri Kolar, two large charcoal drawings by Jo Baer, a set of four *Nineteen Greys* by Bridget Riley and one or two other things. I said I'd give these, thinking I should give some international work. But they were declined. They thought they weren't worth £90,000. I think they had got them valued by a London dealer on the basis of what a run-of-the-mill Mary Swanzy might get, rather than on the basis of the particular picture in question. They thought a Swanzy was worth only £4,000 or £5,000 at that time.

However, a month later a work similar to mine was sold for £70,000 sterling plus fees at Sotheby's. It wasn't as good as my futurist composition. I then told IMMA the offer was closed and I sold it later, to prove a point. I sold for a figure in excess of the value I'd put on it for IMMA.

I've given some of the other things to my family.

That was disappointing for me. Here I was, wanting to give them something special and they didn't want them. After all, they had asked me for the donation.

VR: *Gordon Lambert's collection has greatly enriched IMMA, hasn't it?*
PJM: Oh absolutely. We've been great friends and I did suggest to him some years before that he should consider leaving his collection to the nation, as he had no family to provide for.

If I had my way I'd give the entire Arts Council collection to a national institution. It's almost 1,000 works. I had thought of building a museum and giving my own collection to New Ross, to give something back, but when you have a family you have more pressing responsibilities.

Subsequently when IMMA did not prove to be a runner for the Arts Council collection, I felt that somewhere like the Royal Hibernian Academy, if expanded, might be a suitable venue for housing it on public view. When Basil Goulding died I suggested to Gordon, who was then chair of the Contemporary Irish Art Society, to write to the Taoiseach, C.J. Haughey, suggesting that the Government buy the entire collection of Sir Basil Goulding

and site it in a provincial centre. We were talking about a few hundred thousand, that was in the early 1980s. Basil was dying of cancer and the Contemporary Irish Art Society gave him a farewell party at Gordon's home. We didn't say anything about dying but it was understood.

Basil was the number one collector[9] in the 1950s, 1960s and 1970s. He had the income and he had the eye. I regret from a national point of view what happened Basil's collection. All the international works were first offered to London dealers and went out of the country for low prices. I was sad to see his Kokoshkas, his huge oils by Auerbach, his exceptional Vasarelys and other things now worth millions going for £2,000, £3,000 each.

It was the outstanding private collection in Ireland.

But it was too early, people weren't tuned in.

VR: *The Basil Goulding collection was donated to Kilkenny Design wasn't it, but that had none of the international work, is that so?*

PJM: Only a small fraction of his Irish pictures, albeit important ones, was donated to Kilkenny. The greater proportion was sold off to museums and to private buyers through the Dawson and Hendriks galleries, after the foreign works had been disposed of to dealers.

VR: *How would you describe Basil Goulding and Gordon Lambert?*

PJM: As two wonderful Irishmen. Basil was a most gifted Irishman. Like Gordon, he was a talented sportsman. They were businessmen. Art crosses all boundaries. We moved in different social circles and came from different backgrounds. It was through love of art that Gordon and I got to know each other and became close friends; which we are to this day. The late architect Peter Doyle introduced me to the Contemporary Irish Art Society in 1973. When I joined Basil said, 'I'm delighted Pat to learn that you're now one of us'. The Contemporary Irish Art Society had been set up in the Dawson Gallery in 1962 at an exhibition of Pat Scott's, when Basil turned to his eight or nine friends and said, 'Will you join me in giving ten pounds each to purchase the finest work in the exhibition and present it to the Municipal

Gallery, which has no funds to purchase works of art?'

 £90 bought the big one, now on show at Pat's exhibition[10] in the Hugh Lane [Municipal Gallery].

VR: How did you get to know Gordon?

PJM: I got to know Gordon through the Hendriks Gallery. We were initially rival buyers for the best pieces in exhibitions. I remember one day forecasting to him and David (Hendriks) that thousands of Irish people would be interested in art in a few years time. It has come about.

VR: How do artists fare now, do you think? Is it correct that of the Arts Council's 47,000,000, only one and a half million goes directly to artists, including visual artists this year?

PJM: Well in 2001, the figure was actually £2,200,000. That was made up of awards and bursaries to individual artists, and *cnuais* to Aosdána members. In addition we indirectly support artists through our grants towards artists' facilities such as resource organisations, galleries, studios and workspaces. We spent £8,400,000 on these in 2001. We spent over eight per cent (£3,900,000) of our total budget on visual arts in 2001.

 Top of the range artists like Louis le Brocquy and Tony O'Malley are doing very well. Many younger artists are doing quite well too. A young artist like Mark de Freyne sold 32 pieces on his second solo show recently. Half of them were bought by young people who were probably under 30.

VR: How did your own interest start?

PJM: I'd come to Dublin from New Ross, where I was born in 1939. I went to the Christian Brothers and did my Leaving Cert at sixteen. There was nothing in my background that particularly encouraged me to have an interest in the visual arts, although my grand-aunt Liz Furlong made patchwork quilts; one of hers was featured on the front of a Kilkenny catalogue design a few years ago. Stanley Mosse said he had bought two of hers.

 I applied for the Central Bank of Ireland, about 400 people applied. I was the one from Leinster who got the place. I came to Dublin in 1956. In the Central Bank I was in charge of

Patrick J. Murphy and Tony O'Malley at the Butler Gallery, Kilkenny Castle, 1992 (photograph Jane O'Malley).

delivering cheques for signature by the Governor J.J. McElligott. While he was signing the cheques I'd be looking at Lady Lavery, the portrait that's now in the National Gallery and that was on the pound note. Then I went to Trinity, to study at night. I took English and Irish for my BA. I graduated at the Institute of Bankers at the same time. I also did a B. Comm. Music and poetry were my special interests then. I got the Jellett prize for Irish. George Dawson in Trinity was busy holding international exhibitions at the time. I remember seeing his collection of modern prints which was very good. In 1959 I applied for Guinness's and got on the number one staff. The top brewers were all Oxford and Cambridge graduates. Guinness was full of art. The brewery was full of Nathaniel Hones and paintings by Shepherd of African wildlife. In the boardroom there were beautiful William Ashfords, and a fine view of Dublin from Phoenix Park by William Sadler.

The late Bryan Guinness, Lord Moyne, was very keen. He was a poet and an amateur painter. Over in 98 James's Street Lord Moyne had a collection of Japanese prints on the wall. There was an ingredient that went into the Foreign Extra Guinness called 'foul foreign drawings', meaning drawings from the bottom of the vat! So a wit named Paddy Ryan called Lord Moyne's woodblock prints his 'foul foreign drawings'. Sadly,

they faded through direct sunlight.

VR: *So you were inspired to collect.*

PJM: I began collecting in 1963. I married in 1964. I was 24 and Antoinette was twenty. I then went back to Trinity by day, and brewed by night. I took an MBA and got first place. I got a scholarship to America but couldn't go, as the Brewery wouldn't release me.

Michael Wynne, before he joined the National Gallery, was in my class. We remained friends ever since. We set up a syndicate of two, to buy Irish art, it was older Irish art. Michael had the knowledge and I had the enthusiasm. It was fun.

When we'd bought ten, we'd take five each, on a drawn lottery basis.

I remember buying a Paul Vincent Duffy view of Wicklow for ten pounds. Michael felt it was as good as a Hone. I was passionately reading Thomas Bodkin's *Four Irish Landscape Painters*[11] in Rathmines Library. It was out of print at the time, and eventually even the copy in the library disappeared.

VR: *Bodkin's 1949 report* The State of the Arts in Ireland, *commissioned by the Government, actually led to the founding of the Arts Council in 1951, didn't it?*

PJM: That's right – Thomas Bodkin was one of the leading figures in the arts scene in the first half of the twentieth century – he was director of the National Gallery of Ireland from 1927 to 1935 and was a long-time adviser to Taoiseach John A. Costello. He was commissioned by Costello to write the report and one of his recommendations was the establishment of a body that would be empowered to 'plan and execute schemes for the promotion and application of the arts'. The resulting arts legislation (the first Arts Act; of 1951) included provisions for setting up the Arts Council.

VR: *Patrick Little, too, seems to have tried to persuade politicians to create an Arts Council – Patrick Little who in fact became the first director of the Arts Council in 1951. When did you begin to be committed to contemporary art?*

PJM: It was after buying a Patrick Pye *Crucifixion* at auction. I

couldn't understand why I liked it so much. At £22, I'd paid double the estimate. It began to dawn on me that modern art was for me. I read more and more on it.

VR: Did you know many artists then?

PJM: I knew Seán McSweeney from the early 1960s before he got married and before I got married.

His first exhibition at the Dawson Gallery was a big success. I think it was Nicholas Robinson's father Howard who was reported to have bought nineteen. He thought Seán was the next Jack Yeats. Seán's career faltered after that, but he took up again thankfully. Now he enjoys the high reputation he rightly deserves. He had some very difficult years, living in a two bedroom cottage in Wicklow with five children and little income. I only knew Seán well in the early 1960s. I did buy a strange abstract painting by little John Kelly. I knew Desmond Carrick, who was in Guinness's. I knew Tom Ryan socially. I met Brian Bourke in the early 1960s but didn't get to know him well until later. I met him at a Fleadh Ceoil in Wexford, the same day I met my wife. I commissioned him in 1982 to do a portrait of Antoinette. He did seven!

Later in the 1960s I got to know Mary Swanzy and W.J. Leech in London.

VR: Where did you meet Leech?

PJM: In 1968 Guinness sent me to London to be a planning brewer. I was the first of my kind to go abroad. I mean Irish, Catholic. I got promoted to being a planning brewer. I couldn't be a planning brewer in Dublin because of the Oxford, Cambridge tradition of exclusivity there. It was all right in London. Guinness and Jacobs too, where Gordon was, had a reputation for exclusivity then.

In London I was in and out of Sotheby's and Christie's, still looking at nineteenth-century Irish art.

Before that I went into old Gorry in Dublin and bought a Patrick Tuohy. I catalogued his work and wrote it up in my hotel bedroom in London in 1968. After nine months I brought the

family over and we visited every great house we could, and all the galleries, at the weekends.

I was preparing to go to Kuala Lumpur, as a stout brewer, eventually becoming brewing manager. In Malaysia I organised my first exhibition of Irish art. I became vice president of the St Patrick's Society of Selangor there. There were about 300 Irish people, mostly rubber planters and tin miners living there. There was a convention that Northerners and Southerners would alternate as presidents and vice presidents of the society. They said 'What will we do for St Patrick's Day?' I said I'd organise an exhibition of Irish art from Ireland. They usually had a ball. The exhibition was in Galerie Eleven in Kuala Lumpur.

I wrote to the Arts Council asking for help. They sent out unframed prints, the complete set of *The Táin* by Louis le Brocquy and etchings by Patrick Hickey. I framed them out there. I got David Hendriks to send me out oils by Colin Middleton, Cecil King and Barrie Cooke.

I got the Dawson to send me Seán McSweenys and a few other things. The remainder I borrowed from private collections. I invited Mary Swanzy to send me a drawing. We were great friends, we corresponded. She sent me seven and four oils. She wrote 'no commercial value' on the outside of the parcel! The exhibition was a success. The National Gallery of Malaysia bought a Louis le Brocquy print, a Pat Hickey print, and a Mary Swanzy oil.

The Malaysian people I was working with printed the catalogue and printed Louis's bull green on white rather than black on white on account of St Patrick's Day. I wanted a Leech in the exhibition. One of my friends out there had one but he wouldn't lend it because he said his aunt had given it to him and he was worried that something might befall it. But they were all insured. Guinness sponsored the exhibition.

VR: *You got to know Leech in London?*
PJM: I had written to him in 1967, admiring a still life in the RHA annual exhibition. He wrote me a few letters and I had dinner

with him three or four times in 1968 when living in London. He lived in West Clandon in Surrey then. Dinner was sherry and a little fish. I was a young man, a rugby player and a runner, and I was ravenous after those dinners. So I'd get fish and chips afterwards in Clandon village before I took the train back to London.

I remember at Park Royal some of the men said to me 'Pat, you know about art, what should we buy?' I arranged an outing to Surrey to see Leech. I arranged a car and we had a meal and drinks on the way down. That was March or April of 1968. There were about 300 works in the studio. They were priced between £20 and £200 each. The average price was £20 to £40. The one of his wife on the chaise longue, smoking, now in the Hugh Lane, was there, so was the *Big Aloes*, now in the Ulster Museum. My London Guinness people ended up buying nothing. They couldn't make up their minds. I was so embarrassed. As we were going out I said to Leech, 'How much is that nude there? I'll have it'. He said 'It's £90 but £60 to you, Pat'. It was also of his wife, his second wife. The RHA had refused to exhibit it. 'What will you do with it?' 'I'll hang it in the drawing room,' I said. 'What will your mother-in-law say?' he asked. That's the Leech *Nude* that's now on loan in the National Gallery of Ireland.

Only the brave deserve art. Buy it now, I say, not in the future. You should always stretch yourself.

VR: *And Leech died that summer. When did you get involved with Rosc?*

PJM: One day, after we'd come back to Ireland, I met Michael Scott. 'Hello Tom,' he said. 'I want you on my *Rosc* committee.' It's pronounced Rusk and it means vision or eye, it was used in Gaelic poetry. 'Rosc Catha na Mumhan' was the battle song of Munster, so it's a form of expression. Michael Scott used to talk about 'that wonderful four letter word'. That was about 1975.

I remember going to the first *Rosc* in 1967, at the Royal Dublin Society. I realised that contemporary art was what I was moving instinctively towards. I remember an incredible Bacon.

I was so proud he was born in Dublin. The first *Rosc* was very interesting for the jury, it was the easiest, they had the whole world to choose from. Nothing of its kind had been seen in Ireland before.

VR: *Not even in* Living Art*?*

PJM: *Living Art* had shown some Picassos and so on, but not major works on a major scale. The Picasso nude was incredible. I remembered Tom Ryan saying to me, 'That charlatan Picasso'. After seeing the three Picassos at *Rosc '67* I decided he was not a charlatan. Britain never had anything as important as *Rosc*. I reckon it was as good as *Documenta* or the *Venice Biennale*. Maybe more interesting in some ways; it was smaller and more focused. The concept of the old and the new was unique at the time. Major works of contemporary art were brought to Ireland and shown in conjunction with high crosses, carved heads and treasures from the National Museum. It was an opportunity for the Irish public and the international public to see Irish and international art side by side. It gave Irish people a new pride in the ancient art of Ireland, and showed that if it had the power to move the spirit, art could be made yesterday or 1,000 years ago.

The juxtaposition of the old and the new threw up a lot of prejudice. There was talk of *Rosc* and rubbish. Seán Keating did famous interviews with Colm Ó Briain. He was a fine traditional artist, a lovely old man. I met him afterwards. He was bewildered by *Rosc*. Irish artists didn't travel much in the 1960s. Only the privileged few had the opportunity to go to New York, London, Venice, Paris. Bringing modern art in was very important for artists and for the public.

Michael Scott and James Johnson Sweeney, an American curator/director of Irish ancestry developed the idea. Michael Scott was an amazing personality. He was an actor with the Abbey, played rugby for Lansdowne, as an architect he built up the practice of Scott Tallon Walker; he was a womaniser and a lover of the arts, a passionate optimistic lover of the arts. He even drew a little bit himself, spidery landscapes which he

showed occasionally at the Dawson. Cecil King and Dorothy Walker were active from the beginning. Cecil was vice chairman for many years.

Cecil was a businessman of great charm and lively intellect who absolutely loved the arts. He came from Rathdrum in County Wicklow, a Protestant; he initially trained as a printer, and started in the course of business collecting art, and painting himself. He started out painting in a figurative manner, little pastels of the circus. He loved the circus. Later, he graduated to linear abstraction. He was particularly admiring of early *Rosc* artists like Barnett Newman. He bought some marvellous pictures, for instance from Paddy Collins he bought *Moorland Water*, now in the Bank of Ireland collection. It was in the *Artists' Century* exhibition. Cecil sold it to the Bank when he was hard up. He was passionate and enthusiastic about *Rosc*, an indefatigable worker on the committee.

The first *Rosc* was huge money. They had to get a big sponsor. Dr Tim O'Driscoll was on the committee, he was Director General of Bord Fáilte, a big personality in Irish cultural life, a friend of Michael Scott's, very useful for making contacts.

VR: *They were to happen every four years.*

PJM: Yes. 1971 was the next *Rosc*. I missed it completely. I'd gone to Africa from Malaysia. We were building a new Brewery in Kumasi, Ghana and I had to supervise it. I had to hire 360 African workers in a week. I did it. I had two tests; I'd put a clock on the wall at ten to one, and I printed a sentence in English on the wall. If they could read both, they qualified for employment. One of the chaps had worked for Heineken, a rival brewery. He was a great catch. In the one-minute interview I asked him what he had done with Heineken. 'Please sir,' he said, 'I cleaned the toilets.' He was very good and learned the process quickly. Within a year he was a brewhouse foreman. I had a team of six brewers with me, trained people from Britain and Ireland, but I couldn't leave. I was general manager and head brewer at the same time. I personally did the first six brews and

sent samples back to James's Gate for analysis and approval or otherwise. It was High Gravity Foreign Extra Stout, with an alcohol content of over 8% by volume. Kumasi was where we were brewing, it means city of blood. It was inland in Ghana, in the Ashanti region.

Dublin said the product was first rate. We were delighted. I got a treble increment after that. Someone sent me out the *Rosc* '71 catalogue. Incredible. Maybe more avant garde than '67. Sixty-seven had scooped up the giants. They chose slightly younger artists and it was more abstract in 1971.

VR: *You were back for the next* Rosc?

PJM: I came back to Ireland in 1973. While in Africa the Maltsters of Ireland had head hunted me and offered me the job of MD. I accepted for two reasons. I loved travel and I loved exporting. I thought it was patriotic to export. I eventually exported malt to 33 countries. Guinness tried to persuade me not to resign but with the Maltsters I was in charge of my own operation, not a cog in a big wheel in James's Gate.

We had three children at that stage, aged eight, six and one. Our fourth child, a son, was born subsequently. There was schooling to consider. Michael Scott knew I was collecting art, so – 'Tom will you join my *Rosc* committee?' (He was confusing me with the playwright Tom Murphy). Initially I was kept away from the art end by the oldies. I was only on the finance sub-committee. We raised some money, it was difficult with all the *Rosc*-and-rubbish publicity. It was impossible to get a major sponsor for 1977. It should have taken place in 1975, but lack of finance was the reason it was delayed. We went ahead in 1977 at the Hugh Lane Gallery, a smaller venue, and confined it to European artists only. Cecil was great friends with Ethna Waldron, the curator, so we secured the space. It was a good *Rosc*. The chairman was Ronald Alley, whom Michael Scott referred to jocosely as Blind Alley.

I was mainstream after that, on the main *Rosc* committee. Gordon was also on it. We had the next *Rosc* in 1980, the

fourth. Money was a huge problem. Gordon was all on for cancelling it but Dorothy badly wanted it. The AICA – the association of international art critics – conference was to be held in Dublin in 1980 and she wanted the exhibition to be on too. She was up for the presidency of AICA. We had to make extreme efforts to get sponsorship, we squeezed everyone to make it happen. Dorothy attended a dinner in 1979 with Michael Scott and they persuaded Tony Ryan, after many bottles of wine and vigorous dancing, to donate £50,000 for *Rosc '80*. It was the difference, it made it possible.

We had to get a new venue each time. Dublin did not have a single suitable venue. The RDS charged a lot.

The jury for 1980 was a change. The Irish members were beginning to assert themselves. Dorothy was chair of the jury. She resigned in the middle of the exhibition. I felt the committee should see through the exhibition, which entailed a lot of work post the exhibition. I recommended to Michael Scott that he should not accept her resignation. 1980 was judged by some not to be so good. There were mixed reactions. The Irish jury had been advised by an international advisory panel, it was the whole world again.

We had Koji Enokura. I had bought some small pieces by him in Japan. His paintings reminded me of Patrick Scott's works, but he used lead and engine oil on cotton duck. I persuaded the committee to include him in *Rosc '80*. He came and stayed with us – the committee always put up artists at their own expense. We drove them around and helped them. Cecil mounted the 1980 exhibition. It was in Earlsfort Terrace, before it became the National Concert Hall. The Contemporary Irish Art Society presented Enokura's large painting at *Rosc '80* to the Crawford Gallery in Cork. They kept it for a time and then returned it on the grounds that they were collecting Irish art only. We immediately offered it to the Ulster Museum, where it now is. It was paid for by Illa Kodicek, who came from London with the English Contemporary Art Society to see *Rosc*. She had a

wonderful private collection, some of which she bequeathed to the Tate. She told me her Picasso, Bacon and Braque were to go there. She had Bonnards, Matisses, Moores, Kleins and so on. I introduced her to Homan Potterton, then director of the National Gallery after James White. We arranged a dinner party in London. Nothing happened. She died a few years later and her collection was auctioned, with proceeds going to a Jewish charity.

In 1980, the old section was the Dr Sackler Collection of Chinese Art. It was exhibited in the National Gallery. Brian Lenihan was Minister for Foreign Affairs and Sackler wanted an honorary doctorate for lending his collection. Michael Scott had access to Lenihan who presented a gold medal to him instead, at a small VIP dinner in Ivy House with the *Rosc* committee present. It seemed to keep Sackler reasonably happy.

Shortly after *Rosc '80* Michael Scott invited me to lunch, and said, 'We want you to take over as chair'. He thought I had youth and energy. He thought, God bless him, that I had good taste and might improve the quality of the exhibition. I said I would only take it on if I could appoint some new people to the committee, who would be a bit younger and do some work. I appointed the architect Peter Doyle, Noel Sheridan of the NCAD, banker Noel Wallace, Rosemarie Mulcahy, Mike Murphy of RTÉ, Vincent Ferguson, the collector, and Brian Ferran and Ted Hickey from Belfast.

Irish artists were complaining that Irish artists were overlooked for selection in *Rosc*s. Two had been included in 1977 – James Coleman and Patrick Ireland.

VR: *There were seven in* Rosc '80.

PJM: *Rosc '80* had Robert Ballagh, Michael Craig-Martin, Brian King, Louis le Brocquy, Nigel Rolfe, Patrick Scott and William Scott among the 50 chosen living artists.

Louis (le Brocquy) had written to Michael Scott complaining. Michael Kane and I fell out but we made it up later. He wanted 22 Irish artists from the *Independent Artists* group to be in. I thought 22 Irish artists too many, but 22 from the *Independent*

Artists was simply out of the question.

The first thing I had to do was clear the deficit of £30,000, which I did. Dorothy objected on procedural grounds to my chairmanship. Michael had appointed me without consultation with the old committee. Her objections were overruled. We got on with it and started to plan *Rosc '84,* the fifth *Rosc.*

I was appointed to the Cultural Relations Committee and the Arts Council around that time. I became very involved on a number of fronts. That helped.

My new committee members were all fired up. I discovered that Guinness, my old employers that I still had friendly relations with, had a premises for disposal. Gerald Davis had rung up one day to say he'd heard there was an old building off Thomas Street that might suit.

It was the old hop store. I'd worked there. It was a beautiful old building. They were going to knock it down, someone said. I contacted the board of Guinness Dublin, got an invitation to lunch for Mike Murphy and myself and asked them for a building for *Rosc.* Mike Murphy was my secret weapon. They offered a vat house but we asked for the hop store which was an even better space. I hoped it would become a permanent national exhibition space. Mike's personality and charm wooed the Guinness directors. So instead of knocking down the hop store we got it for *Rosc '84.* Tony O'Reilly gave us £40,000 for the catalogue, which Rosemarie did. We went to see Ted Nealon and Garret FitzGerald. They gave us some money and got us some EU funds to restore the Guinness Hop Store. I had Peter Doyle doing the designs, but he got shouldered off by Guinness who had special contacts with Ronnie Tallon. I was disappointed for Peter who had done lovely designs but I knew Ronnie would also do a good job. Guinness owned the Hop Store. All they could guarantee was accommodation for two *Rosc*s – '84 and '88.

For the '84 Jury I said 'Let's have a collectors' jury'. We had had two or three international juries from curators and critics,

and we'd had the mixed Irish jury. The collectors we had were Count Panza di Biumo, I got him from Leslie Waddington, who told me he was the foremost collector of avant garde art in Europe. I was chair of the jury. The third jury member was Frits Becht of Holland, a millionaire businessman in market research and a passionate collector of modern art. I went and visited them and saw their splendid collections. We proceeded to select.

We decided to stay with the traditional number of 50 artists and with the old exhibition in parallel.

Money was still a problem. We'd got sponsorship from everyone: Aer Lingus, Guinness, the Arts Council and we'd got benefit in kind, with the Maltsters providing the office, fax and phones. I combined business travel with selection for *Rosc* to keep costs down. Noel Wallace and Vincent Ferguson were a great help on the committee.

However, at the end of the selection, Count Panza said, '50 is too many. There are only 33 outstanding living artists and I think we should confine it to that'.

I suggested adding ten Irish artists. Panza agreed but Becht disagreed, saying that Ireland had no tradition in visual arts. He resigned. We proceeded.

VR: *Exciting times.*

PJM: I had brought Panza and Becht to see various collections and visit studios in Ireland. It was a mixed success.

We decided to put the Irish selection out to another juror. We offered it to Declan McGonagle, who was then the young leaping tiger of Irish art, in charge of the Orchard Gallery in Derry. He turned it down, to my great disappointment. We then invited Ronnie Tallon to do it. He did it well.

He chose Anne (Madden) and Cecil (King) and Felim Egan and Deborah Brown, and John Aiken and Tom Fitzgerald and Eilís O'Connell and Michael Warren and Barrie Cooke and Sean Scully.

We had some really good examples, not just good artists, in '84. There was Bill Woodrow's *Elephant,* Schnabel's *Matador*

on a Stick, Long's *Mud Hand Circles* and *Dublin Line.* Chia had a number of pieces. We had Kiefer, the first time he'd shown in Ireland. Kiefer was asking me to look for a house for him in the west of Ireland at that stage.

I remember Richard Long and his wife coming to dinner in our house and Richard bringing a little bag of stones with him. 'A sculpture for Patrick Murphy,' he said.

Cecil and I drove out to the Dublin mountains and bought a load of hand-cut turf, as specified by Carl Andre. We made sure it was cut with the sláin. He made a wonderful installation from it in the lift shaft of the Hop Store. Afterwards I burnt the turf at home. It felt sacrilegious.

I decided that the restored Hop Store was the ancient section for that year. But I also took up an offer of 150 water-colours and drawings by Joseph Beuys. I selected 80 of the finest of them and they were shown in the visitors' section of the Guinness Hop Store. Guinness sponsored it.

VR: *You chaired the sixth and last* Rosc *too.*

PJM: By the time 1988 came Guinness had commandeered the ground floor of the Hop Store for a museum of brewing. So we went to the Royal Hospital as well as the Hop Store. I remember Ted Nealon saying, after *Rosc '88*, 'What am I to do with this restored building?' – meaning the Royal Hospital. I said 'Fill it with pictures'. *Rosc '88* was thus the forerunner of IMMA.

For *Rosc '88* we picked museum curators again. Gordon recommended Kynaston McShine from MOMA in New York and I came across Olle Graneth, director of the Museet Moderna in Stockholm. I chaired. Michael Scott sat in sometimes.

Every year I used to feature an Irish artist on the Maltsters Christmas card. I featured a Tony O'Malley bird lake painting and Kynaston who came from Trinidad and loved birds said 'I really like that painting'. Tony was in. I went over to St Ives to select him in 1987, Basil Blackshaw, Brian Bourke and Kathy Prendergast were also in *Rosc '88*.

When Kynaston came to Dublin I remember him asking to

go to Camille Souter's studio. But Camille didn't show work in progress and would not admit him to her studio. They felt they had to see work in progress, and so she wasn't included. Kynaston had seen my *Slaughtered Cow Twenty Minutes Dead* (1977) by Camille and thought it was first rate. Other Irish artists included that year were Mary FitzGerald, James Coleman and Francis Tansey.

For the parallel show we had George Costakis's collection of avant garde Russian art. He was living in Greece and I contacted him there and his curator in New York.

I managed to persuade him to let me select from the 150 works he was allowed to take out of Russia. He agreed to more or less everything I chose, so we got 122 masterpieces by the Russian Suprematists. John Meagher of the architectural firm de Blacam and Meagher hung the contemporary exhibition in both venues, while Costakis's curator, Angelica Rudenstine hung the Russian works in the RHK with the assistance of Ruairí Ó Cuív. In *Rosc '88* we had *Tim Rollins and The Kids of Survival.*

VR: The Kids of Survival – *the American community art project?*

PJM: Yes. I went to visit them in the Bronx. The taxi man said it was dangerous and wouldn't wait. I went into the school. Tim was lovely and the kids were great. I chose two pieces and Tim said they'd make a third. He suggested featuring someone perhaps who had done a lot for the arts in Ireland. I said 'our present Taoiseach has'. That was C.J. Haughey, so I got C.J.'s office to send over photos. When I escorted him around the exhibition afterwards I had a suspicion that he didn't like being portrayed as a hybrid. Rollins and the kids were doing an animal farm series at the time, portraying people as geese and ducks and so on. The kids chose a wolfhound's body for C.J.'s. I think they knew wolfhounds from St Patrick's Day parades in New York. As a noble animal, it was meant to be a noble tribute. I had told them what he had done for Irish artists.

After *Rosc '88* the usual deficit of around £30,000 wasn't being cleared. In 1989 we got an unsatisfactory response from

the Arts Council. We held an art auction. The committee almost all donated something. I gave four items, including a gorgeous Mary Swanzy oil, which sold well, and which I miss to this day. Several artists contributed.

We also held an exhibition of Henry Moore graphics, 36 prints, at the Bank of Ireland. I'd known Henry in the 1980s. The proceeds of the exhibition and the auction cleared the deficit.

We were moaning back in the 1970s and 1980s that there was no home for *Rosc*. The Irish Museum of Modern Art opened soon afterwards and some people said there was no need for *Rosc* now that it was there. So we never had another, sadly.

Interviewed on 2 and 4 April 2002.

1. RHA *Artists' Century, Irish Self Portraits and Selected Works, 1900-2000,* Oysterhaven, Gandon Editions, 2000.
2. Máirtín McCullough was chairman from 1984 to 1988.
3. Professor Colm O hEocha was chairman from 1988 to 1993.
4. Adrian Munnelly was director from 1983 to 1996.
5. Professor Ciarán Benson was chairman from 1993 to 1998.
6. Professor Brian Farrell was chairman from 1998-2000.
7. Patricia Quinn became the director of the Arts Council in 1996.
8. OPW, *From Past to Present: Art from Public Buildings 1815-2001,* Dublin, 2001 Touring Exhibition.
9. 'My father, Basil Goulding (1908-1982) chairman of Goulding Fertilizers, was a champion of contemporary art. His collection was my school room, his pithy enquiries my lectures. "It is not the idiom that counts", he used to say, "it is the perfomance within one". Tim Goulding, in conversation with the author, July 2003.
10. Hugh Lane Gallery, *Patrick Scott, A Retrospective,* Dublin 2002.
11. Bodkin, T., *Four Irish Landscape Painters,* Dublin, 1920, new edition, with introduction by Julian Campbell, Dublin, IAP 1987.

Professor Anne Crookshank, director, Castletown Foundation, and Professor Kevin Nowlan, foundation chairman, at a reception in the Bank of Ireland Headquarters, May 1984 © The Irish Times.

Anne Crookshank

Anne Crookshank was born near Belfast in 1927. She was educated privately and at convent schools, and took a degree in History in Trinity College Dublin. She did postgraduate work at the Courtauld Institute of Art, London. She was the Keeper of Art in the Ulster Museum and a member of the Northern Ireland Arts Council. She started the Art History Department in Trinity College and was the first Professor of Art History there. She and the Knight of Glin have collaborated on several major publications on Irish art.

VR: *What a lovely research room. It's the full depth of the Rubrics here in Trinity.*

AC: These are seventeenth-century rooms. The six windows, three on either side, are very nice. I think there is only one other surviving room that hasn't been divided up. The top of the building was greatly altered in the nineteenth century.

VR: *You set up the art history degree here in Trinity, in the 1960s.*

AC: In 1966. There had been a trial run before that, starting in 1964, funded I think by the Gulbenkian. George Dawson got it going. I used to come down from Belfast, giving a couple of lectures a week. Others did that for two years also. It was an immense success. I came down to run it in 1966 and gradually appointed staff and bought things like slides, which people never realise are necessary. To start with, it was part of a general studies degree. People did art history for two years with other subjects. It became an honours degree a few years later. It's still part of a two-subject honours degree. There are very few single honour degrees in the arts; history and english being obvious examples.

VR: *UCD was starting art history around that time too. Did you know Françoise Henry, who set it up?*

AC: Yes. I knew her. She set up in UCD at almost the same time. She was jealous of the position of UCD. She always worked there and wanted to be certain that it was *the* university. She wanted art history to start there.

She was personally friendly to me. She'd known my family. I had done the diploma under her, going to the lectures she ran in UCD. There were no art history lectures in TCD when I was a student in 1947. But in the end she hated the fact that TCD had an art history degree. She ended up by not speaking to me!

VR: *I see your dedication to your great-grand-aunt Margaret Stokes in* The Watercolours of Ireland.[1] *Dr Henry would have admired your genetic link with this great Irish family.*

AC: Françoise was in Ireland right through the 1930s. She had plenty of time to get to know my family, who were quite eminent. They were professionals, mostly doctors and lawyers, people like

the Jelletts and the Stokes. Mainie Jellett was my first cousin once removed. My father was the second son of a large family, there were seven or eight of them. Mainie Jellett was one of the daughters of my granny's younger sister. There was a considerable age difference between my father and his cousin Mainie Jellett. She would have been closer to me in age than to him. That's the way those Victorian, Edwardian families went. Those heroic women producing child after child.

My mother's family came from west Cork. My parents lived in India. My father was a geologist. My grandmother, my mother's family, brought me up. Her name before her marriage was Miss Somerville Townshend. I'd be a very, very distant cousin of the present Townshends. We'd go back to the seventeenth century for close cousins. My father's family came to Ireland in the first half of the seventeenth century, to the North of Ireland. I was born outside Belfast, in Whiteabbey, it's Newtownabbey now. It joined with Whitehouse to share a Church of Ireland church. When my parents returned to India after leave when I was five, we were left to be brought up by our grannies, one near Belfast, one in London. Both grannies loved us very much. So it was not the usual miserable childhood of the Indian child.

We always stayed with Granny, née Stokes, at Easter. We decorated the church on Easter Saturday. We went to the remains of a garden whose house, 'Moneyglass', had been ruined, to pick flowers on Good Friday. The garden had vast quantities of daffodils and on Saturday morning we decorated the church for Easter with them.

On one dreadful occasion someone gave us red and white flowers – innocent children that we were, we put them on the altar. I remember the rector being furious, and my granny being furious too. She fought the clergyman, who saw the flowers as papist. She thought it outrageous that her grandchildren would be accused of being papist. The flowers remained. We were not a bigoted family.

The first Mass I attended I went to with Granny. It was her

With her ayah behind her, Anne Crookshank pets the baby hyena on her mother's lap. Her sister Elizabeth stands beside their mother. India, early 1930s.

cook's wedding. She told us it wasn't going to be quite the same – our eyes were out on stalks. We thought it was fun.

We'd been to India and knew all sorts of religions. We had governesses until I was eight, when we were sent to an Anglican convent school in London. At the beginning of the war we were sent to their convent in Hastings for safety. I had whooping cough at the time the Germans marched into France – all schools at the south coast had to be evacuated. It was a government ruling. I was wrapped in a blanket and put in a train back to London.

There was a fair period when we didn't go to school. My mother who was visiting us was trying to get us to India to rejoin my father. So we went to Carlisle, halfway between Liverpool and Glasgow. We were all set to get the boat. You'd get 24 hours notice and all the boats went from these ports. Unfortunately virtually all our clothes were burnt in Thomas Cook's where they

were being stored, and the next thing was that the Japanese came into the war, and we could not go to India.

VR: *So you stayed in Carlisle?*

AC: Mummy decided we'd stay in Carlisle. She wouldn't go back to Ireland. She would have had to stay with her in-laws in Tipperary. She didn't get on with them. We were with *her* cousins in Carlisle. There was a question, just maybe, that school would be a good idea again. There were only two schools in Carlisle which were considered appropriate. All considerations were social, I may say.

She was in favour of the Catholic convent school. The nuns there were admirable. They didn't mind a bit about the fact that I was a Protestant, and were pleased when I put up my hand and said 'in my Bible, that's different' and we had a great discussion. The school was dedicated to the Sacred Heart of Mary, you couldn't make it sound Protestant if you tried.

VR: *Did you plan to make a living?*

AC: We weren't monied, we lived on salaries. We were professional people. We were bright and it never occurred to any of us that we wouldn't do well eventually. I was brought up to be a lady and do nothing. I was the first member of my family who through and through from start to finish earned her living. Now my Aunt Harriet worked hard, but she worked for nothing for a missionary society, quite a different thing.

There would have been a bit of money in the past but never much. The member of the family who came from Edinburgh in the seventeenth century, Master John Crookshank, had been to university. He became a Presbyterian minister. We gave up religion pretty early, it was quite useless being a Presbyterian, there was no chance of preferment. The Presbyterians were hounded in the seventeenth century but things got better quicker for them than for Catholics. The Acts were aimed at the Catholics but they caught the Presbyterians too. We were Church of Ireland by the time the Siege of Derry arrived. We weren't the stuff of martyrs. Our interest in religion was clearly modest, but

we were devout enough.

In Granny's family, my father's mother's, one member was a United Irishman, Dr Gabriel Stokes, though he stopped being one by 1798 because he didn't believe in bloodshed. And quite right he was. Wolfe Tone is said to have remarked that he would have made a good minister for education.

VR: Your father had been to Trinity.

AC: Yes. My father had fought in the 14/18 war and finished his degree afterwards. He was in India in the Second World War and joined the army again to help release young men to go and fight the Japanese. He was posted to the North-West frontier, tribal territory which is really not ruled by anyone but the native tribes. He was there in an outpost of the British army when he was badly wounded. It was very trying for my mother, for after she received the telegram to say he was wounded, it was another six months before she heard again. He had a first-class Indian doctor and had the highest opinion of Indian medicine. He recovered because he was determined to. He was building landing strips for aeroplanes, planes that had been hit by the Japanese or run out of fuel, when he was on crutches. He was an engineer as well as a geologist. When he was in Trinity before and after the 1914-1918 war he studied engineering, which included geology.

VR: Like art history, geology was a subject which gained its independence late. When you came South to start up art history in TCD, how did you like Dublin?

AC: I found Dublin a very stuffy sort of place. I like Belfast better than Dublin. If I didn't have more cousins than I could count I wouldn't be here. In Belfast there were dozens of people who invited you and loved to get to know you. The ordinary people, the townspeople, who would be having a meal at six and another at ten, were very friendly, though I found it difficult to cope with the food!

I left Belfast in 1966. Then I think Dublin was as divided between Catholic and Protestant as Belfast. I would say that

Protestants in Dublin remained a fairly isolated little group.

I remember putting up an exhibition of modern church interiors in the Museum in Belfast. The Catholics were saying they couldn't get anywhere because they were Catholics. I said 'stop being so silly; it's because you don't push hard enough'. In the early 1960s you could and did say anything.

VR: *Anything?*

AC: I will admit there was an occasion when I was really hurt by a Catholic. In the (Ulster) Museum there was a young man who had a girlfriend in the Irish Department of Queen's. They were Catholics. 'Let's go to Donegal some weekend', I said. In those days you didn't share a bedroom with your fiancé so I shared with the girl. He had a room of his own.

I drove them, and as I was dropping her home, I asked her what number on the street she lived at. She said she wouldn't like her mother to know she'd spent a weekend with a Protestant and wouldn't let me drop her to the door. I was furious. I thought it was silly. It was preposterous. How could her mother know I was a Protestant – I'd be in the car. After all, I'd spent a weekend with two of them and driven them to Mass.

VR: *If you'd got out of the car would your religious denomination be evident?*

AC: You'd know I was a Protestant by my clothes.

VR: *Your clothes?*

AC: In Belfast people would be wearing say, a coat, a green coat and they'd have a green bag and green shoes and a green hat. Catholics tended to wear rather gay bright clothes. It was softer colours for Protestants. I wasn't the only one with the problem. I remember Mary Boydell wanting to go and visit a convent which had some fine glass, which she was studying, and her friend, a Catholic, was encouraging her, and suggested at one stage that no one would know she was a Protestant, in case that helped. Mary insisted they would know by her clothes and quite right she was. But nuns love Protestants, they don't mind a bit.

VR: *I would have thought accent would be the giveaway.*

AC: No, of course not, lots of Catholics speak English perfectly, better than many Protestants.

VR: *You were chairperson of the Northern Ireland Arts Committee of the Arts Council at one stage.*

AC: After I was down to Dublin I was still on the Arts Council. At the beginning of the Troubles I was chairman of the Arts Committee. There were so many hoaxes. The number of times we walked down those stairs in that big modern building in Bedford Street! People had come from all over the place. So we'd have the meeting on the grass behind City Hall until the police told us we might return.

VR: *Was your long involvement in the Northern Ireland Arts Council related to your work as keeper of art at the Ulster Museum? It stretched over something like seventeen years.*

AC: The keeper of art at the Ulster Museum was nearly always at Arts Council meetings. You'd have to work closely because money was so tight. Then later I became a proper member of the Arts Council.

It was very different to nowadays. We believed in proper pictures and proper music. Nowadays it seems to me they've gone to the dogs in going down to the level of the people rather than bringing the people up. I always fought against amateur groups getting money. For the most part I see community artists as amateur artists.

VR: *You'd worked in London before returning to Belfast.*

AC: I had worked in the Tate. I was therefore familiar with the idea of seeing the art of other countries. Ireland didn't have exhibitions of foreign artists. Universal travel had not started in the 1950s. *Living Art* exhibitions had included some European artists, but I thought we should have them in our collection in Belfast, our permanent collection, for teaching. As we have them in the National Gallery here.

VR: *It's often said that you bought outstandingly for the Ulster Museum.*

AC: I did buy modern foreign art, as well as Irish modern art.

I failed, at first. I didn't have the hang of how to handle a committee. I saw a Pat Scott in the big exhibition in the Hugh Lane the other day, it was the back view of a girl, I had wanted it for the Ulster Museum. I was a fool to imagine that they would accept it. But I got the hang. Before we went to buy I went to each member of the committee with the life story of the artist, and photographs of the work, and explained to them why we had to have it. You have to inform them more than can be done at a committee meeting and it was worth while to butter them up.

I did buy a William Scott and behaved rather badly over that. I explained to the committee that he was representing Great Britain not Ireland in the *Biennale* and as he was an Enniskillen man we should have one. So they agreed I might buy. The painting I selected went on tour with the British Council for about two years. When they saw the painting I'd selected they had a seizure. One man called me the Whore of Babylon. I may say I just loved that. Of course I was shocked but I realised you can't take that sort of remark seriously. It was rather a high point in my career to be called a whore of Babylon.

VR: *Over a William Scott! Did you buy American art?*

AC: We couldn't afford a Jackson Pollock. I knew he was beyond our means, but we did buy Helen Frankenthaler and several others. We got a lot of good paintings. We bought a lot of European stuff, we bought Dubuffet, Tàpies, Appel. We were the only place in Ireland doing that.

The Ulster Museum was the most advanced in its purchases outside the Tate and the National Gallery of Scotland, in these islands. Ronald Alley was on the staff of the Tate so I knew him well and he kept an eye on things for me. We got together and made a list of artists we thought were representative of the time. When an exhibition came up he would write to me and say 'there are some good pictures'. I'd go and look but we had very little money. I wouldn't ever allow the commercial galleries to send an object to Belfast. I took the committee over

to London. I remember the first time I tried to get them to buy a Yeats, Estyn Evans, a really great geographer, said of the price 'that works out at so much a square inch!' and we didn't buy. So I felt it was important not to give them too much time to think. They were so exhausted by the time they visited some ten galleries in London in the day that they would say yes to anything!

We were the first gallery in Ireland to own and hang a Francis Bacon. We got one for £15. The Contemporary Arts Society in Britain had a committee which bought whatever they thought was good and these pictures were then donated to galleries who subscribed to them. We were mean old cats and only gave them £15 per annum. I thought we wouldn't get the Bacon because we subscribed so little. But we were given it. One of the Popes. It was staggering. I only put in for that. No one except the Scottish National Gallery wanted a Bacon. They were hugely worth more than that. You paid £15 for a dress, after all, a nice dress.

VR: *What was happening in Dublin in the mid 1960s?*

AC: The Hugh Lane had no money. They had a lot of pictures, they were all gifts. Very many of the early gifts were from grandees, not to mention Hugh Lane but also people like the then Prince of Wales. The National Gallery did extremely few exhibitions. The regular shows start with James White. Before he went to the National Gallery of Ireland he also did exhibitions in the Hugh Lane. He was a very pioneering person, but he didn't have much money. He did a big old masters exhibition in the Hugh Lane when he worked there. It should have been in the National Gallery. He could only start in a mild way with modern art when he was in the Hugh Lane. You couldn't do much in Dublin then – the committee had rejected a Henry Moore and a Rouault.[2]

In Belfast I had an exhibition of a noted Belgian collection. The paintings were slightly pornographic. 'The Presbyterians won't stand for it,' said the director. I said 'I'll tell you what we'll do, we won't let them talk to you; I'll tell the attendants to call

me if there are any complaints'. So I came down whenever there were complaints. 'I can't see what's the matter,' I said, 'could you explain it to me?' You should just have seen them, the shock of explaining a 'pornographic' picture to a nice young girl. Soon the dreaded news spread. They realised defeat and they accepted it. In order to make a breakthrough you have to do that sort of thing. There was nothing seriously improper. I aimed at exhibitions that were informative, not necessarily pleasing. But a bit of scandal is a help, it brings in the newspapers and people come when they read about it.

VR: *At a time when there was so little published on Irish art, keeping up with contemporary Irish art was much more field work than anything, wasn't it? You curated a Camille Souter exhibition in the Ulster Museum in 1965, sometimes seen as her breakthrough exhibition.*

AC: Dear Basil Goulding[3] had so many of her pictures one didn't have a great deal to do but I am delighted if it helped her. I'm very proud of having had the first Irish exhibition of William Scott (in 1963). Yes, you have to go and look at modern art all the time. I'm now very bad. I know it pretty thoroughly up to 1980. I then had a series of illnesses over a five-year period. I got out of going to exhibitions. Now I'm slightly at sea.

VR: *You'd written the catalogue entries for many of the* Rosc *catalogues.*

AC: *Rosc*, yes, immediately I got down here I had a visit from Michael Scott and Fr Donal O'Sullivan.[4] Fr Donal knew his stuff. He was very good on modern art, very good indeed. He was tremendous fun. I shall never forget when Oliver Plunkett was made a saint, we were both on the Stamp Committee. Fr Donal said to me, 'you won't really approve of this but we want to have the pieces of his body in England brought over here'. I didn't approve. I find St Oliver's head in Drogheda rather unpleasant. 'It's no use', Fr Donal said, 'we Catholics don't mind if it's a big toe on display'. He was quite witty. I thought the saint should be allowed to rest in peace. The head should not be on

Anne Crookshank,
The Ulster Museum, 1963.

show. It's incredibly small. They must have used the North-American technique for shrinking the skull.

VR: When did you start your major research into Irish art?

AC: Toward the end of my time in Belfast and very seriously once I came to Dublin. I decided we must know about Irish painting, older Irish painting. It was preposterous that we never knew what was on the walls. In 1969 the Knight and I decided to do the portraits exhibition.[5] I had tried to get people into the Ulster Museum to see Irish art. *Great Pictures of Ulster* was a wild success, I did *Great Irishmen* just before I came South, they were queuing to get in. I did enjoy hanging the twentieth-century ones. It was perfectly wicked, I put all the opposite sides beside one another. We had Cathal Brugha and Padraig Pearse and the Protestant opposition all mixed together. We didn't segregate them. We had Irish women too. The number of great Irish women in the past who had their portraits painted was very limited. Most of the famous women painted were high-class prostitutes. Lots of nice Irish women were painted but they didn't figure as great.

VR: *You had your own portrait commissioned by appreciative students and colleagues.*

AC: I've had three painted. I don't think two look like me. I think the third does, but it makes me look very cross. It's by an American artist called Larry Coulter and is in the Ulster Museum. They

wanted portraits of members of their staff and I said Larry was doing one of me and they came and looked at it. I didn't have to sit for Larry, who was at that time my next door neighbour. He took a million photos. I lent the jumper and the necklace. He does a very good job with the photos.

VR: *Was Derek Hill, also your neighbour in Donegal, commissioned to do one?*

AC: My colleagues in Trinity didn't like it. I think it's a nice picture but it doesn't in the least look like me. Very few painters can paint women, their likeness. Then I tried Lawrence Gowing. The Gowing is in Trinity. It's a pity young artists aren't taught to paint portraits. It's one of the few ways they're going to make some cash.

Some years ago I was writing a chapter in a book on Irish medicine, with Dr Eoin O'Brien and several other doctors. I was amazed to see that there were only three portraits of nurses, two in the Rotunda and one in Steevens, and that there wasn't a single female doctor's portrait in any hospital in the country, no official portrait had been commissioned. It shocked me. We'd been having women doctors since the beginning of the last century. And when you think of the quality of the Irish nurses you are forced into being a feminist.

VR: *Yes. Was your degree in history useful in researching Irish art?*

AC: I'd done a degree in history here in TCD, yes it was useful.

VR: *You were a scholar?*

AC: Yes. As a scholar I wasn't allowed to have scholars' dinner with the men. As a result I have never been on Commons and I will never go on Commons. We weren't even allowed to have lunch with the men. Meeting the opposite sex was clearly sinful in the eyes of the Board. Catholics who think that Protestants are liberal make a big mistake. There was I, brought up by governesses and two grannies, by Protestant nuns and by Catholic nuns, and I wasn't allowed to feed with the men. Much too dangerous. I may say I was quite as narrow as any Catholic at that time but the Board's attitude helped to cure me.

In Trinity Hall men would climb up the walls at night and come into the girls' rooms. It was just a joke. The unfortunate girl would find the boy at her door or window. We couldn't get them out until morning so the girl would appear at your door with a blanket to stay the night and give the man her room. We were frightfully proper. In Trinity Hall men were not allowed in the front door, though we did give a dance once a year, when they were.

After six, women couldn't go anywhere in TCD except the library. You had to sign in. You signed in at front gate and again in the library. There wasn't a loo for girls after six. You had to go to Jury's Hotel in Dame Street. You had to sign in at front gate again. That was all after the war, when there were plenty of girls in Trinity.

VR: You and the Knight of Glin have collaborated on Irish art for over 30 years.

AC: I knew the Knight in Belfast. He was a student at Harvard at that point, studying art history and architecture. We did the portraits. We hadn't a clue, it just wasn't known. We started from scratch. There had been nothing since Strickland[6] except *Four Irish Landscape Painters* by Thomas Bodkin. Our book *The Painters of Ireland*[7], set the excitement off. We are just publishing another book, *Ireland's Painters*,[8] which adds substantially to the first one.

VR: So you and the Knight got on with it.

AC: If it hadn't been for the Witt Library we couldn't have got on so fast.

VR: You had studied art history at post-graduate level in the Courtauld and actually worked in the Witt Library, in London.

AC: At that time, I could have gone to the Courtauld or to Edinburgh – that was that as far as art history was concerned. I didn't want to be on the periphery again. Dublin was on the periphery, and so was Edinburgh, with a very cold climate. So I went to the Courtauld.

VR: Do you think that art history in England was very enriched by

its open door policy towards European refugees, before, during and after the war? I mean without Warburg, Saxl, Wittkower, Pevsner, Panofsky or Gombrich where would European art history be?

AC: I was lectured by Wittkower, Blunt and Gombrich, not by Pevsner. Gombrich was a genius; such universal knowledge. His lectures were excellent.

VR: *Were you influenced by internationalists like Pevsner seeing merit in the local and documenting it, in your turning to Irish art?*

AC: They did look at minor people. And local. Anthony (Blunt) wrote some very good articles on Blake. Anthony I liked very much. The new biography[9] is I think very good, it's by a girl who didn't go to the Courtauld. The spying is put in place. It was a minor part of his life. Anthony was very helpful to students. Denis Mahon who did criticise Blunt was one of the few very great men who really knew enough to criticise him. The Courtauld was not a very happy place. There was a good deal of in-fighting.

VR: *Blunt's two volumes[10] on Poussin are still absolutely thrilling.*

AC: Yes. Art history has changed a lot but they remain accepted. I know people now feel Panofsky put too much value on symbolism, and not enough on social situations. But you have to give him credit as a great thinker and writer.

VR: *Certainly. Getting back to your research on Irish art, do you use X-ray?*

AC: We use photographs and our own eyes. We have a very serious archive, it has been given to TCD.

VR: *Given how many of your graduates have worked on Irish art, would you say TCD is perhaps the home of Irish art history studies?*

AC: It would be fair to say that, as even in the early Christian period Professor Roger Stalley is now the known expert. A lecturer on Irish art in UCD, Nicky Figgis, was a student of mine. We never pushed Irish art down their necks. It was only a special fourth year subject. I always think it's peripheral. The important thing is to know the main figures first. When you've done that you look at minor schools. You're doing it no good at all to say

it's other than that. It's no good to overpraise.

There are artists who should be in the English textbooks. Latham and Roberts should be in, and Ashford who, though born in England, was first president of the RHA and came here at eighteen and stayed for the rest of his long life. He isn't in the English books. Barry, Maclise, Orpen are in the books, they worked in England and are often thought to be English.

VR: *It's often where you practise that puts you in the books, isn't it? Camille Souter and Barrie Cooke and Martin Gale are in Irish art, though born in England.*

AC: Yes. We knew nothing about many of the artists until 25 years ago, so how could they be in the books?

VR: *After going through the photographic archive in the Witt Library in London what was your next research move?*

AC: Literature and archives and going and looking at pictures in private collections, all of which were more important than the Witt.

I remember spending three days sitting on the floor, reading *Burke's Landed Gentry of Ireland*, I think it was the 1912 one. You had to start with the people whom you knew would have commissioned Irish artists and you hoped they had taken their pictures with them when they went to England. A lot of them didn't reply to our letters, of course, but we found a great deal. A lot were in attics or back passages!

VR: *You had the Irish paintings in the National Gallery of Ireland to work on?*

AC: The Gallery had by accident collected Irish paintings. There are private collections which are better than the National Gallery's, though it has a very *numerous* Irish collection. They have the very fine Lucan paintings by Roberts, and the splendid James Barry self-portrait. But an awful lot is not the best. It has many minor works. It's poor on spending money on Irish artists. The stuff being bought now by private owners is being brought back to Ireland. One admires a lot of these modern collectors for what they are doing for Irish art.

When the houses of landowners were burnt, they managed

sometimes to get their things out, but they took them to England and they were sold without knowing the names of the painters. So for instance, we're in a bad hole about Irish racing pictures. They were sold at the times of the Troubles (1922) and earlier at the time of the Land Acts and they have got attached to English names. I'm convinced there were a number of Irish horse painters. Everybody got onto a horse in those days, the women and the men. We have one, two, works by a few horse painters. Quigley in the eighteenth century, James Henry Brocas, George Nairn and William Osborne, father of Walter in the nineteenth century. Roberts was considered a horse painter, but we haven't his horse paintings, we have his landscapes. For the most part artists didn't sign and there must be hundreds more horse paintings.

VR: *Who was your greatest rehabilitation?*

AC: There was this terribly good portrait in the Common Room in TCD. Strickland said it was by Latham. I thought it was excellent and that there must be more. It was the Berkeley portrait. Latham never signed. At that time it was the only known Latham. By the time I wrote my article there were 90 or so, and now there are about 120. But then!

Others got going. Andrew O'Connor in the National Gallery did a lot of work, partly through engravings. Knight thought his next door neighbour had one and we went down and looked at it. And it was one. Knight found a Latham in Australia – so many had gone out of Ireland, that was a major part of the problem.

When we had that exhibition on portraits (in 1969) a man wrote to Knight and said he had a picture in Edinburgh by 'Leatham' – the name was pasted on the back. I was going to Edinburgh anyway so I went to see it. He had a magnificent Latham. It was of Colonel de la Bouchetière, a French Huguenot. It went to the Ulster Museum. It's the only Latham we found, other than the six that were engraved, that had documentation. Latham was wiped out completely, totally unknown. Several of his works had been given to Hogarth, including the one of the first Duke of

Wellington's grandfather. In the most recent National Gallery of Ireland eighteenth-century catalogue a picture known for a long time as a Hogarth is now catalogued by Nicky Figgis and Brendan Rooney as a Latham, and we will find more.

I found quite a number of paintings in the Armagh Museum which had come from a great house. There was an Astley – he spent some years here and painted a large portrait group of the Molyneux family. It's now in the Ulster Museum. They were a major family, an intellectual family at the end of the seventeenth and the beginning of the eighteenth century. They founded the philosophical society and things like that. Sir Capel Molyneux's picture is I think dated 1740. It turned up in the Tate, under 'unidentified British school'. It was a gift – they had accepted it as a Hoare of Bath. They changed when they saw our files. It isn't in the least like a Hoare. It's by James Latham.

Ashford was perhaps slightly easier to find than Latham. The complete blank on Latham wasn't there, and he did sign.

VR: *Presumably there were still a large number of works in Irish people's homes?*

AC: It was Homan Potterton who happened to go to Stradbally House and said it was alive with Irish pictures, which it was, including six Lathams. That family were commissioning and collecting in a major way in the mid-eighteenth century.

We toured Ireland and I remember on one occasion we went to six houses in one day. Was I exhausted! We just kept going. Knight found something in a magazine while he was in a waiting room at a doctor's or a dentist's one day. It was a painting with the Boyne obelisk. He knew it would have been painted in Ireland. We went from Scotland to Dorset, in and out of houses finding pictures and we found that picture. It was with descendants of the daughter of General Ginkel, William III's general, notable at the siege of Athlone. We were greatly helped by this Irish thing of people knowing their ancestry. There was another case where Knight had seen a print, in Oxford, but he couldn't remember exactly where, and he knew

there was a painting if there was an engraving, and we found that too.

The thing about working in the Witt was that it wasn't immediately useful, you had to know a lot to use it. But the Witt increased my knowledge of Morphy. I remember finding a Morphy near Tintern Abbey, near Fethard on Sea, in Wexford. The family had sold the place. The descendant, an elderly woman, lived in a tiny house, a village street house. She was wearing a wrap around overall apron. The house was crammed full with marvellous inlaid Dutch chairs; everything was clearly great house furniture. She said the pictures were in the attic, so I went up. They had obviously brought over English pictures to begin with but finally I found a Morphy. He was the Catholic Irishman who painted Oliver Plunkett and a lot of Catholics. He was educated in London in a Catholic artist's studio. Jane Fenlon found all that out much later. In James II's reign the English army were opposed to the King, and Collins Baker in his (1912) book quoted a source which said that Morphy was beaten up by them in Yorkshire. A number of Yorkshire families still have Morphys. There were a lot of them in Malahide Castle. By 1690 he seems to have started painting Protestants.

VR: *So much Irish art left Ireland, over the years.*

AC: Just six weeks ago a drawing book, called the *Cries of Dublin* – scenes of everyday life – by Hugh Douglas Hamilton turned up in Australia. It was done in 1760, just after he'd left the Dublin Society Schools – Joe McDonnell tells us it has an English binding, so he probably took it to London and from there it went to Australia.

VR: *Artists did travel, especially to Italy around then, to train?*

AC: Hugh Howard was one of several Irish artists who went to Italy for training. His brother was a bishop and wrote to him asking for pictures, for furnishing purposes really. The Howard papers were used by Cynthia O'Connor in her work on Lord Charlemont.[11] Howard, when he was in Italy, worked as an agent for a number of people. English painters came over here too.

VR: *Is there much known about earlier seventeenth-century painting*

in Ireland?

AC: There are some deeply interesting paintings but we know very little. That picture of Máire Rua is perhaps done by a travelling painter or even a coach painter. She is wearing an Italian Renaissance brooch, it's very similar to one in the V&A. It's exquisite lace. It's Brussels, if I remember. One wonders did Rinucinni bring over her mermaid brooch. Máire Rua lived in west Clare and like the old English was hoping for the best under Charles I who had a Catholic wife. They hadn't lost all their lands by then.

Serious collecting really starts in the second half of the century. For instance the Duke of Ormonde had a very large collection. He was brought up under the aegis of the Archbishop of Canterbury. He and his wife were committed Protestants but all his relations were Catholics. His grandson was such a committed Protestant that when he became commander-in-chief in Spain and later retired to Avignon, he remained Protestant. Can you imagine – a Protestant leading the Spanish army? He was so grand that no one could do a damn thing about it. French society took to him like a duck to water.

There was some collecting during the Cromwellian era. The Percivals in Burton House in Cork, later Earls of Egmont, were buying. They were commissioning continental artists as well as Irish and mostly they employed the best. There's a letter from Smitz, a Dutch artist who worked at Hatfield, in which he's sending varnish and so on down to the Percivals. The letter shows they had Van Dycks. The Egmont papers are in the British Library. There is a marvellous letter from Bishop Berkeley to Percival in the early eighteenth century saying, 'I am sorry to hear ... that you have lost your statues ... coming from Italy; though on second thoughts I almost doubt whether it may be reckoned a loss ... The finest collection is not worth a groat where there is no one to admire and set a value on it'.[12]

VR: *There were, of course, very many notable collectors in eighteenth-century Ireland?*

AC: Yes, many. For instance, there's the Cobbe collection from Newbridge, exhibited[13] recently in London. It was bought for them in the eighteenth century by the rector of Donabate, Matthew Pilkington. He wrote the first dictionary of painters in the English language. Pilkington purchased for others too. The collecting of pictures in Ireland is just beginning to be studied. We have a chapter on collecting in our new book.

Dublin in the eighteenth century had been a very artistic city. The Irish were great Grand Tourists. The first British one painted by Pompeo Battoni was Irish. We have customs and auction records to indicate a trade. A man called Sweetman, of a Catholic family, had to sell his first collection because he was in the 1798 rebellion. He had to leave Ireland and settle in Paris. He made a second collection which his son had, and which was sold in Ireland in 1820. It included a lot, probably bought by his father on the continent. One of the pictures was a Poussin. It's now in the collection of the royal family in Yugoslavia. They returned to their country the other day and though in the photograph in the papers the Prince and Princess were seated under the Poussin, it didn't show. We got just the label! We know it is still there.

Madden, one of the founders of the Dublin Schools, made a collection of pictures and left twenty to TCD, to be chosen for the Provost's house. A large number were Italian or copies of, and fewer were from the Low Countries. Eighteenth-century travellers say that most paintings in Irish collections were from the Low Countries. The only great Madden picture is from there, it's by Rembrandt's teacher Pieter Lastman.

The Earl Bishop of Derry had a colossal collection. Nicky Figgis has done a lot of work on him. An enormous amount of what he was importing never came, due to the Napoleonic Wars.

Maurice Craig in his book on Dublin has the lovely story about two young women walking along St Stephen's Green, seeing a man standing on the steps of his house, and him inviting them in to view the house. The house was hung heavy with

pictures and as they left he proposed to one of them who accepted. Yes, there was collecting!

VR: *Your research was quite document led, as you say. Did the burning down of the Four Courts during the Troubles (1922) impact significantly on your research?*

AC: Wills drove us mad. We had dreadful trouble finding when people were born and died. The awful wars and such disasters as the endless sending people to Connaught in the seventeenth century have ruined our history. But in the twentieth century all those pictures on the quays, the ones that Bodkin bought, and the pictures that Judge Murnaghan bought walking home from the Four Courts to his house in Fitzwilliam Square, they were either from houses that were burnt, or the sales after 1922 or the Land Acts. There were great auctions all through the nineteenth century and later. A lot of gentry faded out after the Famine. They sold up, they didn't have any money.

Unfortunately, where do you find the poor buying pictures? It *is* an élite activity. The Victorian idea was to open the National Gallery for nothing and show people art free. A lot of artists were very poor but the Dublin Society Schools were happily very paternalistic. Poor students got clothes grants and were paid to go to Italy, sometimes by individual patrons, through the Society.

The National Gallery have refused paintings of the greatest social as well as aesthetic importance. There was a harvest night picture, of harvest men dancing dressed in sheaves of corn. It had been owned by the Tighes of Wicklow. It showed the family watching the harvest dance from the windows of their house, 'Rosanna', and the estate workers were surrounding the dancers and the piper. It was by Maria Spilsbury Taylor, who worked as a governess for the Tighes and for the Hamiltons.

VR: *Was she a näive painter?*

AC: No, she was trained, she was the daughter of a painter, and well known engraver. I sent the Gallery a photo. I did everything I could to persuade them to buy it. I think it was £20,000, but it

was quite a few years ago. Still they could have raised it. Showing art gives us pride in our past.

The Folklore Commission have a number of fine pictures in UCD. I think they should be more easily seen. They are of great social interest. They are very nice people, they understand about me not knowing a word of Irish, and not being able to pronounce their names. Knight's Norman-Irish and I'm Anglo-Irish and we're not allowed – at least it's considered peculiar – that we should be so interested in our country. But we are. We are deeply interested in Ireland.

Interviewed 25 April, 20 May 2002

1. Crookshank, A. and The Knight of Glin, *The Watercolours of Ireland*, London, Barrie and Jenkins, 1994.

2. In 1955, the Art Advisory Committee chose to reject the offer by the Friends of the National Collections of Ireland of Henry Moore's bronze *Reclining Figure 2*, 1953. In 1951, the offer, by an anonymous group, of Louis le Brocquy's *A Family* 1951 (donated to the National Gallery in 2001) had been rejected by the Advisory Committee. Dublin Corporation overode the Committee's decision on the Moore. It and Rouault's *Christ and the Soldier* (rejected in 1942) became part of the collection in 1956. The author is indebted to Róisín Kennedy for this information from her draft PhD. thesis on Irish art criticism 1939-1984.

3. *Two Painters from the Collection of Sir Basil Goulding*, Belfast, Ulster Museum 1965.

4. Fr Donal O'Sullivan S.J. was director of the Arts Council from 1960 to 1973.

5. Crookshank, A. and The Knight of Glin, *Irish Portraits 1660-1860,* Paul Mellon Foundation for British Art, 1969.

6. Strickland, W., *A Dictionary of Irish Artists* 2 vols., Dublin, Maunsell and Co., 1913.

7. Crookshank, A. and The Knight of Glin, *The Painters of Ireland* c. *1660-1920*, London, Barrie and Jenkins, 1978.

8. Crookshank, A. and The Knight of Glin, *Ireland's Painters 1600-1940,* New Haven and London, Yale University Press, 2002.

9. Carter, M., *Anthony Blunt, His Lives,* London, Macmillan 2001.

10. Blunt, A., Nicolas *Poussin* 2 vols., London, Phaidon, 1967.

11. O'Connor, C. *The Pleasing Hours,* Cork, The Collins Press, 1999.

12. Crookshank, A. and The Knight of Glin, *The Painters of Ireland,* p. 33.

13. Laing, A. (ed.), *Clerics and Connoisseurs, An Irish Art Collection through three centuries,* London, English Heritage, 2001.

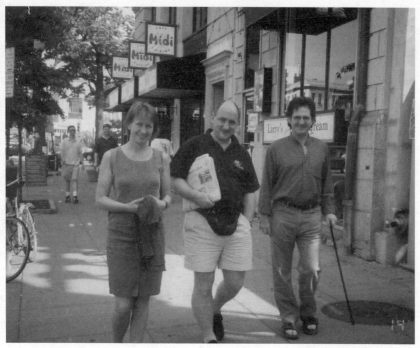

*Vivienne Roche, Jerome Hynes and Professor Ciarán Benson in
Washington during the Island, Arts from Ireland Festival, 1999.*

Vivienne Roche

*Vivienne Roche was born in Cork in 1953. She was educated at Miss
O'Sullivan's Primary and Secondary School on the South Mall, at the
Crawford School of Art from 1970 to 1974, and from 1974 to 1975 at the
School of the Museum of Fine Arts in Boston. She was a founder member
of the National Sculpture Factory in Cork, and from 1989 to 1997 was the
chairperson. She served on the Arts Council from 1993 to 1998, and was
on the governing body of the Cork Institute of Technology during these years.
She is on the Board of Trustees of the Dublin City Gallery, the Hugh Lane,
is a member of Aosdána and of the RHA. She has two daughters, and lives
in County Cork.*

VR: *How important is public art to you?[1]*

VR: The more I work as an artist[1] the less distinction there is between public work and studio work. Some of the interesting things I'm trying to deal with now are the links between formal expression and the privacy of personal meaning.

When I was studying sculpture in America in 1974-1975 the thing that most influenced me was architecture, which is ultimately the most community based and public art form.

VR: *That was a few years before the percent for art schemes began operating in Ireland?*

VR: Yes, it was before the first percent for art scheme, before there was a way of making a living as an artist and of making work that was in the community, and of society.

Now I think it's surprising that one key area where it might be possible for an artist to make a living – public art – is hardly touched on in art colleges in Ireland. The necessary skills are not nurtured.

It may be that many people feel they shouldn't have to negotiate their position in society as an artist. With art in the public arena you need to communicate your intention in some way before the work can commence. Communicating an idea in advance of making the art work may not be what many artists want to do – as the development of ideas can be in the making.

There is a contemporary conflict between art made inside and for outside the gallery. Galleries and institutions have exhibitions that can take in whole cities. Artists are frequently looking for new spaces in which to show. On the question of new alternative spaces, a disdain for public art is ironic.

I'd rather talk about making art public than about public art.

VR: *You've participated in critical assessments of public art.*

VR: While I was on the Arts Council I was part of a group that looked at public art and produced a report on it.[2] That was a group comprising the Department of the Environment, the Department of Arts, Culture and the Gaeltacht, the OPW, the Arts Council and Temple Bar Properties. We found a sameness in terms of scale,

materials and so on in public art.

VR: *Had that sameness anything to do with the financial ceilings – although up to 1% of the cost of a project could, at the discretion of the project manager, be spent on public art, the 1% couldn't exceed £12,000 for DOE and £20,000 for OPW projects, until recently. So a sameness of scale was likely.*

VR: Yes. Some of the recommendations of the *Report* were acted on quickly, like the financial ceilings moving from £20,000 to £50,000, with the Department of the Environment and from £12,000 to £20,000 with the OPW.

We realised that the way artists now work needed to be reflected in public art – not all work should be permanent. The *Report* opened up many new ways of working in the public arena including making temporary art.

The *Report* also recommended that the percentage scheme should be extended to cover *all* government departments with capital building budgets – like Health and Education – and that schemes could be combined from different sources to maximise the opportunities that arise for art, through the development of infrastructure. As building projects have increased in scale and costs these combined budgets allow the art element to become more appropriate to projects.

VR: *Many artists seem to find that they do not make any money on public art projects. Many just don't apply to do such projects.*

VR: For too long artists have been trying to work magic on tiny budgets, particularly in relation to permanent work. But I think many artists who could submit for public art projects don't. They assume there is a conservative attitude, that their ideas won't be well received. That's a form of self censoring. I've been on juries where there has been a real openness to new ideas from the community of interests represented on the jury. Many a local authority councillor, community representative and public servant are more adventurous than the artistic proposals acknowledge. Sometimes proposals have been very disappointing, and no projects are selected.

The *Report* tried to devise systems to let public art evolve successfully in Ireland. There has to be room for failure in the process of public art. For there to be failure there has to be critical assessment. There's a negativity about public art on the part of critics.

VR: *What kind of critical assessment are you thinking of?*

VR: A critical assessment of individual projects is needed. Each project has to be assessed in its context, not as an overview of public art generally. The critical assessment needed is to look at the work of art and the context in which it is made.

I would say that the OPW, as a result of the *Public Art Report*, have since taken a very positive role in public art. They commissioned very little work before the review group met; they used their budget to purchase art. Immediately they developed a sophisticated commissioning process, while raising the financial ceiling from £12,000 to £20,000.

The OPW both documents and records all commissioned and purchased work; they have an extensive inventory. Public art needs a public information process. This is still missing in most schemes. Criticism is part of that process. Even simple things like artists' names and the titles of works are important. Very few works are identified, either by title or name. The media and the public library system could make people aware of what art is in the public areas near them and why it's there. That information is required.

VR: *What are the other issues that discourage artists from applying for public art projects?*

VR: Many artists feel that they can lose control of their work. Work may not be maintained, for instance. Flower beds which the artist hadn't intended can be added to the immediate site of an artwork. Sometimes artists are unsupported in engaging with local communities while the work is being made. Sometimes artists don't want the responsibility of engaging with an audience in such a public way. With commissioned work there are responsibilities on both sides; on the commissioners and on the artists. These

responsibilities often need to be teased out, for the sake of clarity, so that projects can become valued in the public domain.

With positive attitudes, younger or inexperienced artists can learn to deal with some of the pitfalls at a scale they can handle and gradually gain confidence with the whole process. It is good that there are low-budget projects too. You can learn how to handle public art doing a smaller project. Art schools can play a major role here. You can learn about the difference between a 5,000 project and a 50,000 project while still at art school. A practical approach to site work from foundation to installation needs to be taught, as well as a more general exploration of the public domain as site for art – art can shape public experience.

In this regard sculptors have a different tradition to painters and public art points up this difference. Sculptors have always dealt in this area of costs, public monies, scale, maintenance – long before the percent for art scheme came in.

VR: *You were involved in the selection process for the new monument replacing Nelson's Pillar in O'Connell Street? Tell me about this.*

VR I was asked by Dublin Corporation, now Dublin City Council, to be a selector in this project which had a mix of public representatives, architects, both local and international comprising the jury.

VR: *The Welsh architect Ian Ritchie won the competition.*

VR: Yes, with a simple but striking proposal, *The Spire* for Dublin. Most submissions were architectural, in idea and in scale, but not all. One was a poem. I do think Dublin Corporation has shown great initiative in commissioning such a project to lead the urban redevelopment of O'Connell Street. It is to be placed in the centre of what is, in effect, Main Street, Ireland. I was delighted to be involved.

VR: *Were you happy with the process of commissioning?*

VR: Yes, it was a well-publicised international competition, with a challenging urban design brief.

VR: *How tall is it?*

VR: *The Spire* will be 120m high; a conical form emerging from a three metre base, and finishing as a light filled tip about twelve metres high.

VR: *Were people protesting before the adjudication?*

VR: Griping, I would say rather than protesting. Two legal challenges came from people who had taken part in the competition. They had an interest, including a commercial interest, in the outcome. Public discourse can be shaped by such challenges.

VR: *Which is surely a good thing?*

VR: That depends on the motivation for a legal challenge and the issues it raises. It comes back to the role which any kind of public art project can play, which is to shape value in society.

VR: *Was there perhaps disappointment that the piece selected was abstract?*

VR: No. Because of the architectural nature of the competition the outcome was always going to be abstract in some way, as it had an urban design brief. The first images of the winning entry were put out by a beer company for commercial purposes and completely distorted it. It's hard to counteract this kind of distortion until the monument is actually in place.

VR: *Is this a public art project, with amalgamated funding, within a percent for art scheme?*

VR: No. The project is an urban design one. The competition was for a public monument to lead the redevelopment of O'Connell Street and its surrounding area. Dublin City Council committed large money – about £4,000,000 – to it, as part of its plans to develop Dublin – it's part of the Harp Plan for the city centre.

VR: *Are you pleased that the* Arts Bill 2002, *brought in by Minister Síle de Valera shortly before the general election, requires local authorities to plan for the development of the arts?*

VR: I think the bill doesn't build enough on the work that local authorities have been doing up to now in the arts.

I was disappointed that there isn't an actual requirement that local authorities spend money on the arts – they *may* spend

money on the arts as before, though they are now required to have a development plan for the arts.

Since the late 1970s, local authorities have been stymied by central government, and in a way this bill simply reflects this.

VR: Are you referring to the abolishing of domestic rates?

VR: Yes. And for local authorities to develop their plans within the framework of government policies, these policies have first to be clearly stated by government.

The relationship between the government department that includes the arts – it has changed yet again – and the Arts Council and local authorities has been and still remains unclear. The changes in the name of the department reflect the fact that the Government doesn't seem to understand the role of the arts within the broader theatre of evolving culture. Culture was eliminated from the name of the first department created by the first full Minister, Michael D. Higgins, after his tenure in office, when the Fianna Fáil Government came in.

VR: Yes, it changed from Arts, Culture and the Gaeltacht to Arts, Heritage, Gaeltacht and the Islands, and then from that to Arts, Sports and Tourism in less than ten years!

VR: Heritage has also been separated from art this time. In the proposed bill the term 'traditional arts' has been introduced, without being defined. What does it mean? The arts are a living entity built on tradition, on history, as everything is. For this reason the arts should fit comfortably within a broad cultural background, which would include new elements like media as well as elements of our heritage. The idea of the arts now being paired with tourism could be positive but only if there is a basic understanding of culture.

VR: Do you have a definition of culture?

VR: Culture is all the ways in which people make meaningful worlds and make the world meaningful for themselves. It is all the elements that shape a place and its people. It has to be defined and redefined all the time. Culture is a living evolving thing. But now that the word has been eliminated from the Department's

name there is no responsibility on anyone in government to deal with cultural change. For this reason the new arts bill seems static, and even more so when you think of the changes which the country is presently undergoing.

VR: *What do you think brought it about?*

VR: I think the bill came about as a means of reducing the Arts Council as a body.

VR: *Do you mean numerically, from seventeen to nine Council members?*

VR: And also maybe in power. Having served on the Arts Council I think the input of seventeen people from various backgrounds is a positive one. The whole idea is that seventeen people represent different arts and the public access to them. Now if the bill is passed the Arts Council becomes more like a corporate entity than a public agency. The reduction in numbers is supposedly to make it more manageable, but the diversity of interests and experience in the existing Council of seventeen members make it a unique resource. Why change something that has served the country very well for 30 years?

VR: *Since the creation of a new ministry dealing with the arts nearly ten years ago, the relationship of the Arts Council to the Minister may not have seemed clear enough.*

VR: It seems to me that the proposed bill brings the Council more under the Department, specifically, by the fact that the Minister appoints the nine Council members plus the chairs and two members of the three proposed subcommittees. This seems more like control by the Minister than is presently the case. In this new proposed bill the Arts Council is not as independent as it now is.

VR: *How do you see the role of the Arts Council?*

VR: The Arts Council now sees itself as a development agency for the arts. I would say it has always been that. But it has also been the support agency for the arts, both in financial terms and in terms of expertise. It is not desirable that it becomes the equivalent of the IDA for the arts. The commercial metaphor is not compelling and is, I believe, diminishing of the State's more

complete relationship to the cultural development of its people. The relationship between the Arts Council and the arts community must be fluid. The Arts Council must be able to respond appropriately to the changing nature and needs of the arts. We don't need a bureaucratisation of the arts.

I think art is about change. If you're an artist you're dealing with constant change, that's the stuff of life. One of the valuable roles of art in society is to note change and to cause change.

Some of the recent developments in the Arts Council have come about because of the perception of transparency of public funding. The increased funding which the Arts Council has received in the last ten years has already been spent in a transparent way. The Arts Council has always provided an annual report to the Oireachtas.

VR: *Is there a perception that their client-based approach has been eroded by increased use of consultancy reports?*

VR: That's a fair perception. You do need a certain passion for the arts to work in the arts. You don't necessarily get that from consultants. Nor do you necessarily get the trust that is built between the Arts Council and its clients as partners with their dual roles – making art accessible to society and making art.

VR: *The three arts plans from the mid 1990s onwards established the Arts Council's evolving policies over the decade.*

VR: And those policies were then adopted as Government policy through the funding of these plans. The Arts Council's funding allocation increased in this period. But only in line with generally increased public spending. The arts started this period on a very low financial base and are only beginning to catch up.

In terms of tourism potential, I think the arts have been under resourced and under appreciated. A tiny percentage of tourists state that they come to Ireland for the arts, yet we think of ourselves as a country of writers, musicians and artists. Ireland as a cultural destination is not accepted as a value in itself and is not marketed as such.

VR: *You were actually involved in the formulating of the first arts*

Joe McHugh, Elma O'Donovan, Vivienne Roche, Conor Doyle and Ambassador Jean Kennedy-Smith at the NSF, 1994.

plan, when you were a member of the Arts Council.

VR: Yes. The request from the Minister (Michael D.) for the first plan was ground breaking. The idea of planning for the arts surprised people. Funding that plan was a very important commitment by Government. The arts became a normal part of national planning, although there is very little planning for the arts in the present *National Development Plan.*

VR: *You and several other artists set up the National Sculpture Factory in Cork city in the mid to late 1980s. What motivated you to do that? And to designate it as national, which has usually implied location in the capital city.*

VR: We saw it as a resource for the country as a whole and so did the

Arts Council who were supporting it. When Eilís O'Connell, Maud Cotter, Danny McCarthy and I set up the Factory we did so to provide a facility that would enable artists to make work, particularly publicly commissioned work, in a supportive environment.

VR: *Was the percent for art scheme, which was developing strongly in the mid 1980s, a motivation?*

VR: We felt there was some kind of industry which could be created around the percent for art schemes. We felt that artists could shape it. We wanted to have a facility that was better than anyone's individual studio, with equipment for a lot of different materials. Having a facility available to artists working on big projects has a different meaning now than it had in 1989, when the NSF opened. We wanted a facility that would maximise the impact of the percent for art schemes for artists and for the public too. The Factory has evolved over time. It now plays an important role in the debate around art and the environment. Mary McCarthy, the director, has led a number of initiatives hosting public lectures and seminars. This summer we had the 'Daylighting the City' project.

Last year the 'Designing Cities' conference brought together many voices which shape the environment. These projects are often run jointly with the local authority.

VR: *Were you very supported by the city fathers in setting up the NSF?*

VR: Yes. Cork City Council gave us the building, which was the old tram depot for the city, at a nominal rent, and have continued to support the Factory. Over the years a trust has been built up with the local authority and we now feel we're very much in partnership. Joe McHugh[3] the former city manager of Cork, who recently retired as chairman of the Factory, was on the board almost from the beginning (he was a founder director) and gave us a great understanding of how local authorities plan and work. And because Joe was involved, local authorities – particularly managers – trusted the work we were doing in promoting public art.

This sense of leadership, of how the Sculpture Factory could have an active role in developing national policies while at the same time working with Cork City and County Councils in a regional capacity, was crucial to the Factory's development.

Cork was depressed in the mid 1980s, suffering from huge job losses which came together over a short period of time. Its industrial base was decimated. Cork is only recently recovering from that period. Even when the country as a whole was recovering economically, I think Cork continued to be under-resourced and depressed. The designation of Cork as European Capital of Culture in the year 2005 is obviously now very important to the future development of the city.

VR: Is the NSF taking a leadership role in the development of the new docklands in Cork?

VR: Insofar as it can, it is bringing the issues that we feel need to be debated to the forefront. This is the kind of role the arts can play in society. Of course, these issues concern all of us.

VR: You've been interested in helping to shape public debate all along.

VR: The scale of Cork city where I grew up allows for that kind of input. People are in contact at different levels and in different ways. That is how a small city works. And then I have been given further opportunities to participate in national debates on artistic and cultural policies.

VR: And the new docklands development in Cork, does it need legislation at a national level? Will the local authority be able to steer development to meet civic needs, given that so much of the development is private?

VR: Yes, I think it needs legislation similar to that which allowed Temple Bar and Dublin Docklands to develop, particularly as most of the land and buildings are in private ownership. The plan for the docklands is long term. Good architecture will be essential to its success. In effect we're looking at a new city within a city, which, if developed with good urban design, can enhance Cork and the region, bringing people back into the city to live. One has to interest property dealers in good architecture.

I hope that the owners of the properties in question and the property developers will seek good innovative architecture. Much of the recent architecture in Cork, apart from cultural and some education buildings, is of poor quality. It's no accident that cultural institutions like the Opera House and the Crawford Gallery commissioned quality architecture of a European standard.

Vivienne Roche, her daughter Isabelle Hanrahan and Jerome O'Driscoll (right) at the Patrick Ireland exhibition in the Crawford Gallery, Cork, 1996.

VR: They had some EU money.

VR: This money was hard fought for. The value for money both in terms of design and usage is part of good building briefs. Right around the country, arts buildings that have been supported by EU money have brought a real renaissance to architecture to Ireland.

VR: *Artists were often behind these developments. Why was that?*

VR: In Cork alone artists initiated a number of developments that received EU structural funding in the 1990s, like Wandesford Quay, and the National Sculpture Factory. I suppose artists had already identified what structures were needed to enable them to make art in a more sympathetic environment and there were people in positions of power who were wiling to listen to them. The first thing artists need is space. When more public money became available in the 1990s there were good, viable ideas

ready for funding.

VR: *What was it like to be an art student in Cork in the early 1970s?*

VR: The School of Art was part of the Crawford Municipal Art Gallery in the city centre. There was student unrest there as in the NCAD. Some of my political interests were spurred at that time. I was active in the Students' Union. We had a lot of contact with students in UCC so we felt part of a bigger student movement, even though the School of Art was very small in numbers. At that time students were interested in wider issues to do with society in general, as well as in their work.

VR: *What was the unrest about?*

VR: Specifically in the School of Art it was about the changing needs of art education. Students pressurised the VEC and the Department of Education to make major changes in art education. I have memories of going to Dublin to join the NCAD student marches.

VR: *Was there much visual stimulus in Cork then?*

VR: The *Rosc* exhibitions which were in Cork as well as in Dublin were very important in bringing international work into Ireland. The *Rosc* exhibitions were big national events. *Cork Rosc* was in the Crawford Gallery, and with the School of Art upstairs, that had a big influence on us as students.

Also David Hendriks regularly brought work from his gallery in Dublin to Lavitt's Quay in Cork. The Triskel was started in Cork in the late 1970s, by some graduates of the Crawford, and it also brought contemporary Irish art to Cork.

In the early 1970s, there was no visual arts activity in UCC. UCC now contributes to the visual arts scene in Cork. The building of the new gallery on campus will further enhance their role.

VR: *Yes, there's been good work done for the visual arts in UCC since the mid 1980s. It now offers a degree in art history.*

VR: It's good that institutions like UCC and CIT are commissioning good architectural projects. The student body in the School of Art when I was there included architectural students who at that stage could do three years in Cork before completing their

degree elsewhere. The loss of an architectural school in Cork was a serious loss to the city and to the region. All architectural training in Ireland is now in the one city, Dublin.

VR: *An architect clearly needs a formal education, but does an artist need a formal art education?*

VR: Not to become an artist, but good art education helps to sustain a person in the making of art.

But formalising art education into specific degree programmes where the emphasis is on the qualification itself rather than the development potential of the artist has distorted artistic energy. There are some things you cannot teach and can only learn with experience. Contact with working artists is necessary and for this reason the decline in part-time teaching is a pity. Art teaching like all teaching has gone towards the trade unions' preference for full-time posts.

It is rarely compatible, being a full-time teacher and a full-time artist. So often people who are teaching are not practising. An art school has to have a mix of artists as well as teachers to have real energy.

All the skills in the world including intellectual skills don't make an artist. Yet I think it's great that there is an element of formalisation in art education. I would consider my own education in the Crawford in the early 1970s to have been technical rather than academic. The technical side was good. We learnt skills. But there was an intellectual element missing. The idea that you could, for instance, study art history for one year only to pass exams is terrible. That was how it was for the Art Teachers' Certificate (ATC) 30 years ago.

VR: *With the changes brought in by the NCEA from the mid seventies did it improve?*

VR: Yes. In many ways, but there's still a huge lack in art education today, especially in terms of contact with the world beyond art school, which is most of society. Most art schools now are very self-sustaining institutions. Unless an art school has a real link back to the community it serves it will fail in educational terms.

Art education has become very rarefied and also it is very female orientated. There are many more female students than male, and yet many full-time teaching posts are held by men. The dynamic is wrong. The dialogue between artists and students works both ways. I think teaching is good for an artist too. I see very little questioning of the system now. It needs to be questioned.

VR: You know something of that system from being on the governing body of CIT?

VR: I was a member of the governing body of the Cork Institute of Technology, of which the Crawford College is a constituent body, from 1995 to 2000. The whole point of a governing body of a third-level institution is to represent the mix of interests, to make the institution in its care relevant in a wider community. I care about the value of different inputs into decision making. I think there is a lot of cynicism in public life now, and I think that's because there is little regard for public interest, the common good. In professionalising the different elements, including art, something has got lost and that includes the link back to community. The volunteer element, for example, is important. It often represents commitment. It has been devalued.

I came to see art in its public context as so important through thinking of the role, the purpose of making art and understanding that an artist needs an audience. It's a two-way process. Being a sculptor you become aware of that, due to the physicality of the work. It's simply not desirable for me to be just in the studio, making. The fact of showing, or working for a particular site, makes me think like that. Art comes from the person you are. The person you are is not only private. Not everyone is interested politically – I think I'm very political – but if you are, engagement is part of your life and it naturally finds a way into the work.

Interviewed on 13 May and 18 July 2002

1. O'Regan, J. (ed.), *Profile II Vivienne Roche*, Introduction and Essay by Aidan Dunne, Essay by Cíarán Benson, Oysterhaven, Gandon Editions, 1999.
 O'Regan J. (ed.), *Works 2 Vivienne Roche Interview with Vera Ryan*, Oysterhaven, Gandon Editions, 1991.
2. *Public Art Research Steering Group Report to Government, Dublin, The Stationery Office, 1997.*
3. Joe McHugh, born 19 November 1926, died 15 August 2002.

Paul O'Reilly in action (photograph Tom Shortt).

Paul M. O'Reilly

Paul O'Reilly was born in New York in 1934. He was educated there and in Mexico. From 1969 to 1977 he was a lecturer and from 1972-1977 director at the Institute in Mexican Culture at the University of the Americas, Puebla, Mexico. He married Peggy Power-Scanlon in 1966 and they have four daughters. He taught in the Vocational School in Thurles, County Tipperary from 1978 to 1980, and at Limerick School of Art and Design from 1978. He was director/curator of the Limerick City Gallery of Art from 1985 to 2000. He has exhibited his paintings and written for publications in Mexico and in Ireland. He has been administrator of ev⁺a, the exhibition of visual⁺ art in Limerick, since 1978.

VR: *Paul, you've been associated with the prominent contemporary art exhibition,* ev⁺a *for over 20 years.*

PMO'R: Since 1978. My work was selected for *ev⁺a* in 1978; the very first *ev⁺a* happened in 1977. I entered work in 1978 and then somehow got to know some of the people on the *ev⁺a* committee, Charles Harper in particular. They offered me administrative work at *ev⁺a* – unwrapping, truck driving and so on, starting in 1979. I had come back from Mexico in 1977 and I took up the art teacher's job in the VEC school in Thurles in 1978. It was a full-time job that I had for two years. But eventually I failed to secure sanction in the position and so I had to leave.

VR: *Why do you think you were refused sanction?*

PMO'R: The way I tell the story is that I somehow ran afoul of the inspectorate in the Department of Education. The school wanted me to stay and it was the job I found I could do the most good in. I had a fabulous time there. I'd been teaching in Mexico for five years when the university there imploded in on itself in a huge exercise of academic savagery. Then in Thurles I walked into a backyard prefab with holes in the floor and met class after class of those fabulous kids. I still meet adults now who remember the art classes and the sense of confidence they got when they found that they could make things. Traditionally in school the hands and what they did were suspect – they were often struck in punishment. The students got a sense that it was good to make things happen with their hands in drawing and painting. They really rose to making artworks when they had the chance. Very few studied art later but I didn't consider that as necessarily a sign of lack of success. If they didn't go on to become artists/designers they would always be a better, more confident audience for the art they met in the future. At about the same time I had begun teaching part time in the Limerick School of Art and Design, at first on the Principles of Teaching Art course with Walter Verling and Ted Dwyer. Later on Charles Harper had me doing art history and drawing.

VR: *Your wife Peggy is from Thurles.*

PMO'R: Peg is Dublin raised, her family comes from Thurles and Clonmel and west Clare. She spent her youth in Dublin and her holidays in the country and always hankered after the States. I spent my youth in the States hankering after Ireland. I first came here in 1960, hitchhiking with a backpack, going from hostel to hostel. I had planned a year's travel in Europe to visit cities and museums, but the first place I went to was Ireland. My people came from Ireland in the nineteenth century, from Kingscourt and Virginia in Cavan and from Cork. When I returned to the States I met Peggy, we both worked in a restaurant, Schraffts, in Westchester County, New York near where I lived in Yonkers. She had left Ireland for the States in 1959.

VR: *Was this after your art studies?*

PMO'R: Yes, some time after. In 1952 I went to Syracuse University in New York to do a fine art degree with the idea of becoming a commercial artist. I ended the first year wanting to be a painter and eventually refused to go back for the third year; the environment there was so apathetic. So I switched to the Art Students League in New York City. I studied there in 1954-1955 on the basis of its earlier reputation; but it was just like Syracuse, so I dropped out and painted on my own until I was drafted into the US army in 1958. In this I turned out to be very lucky. I was stationed in Bavaria, in Germany, for twenty months and I was even able to paint while there and had a studio set up.

My father's younger brother, my uncle John, had studied commercial art in Columbia University in New York. As a child he was the one who encouraged me the most. My parents and teachers wouldn't let me study art in high school until the fourth and final year. I thrived on it and wanted more. So my mother, a primary school teacher, and my father, a businessman working in New York, sought expert advice on the matter. They sent me to New York by train on a long series of Saturday mornings to undergo a battery of psychological and aptitude tests at New York University in Washington Square. Eventually my parents were invited to a final assessment of me, at which

they were told it wouldn't be a mistake if I was let study art. The way I understand what happened now is that school favours left-brain activities and what they were able to discover in all those tests was the way the right brain, the creative non-verbal brain, works. My parents were relieved of doubt about my ambition and so let me go to Syracuse where, even though my grades were fabulous, I decided to leave after only two years of study – without a degree.

VR: *You came to Ireland in 1977 as an artist.*

PMO'R: Yes, as an artist and also out of work. Peg and I were married in 1966 in Moycarkey, out of the house we now live in. We courted for five years, had saved our money and bought a tent and a Volkswagen and went back to the States for an extended honeymoon trip. We had already decided that we would come back to Ireland to live. We camped for nine months – from October to June, travelling through the east and south of the US. While on our way to California, we thought we'd go to Mexico for three weeks. But the deeper we went into Mexico the further we wanted to go. We camped for three months. We met people who told us about the University of Americas, at that time located in Mexico city. Its degree programme had US accreditation; I had the benefit of the GI bill which meant that the US Government would pay me to study at university so I enrolled as a third-year art student. The dollar went far in Mexico. I found the school environment to be the same as it had been in Syracuse but now I was curious as to why it was that way and it no longer scared me. I got stuck in. I completed a BFA degree and began to take numerous courses that I was interested in. For an MA you had to accrue 76 graduate credits. By the time I received my MA I had 171 credits. The MA was in art history, but those specific studies were the smallest part of my education.

The first day I went back to school in 1967 Siobhán was born! My other three daughters were also born in Mexico: Suzannah, Cristin and Vanessa, the youngest, in 1972. We knew we could never stay permanently in Mexico; it would be difficult

Paul O'Reilly at the University of the Americas, 1969.

to raise four daughters in that culture; we were gringos, outsiders and could never really belong.

VR: You taught in Mexico for a while?

PMO'R: Yes. Mexico changed my whole way of thinking about art. There's a tremendous presence of the Meso-American, the pre-Columbian culture there. It starts to take definition at 1500 BC and it doesn't end until the Spanish arrive in the sixteenth century; a 3,000-year-old civilisation with a varied, complex cultural growth. On top of that there's a massive 300-year long colonial experience, and a major nineteenth-century independence movement and a ten-year long twentieth-century socialist revolution. They have one of the most important twentieth-century artists, who is completely ignored by mainstream art history, a painter called José Clemente Orozco (1881-1949); I think in some ways he's more important than Picasso but his best work isn't portable; they are murals, so you have to go to Mexico to know them and of course, they don't photograph well. My MA thesis was based on the claim that the history and art of Mexico were indispensable evidence for making sense of today's world. Very few, if any cultures today, as great as they may be, have the complexity of Mexican culture, past and present.

When the faculty of this wonderful university went misguidedly on strike I was caught up in it. The faculty closed it down for three or four months and when it re-opened the teachers had been

paid off and had to leave. It was a great tragedy for everyone. The university was a small one – about 2,000 students – with many great maverick teachers coming from all over the world. I had begun to teach as a graduate fellow in 1969 and eventually became the director of the Institute in Mexican Culture within the university. It was an inter-or-multi-disciplinary course of study that brought together 24 teachers from all disciplines in a programme of study that included eight or nine major and eleven minor field trips to modern, colonial and pre-Columbian zones. Such interdisciplinary courses were becoming fashionable in the 1970s, although they were looked down on by some academics who didn't think they were serious, meaning not specialised enough. The students, though, benefited greatly from such a comprehensive interdisciplinary approach.

Peg and I had gone to Mexico for three weeks, and stayed for ten years. That's the effect Mexico can have on you. We all had left by 1977. The house we live in now was Peg's dowry. Her mother, Breda Crotty from west Clare, took me aside when we were married and said the house and its few acres were Peg's. That was a surprise for me. So we live in a thatched cottage that is over 250 years old, still with an open fire. I came back to Ireland with no job; got the job in Thurles; lost it; and started part-time/whole-time teaching in Limerick. I never got sanctioned in Limerick either, the Department of Education blocked me there too, but I worked steadily in Limerick and commuted from Thurles and kept up my work as a painter.

VR: *How did you get involved with the Limerick City Gallery of Art?*

PMO'R: As I've said I was a lecturer in the Limerick School of Art and Design. Toward the end of 1984 the Gallery job was advertised; Charles Harper encouraged me to go for it. I'd been doing administrative work for ev^+a since 1979 so I had some experience to count on. Seventeen people went for the job as far as I remember; I was last in line. The interviewers were Joe McHugh from Cork, Oliver Dowling, the gallerist from Dublin, and Medb Ruane from the Arts Council. I had nothing to lose so I said just

what I thought in answer to their questions. They asked me what I thought the job of curator entailed. I said it was to present the works of art to the audiences as clearly and honestly as possible for the artist's sake; and that the job wasn't to somehow persuade audiences to 'like art'. Medb Ruane turned and said, 'he's the first one that understood that'. I didn't know that what I was saying was exceptional. I'd learned from ev^+a that the adjudicators/curators worked hard to present the artworks as clearly as they could, then they left it for the audience to deal with; it was up to the works of art themselves to persuade or convince the audience. I assumed I wouldn't get the job, but a few weeks later I got a letter saying I had it. I was in two minds about accepting it. My employer was going to be a corporation, bureaucrats. Charles Harper advised me to accept so I took a chance and signed on. It was a very good decision.

When I first went to Limerick in 1978 I had discovered the Gallery at the back of the City Library on Pery Square and I got in the habit of going there nearly every day on my way to the train to spend about half an hour surrounded by works of art. It was near enough to the School of Art so I began to take LSAD students to the Gallery for some art history classes in order to use real works of art instead of slides. I believed then as I do now that slides, though useful in some ways, are inherently misleading and therefore dangerous. Our visits came to the attention of the head librarian; he took exception to the use of the Gallery as a classroom. He called up Richard Ruth, the head of LSAD, and complained; I was banned from going with more than two people. That had reinforced in me the idea that bureaucrats were dangerous. So I went to see Flann O'Neill, the town clerk. He put my mind to rest and eventually agreed I could continue as administrator of ev^+a since it was based in the Gallery.

Up until 1985 ev^+a was always hung in the back gallery - it was a modest, well-designed space. Peter Fuller, the ev^+a adjudicator for 1984, chose about 70 works and double hung

Paul O'Reilly in the Limerick City Gallery of Art (LCGA)
(photograph David Gaynor).

them there; so, too, had many of his predecessors. By 1985 a new city manager, Tom Rice from Cork, and Jim Barrett, the new city architect, had already started to foment change in Limerick. One of those changes was to put the library closer to the people, so it was moved out of Pery Square downtown to the Granary and, on the advice of the Arts Council, it was decided to convert the library building into a proper art gallery. It had been built with Andrew Carnegie money in 1906; the Gallery extension had been added on in 1948. On the first day I started, 5 May 1985, I went to work, and who was there to greet me but the librarian who had banned me. He and the library had to move out and the Gallery was taking over the building. There was some justice in that.

VR: *So Limerick had a serious gallery and its first director/curator?*

PMO'R: Yes. I insisted on keeping the dual title of director/curator; I was trying to avoid the Corporation forgetting there were actually two jobs involved. But they did.

At that time the Arts Council signed a formal cultural agreement with Limerick Corporation, the first of its kind with

a local authority. Limerick has had many firsts in the arts. Limerick had been the mid-west base for the very first regional arts officer, Paul Funge; it had the first city arts officer, Shaun Hannigan; now it was also the first local authority to fund its own first-class gallery of art. Part of the cultural agreement included giving support to the new Limerick City Gallery of Art, which included a modest three-year financial subsidy to encourage acquisitions and a generous donation of major works of art given on a permanent loan basis. This helped greatly to set the example for the future.

VR: *What could you buy with that kind of money?*

PMO'R: One of the first things LCGA acquired was Barrie Cooke's *Woman in the Burren*. It had won a prize in ev^+a 1980. I found out it was still for sale. When the Hendriks Galleries in Dublin closed, I negotiated the purchase of it with those who took over the business after Hendriks died. Some other purchases for LCGA in those years were also prizewinners for ev^+a. My guideline was to buy work that kept faith with the existing collection and yet stretched it a bit so that it began to move in different directions.

VR: *Tell me about the existing collection.*

PMO'R: The existing collection was and is basically Irish and Anglo Irish. In 1948 when the Gallery was built on the back of the Library into People's Park there were massive donations that came directly from artists and other supporters. I was given a handwritten ledger book that listed works but no proper cata- logue had been kept. Robert Carver's *Landscape* from 1754 is the oldest painting in the collection. There are works by Yeats and Leech and Dermod O'Brien, who also donated a lot. Everything was of great intrinsic value. *Chairoplanes* by Yeats is small but the quality is great. There is a portrait of Keating by Orpen that is magnificent, one of his best.

VR: *Seán Keating was from Limerick wasn't he?*

PMO'R: Yes, supposedly he hated Limerick but he, too, gave gener- ously to the new Gallery. The collection now has a total of nine Keatings. Grace Henry gave as well. LCGA has some

gems. A Patrick Hennessy *View of Kinsale* is one of his very best. The Gerard Kelly *Portrait of Miss Vera Palmer*, of the family of biscuit manufacturers, is exceptional. There's a nice anecdote about it. Some time in the 1990s I got a long distance phone call from a woman in England who wanted to confirm that the LCGA collection had a portrait of a Miss Vera Palmer. Some time later this little old lady comes to the Gallery and says she wants to see the Vera Palmer, her aunt. She sat there communing with her aunt for about an hour. She said her aunt had been an awkward person, a bit contrary and had never married. It's a wonderful portrait of such a woman, three-quarter length in a brilliantly painted green dress.

VR: *You don't believe in labelling the pictures in the Gallery.*

PMO'R: Of course it's improper not to use labels but here's what happens when you do. If you have a work of art on the wall, and near it its label, the label says to the audience 'come over here and read me first', and they do. Once the label is read the person is released and most often passes on by the picture. What I witnessed time and again was people thinking they'd done the work of finding the meaning when they finished reading the label. The label seduces attention, especially if the image is vague or abstract. It demands to be read, and this calls for linear, sequential, connected behaviour. The average time for most who deal with an artwork is often only about three seconds, and in this time the work is not listened to; the label is. If there is no label, people have only the work to deal with. When there is no label you could say it is unfair to the artist. But it can be worth it; the work of art by the artist gets full attention. And people can always ask a question about the work. The personal answer they receive (if answers are available) can open up other opportunities for meaning. Labels of course can also be made available in other ways, such as on cards located in the middle of the room.

I don't think that a curator should assume the responsibility to get people to 'like' art. That was not the job I set out to

do. LCGA is a building open to the public. It has a collection owned in the people's name that includes a sizeable number of paintings and works in all other media. The curator's job is to take care of the collection and show it and the visiting exhibitions to best advantage of the artworks for the sake of the artists who made them. You should leave it to the people who come in to make their own sense of the works. You shouldn't take that responsibility away from them. The sense has already been made by the artist, his or her own sense. All you've got to do is try not to interfere with the potential rapport that grows between the audience and the artworks. Of course, you must hang the work and present it properly. You can mislead the audience if you don't. And this means that the curator does exercise an important influence. But all the curator need do is give the work of art a chance to be understood on its terms, on the artist's terms. Let the work of art tell the audience what to feel and think. The curator shouldn't be willy nilly adding what he has to say on top of that. My position is that the artist should be the first person to offer meaning and explanation in the work. If the artist wants to include a written statement then include it. Putting up explanatory plaques and labels seems an imposition to me. If the artist wants to do so then, fine, that becomes a part of the work of art. The audience can always go to books if they want to know what someone else thinks of an artist's work.

VR: *The catalogue of the collection at LCGA prioritises the visual experience. It's a beautiful production.*

PMO'R: *Kingdom of Heaven.*[1] Yes, it came out in 1999 at the time when the whole LCGA collection with very few exceptions came to Dublin on exhibition at the RHA Gallagher Gallery in December 1999. Since it was not possible then to publish a complete catalogue I decided it was best to produce a catalogue that would introduce the audience to the collection. The book is structured the way the collection is presently hung in LCGA. There are four sections: landscape/seascape, portrait, still life

and genre. The book is structured so that the images talk to each other the way they do on the walls of the gallery. George Collie's *The Outpost* is placed in juxtaposition with Gene Lambert's *Pat;* for example, John Shinnors's *Cows Come Home* is close to Sarah Purser's *Man With Muck Rake.* I'm very interested in what happens with certain juxtapositions. For many of the early years I would complement an incoming temporary exhibition with a selected survey of the permanent collection that would talk to the visiting artworks and altogether to the audiences. Of course, the catalogue includes printed words but I kept them as best I could to the back pages. With combinations and juxtapositions you can set up rapport among a nineteenth-century neo-classic painting by Mulcahy, a romantic composition by O'Connor, an impressionist Leech, an expressionist Evie Hone, and abstractions by Souter and Martin; there you have spread out the history of the Irish landscape in intimate conversation; and it would include dealing with the full bias for literal-visual detail as in the [J.H.] Mulcahy to, in contrast, the Fergus Martin which suppresses such details.

VR: *LCGA is run by the Corporation, or, as it's now called, the Limerick City Council.*

PMO'R: After the three-year cultural agreement ended, the Arts Council rightly left the funding of LCGA solely to the Corporation. I started off with a budget of around £25,000 in 1985. That covered everything; exhibitions, publicity, equipment, heat, electricity, acquisitions, everything aside from wages and salaries. The LCGA staff included a part-time cleaner, a full-time security man and myself. Each year I put in for budget increases. By 1991 it was around £40,000 per annum. But that was the year of Treaty 300, the anniversary of the 1690 battle, defeat, treaty and flight. The Corporation overspent; I was told all LCGA could have for 1992 was something less than £25,000, quite a sizeable reduction.

The Arts Council continued to insist that the Corporation remain responsible for maintaining the Gallery, but Arts Council

subsidies were available to anyone to help mount temporary exhibitions. I took some small advantage of this as I built up a momentum of exhibitions – twenty to twenty-five temporary exhibitions a year. So eventually the Arts Council decided that one yearly request for such assistance would be accepted, instead of bothering them for subsidies one exhibition at a time. Sarah Finlay, who knew the Limerick scene well, was in the Arts Council then.

VR: *Sarah was a great visual arts officer, with a real sense of regional development. What were the other big changes in the fifteen years you were in charge of LCGA?*

PMO'R: Yes, she was indeed. Towards the late 1990s then, the budget started to increase again. Jack Higgins followed Tom Rice as city manager, and what he did was of great help. In the mid 1990s the Corporation decided to sell off some properties, which gave them cash on hand. One day in City Hall I passed Jack Higgins on the stairs. He stopped and said, 'You're the only person who has never complained'. Shortly after this incident his decision gave LCGA an extra £80,000; £40,000 was for the catalogue; the rest was designated for renovations and restoration of the collection and for acquisitions. When I was retired in 2000 I think the annual budget was about £60,000. Since I left LCGA the budget has exploded; it's more that double what it was – it's now about £160,000 per anum; money that wasn't there in the mid-1990s is there now, which hopefully could mean a brighter future for LCGA.

It was also at that time under Jack Higgins that the Corporation got successfully behind the campaign to secure EU monies for the extension and renovation of LCGA, the first phase of which was completed in spring 1999.

And in the matter of staffing, one assistant position was added in 1998. With the help of the Arts Council and ev^+a, the Corporation was finally persuaded to bring in some badly needed help.

VR: *How did attendance by the public develop?*

PMO'R: I started out imagining a certain rate of change in terms of audience interest and attendance. This is what partly drove me to work toward increasing the number of temporary exhibitions. But periodically I'd have to face the fact that the audience wasn't developing as I wanted. It was very humbling to realise that things were not changing as expected; so those expectations were realigned and work was redoubled.

VR: You didn't put in a café?

PMO'R: No and for good reason, I think. The ev^+a adjudicators, especially after 1985, would gladly give me advice about how to run the Gallery. In 1985 Rudi Fuchs said, 'You don't know how lucky you are to have this Gallery'. He meant that LCGA was a special, unusual space; it has a mosaic of different sized rooms off a daylit centre space; it's not laid out like a train, carriage after carriage; it's a cluster of rooms with a nucleus. He said it was ideal for a contemporary Gallery. He recommended, 'Put in a coffee machine but don't put in a café or a restaurant – keep to something minimal'. So I set up a coffee point and provided Rombout's filter coffee for 50p a cup. Many other ev^+a adjudicators over the years have said the same. They were impressed by the way the space worked and understood the problems a café/restaurant brings to running a gallery. Why go into competition with your neighbours' cafés five minutes away? Galleries can't really make a lot of money on cafés/restaurants. Such businesses are notoriously the ones that fail the most. And you have to sacrifice exhibition or storage space to accommodate it. The top floor of the Hayward Gallery at Southbank in London has a glorified coffee point; that seems a good thing since it is awkward to get coffee elsewhere in the area. The prime example for me of where a restaurant doesn't work in the true interests of the Gallery is the National Gallery in Dublin. As soon as you go in you can smell the food in the reception area. People use the galleries as pass through spaces; they rarely stop to listen to the artworks.

VR: LCGA collects mostly Irish work.

PMO'R: Yes, with few exceptions. In 1997, for instance, the Douglas Hyde Gallery had a show of Mexican folk art; John Hutchinson brought over two Mexican craftsmen to make ceramic work in the Gallery; one piece was a large Tree of Life that was fired in the kilns at NCAD. I asked for the exhibition to come to Limerick and bought the *Tree of Life* in honour of the exhibition; it's now a part of the history of LCGA, because that exhibition was one of the best LCGA ever had. Admittedly, the fact that I lived in Mexico and knew it well was a strong incentive. I think every gallery should have such a Tree of Life (*El Arbol de la Vida*) as a part of its collection. It brings in another, much needed, level of reality to any art collection.

VR: *Were you the main selector of work to be purchased for the Limerick City Gallery of Art?*

PMO'R: Yes, though mostly by default. Before the recent restructuring of local authorities there was an Art Advisory Committee in Limerick composed of councillors and prominent citizens. The theory was that as director/curator of LCGA I was hired to do their will. Strictly speaking they could have stopped me and vetoed or dictated to me what to purchase. But I had the support of the late Jim Kemmy, the Committee's chairman. I did everything carefully and quietly. Had I not had Jim Kemmy's support life would have been miserable. This all came about in a very strange way.

When I was interviewed for the job in 1985 I was told there was an Arts Advisory Committee who were there to advise and support me. They had regular meetings and seemed interested in being in attendance. At these meetings Jim Kemmy, would say, 'Is there any correspondence?' It was apparent to me that he expected me to hand over the Gallery correspondence. I passed it off by mentioning a few matters verbally. But I began to resent having a committee like that. It all came to a head in the first year. The question was once again raised, 'Is there any correspondence?' I took offence and got up and walked out of the meeting and went over to City Hall to find the town clerk and

tell him what had happened. I didn't find him so I wrote a note, which he only read the next morning. Then I went to the railway station to go home. One of the Committee members ran up the station platform to get me and took me off the train and told me I had done something terrible; no one in memory had ever walked out of such a meeting. So they hadn't ended the meeting. They had adjourned it. And I was in deep trouble. After discussions with the town clerk the next day I learned to my surprise that I had a mistaken idea of the Committee. I was to go into the reconvened meeting and apologise for the offence I gave in walking out. I did so and said I hadn't understood the situation and probably wouldn't have taken the job to begin with if I had known. They accepted my apology and closed the meeting. So it was never recorded that I walked out. From then on Jim Kemmy left me alone. I was never challenged again. I had apologised. I never went out of my way to make trouble and I didn't become his buddy. There was mutual respect and I was given the opportunity to do what I wanted. I bought what seemed best for the permanent collection as a whole, not necessarily what I liked, or would have bought for myself.

VR: *What were your memorable purchases?*

PMO'R: Amelia Stein's first exhibition, *In Loving Memory*, consisted of 21 photographs of gravesites, (really still lives) of Muslim, Christian, and Jewish graves. She was truly generous, and LCGA was able to acquire the whole exhibition. The cost was well over the Corporation budget limit of £1,000. Anything over that had to obtain special permission; so I put the memo request to the town clerk, my boss, along with a catalogue of the works in the exhibition. Luckily I happened to be in the building the day he read the memo. He was appalled that I would consider buying such work. I met him on the stairs. He took exception to the subject matter – death, the dead. When I said that the artist was a leading photographer in Ireland with a great reputation and so forth, he calmed down, took a deep breath, and accepted the risk that he might eventually be criticised for supporting my

judgement.

There was another photographer whose whole exhibition was bought by LCGA. Anne Brennan was a student at LSAD, a nun, a mature student, who had been teaching art in Nenagh. She came to LSAD with the approval of her order to get the diploma qualification. She was one of the first mature students. She was lovely, but a bit timid, and, as an older woman, condescended to and barely tolerated by some of the LSAD staff. In her last year she turned in desperation away from painting to photography and started photographing the people she knew in Nenagh. She had the technical help of an English photographer who was then on the staff. The work was put up for the end of year show, and the staff accepted it with relief but didn't rate it highly. When Cecil King and the NCEA came down to judge all the work they were bowled over by her work and gave her a distinction. King later actually bought some of the work for his own collection. Within a year she had a one-person show in the Belltable Arts Centre; it consisted of portraits and was called *Faces*. This happened in the early 1980s. When I landed the LCGA job I went to Anne, who had also been selected for ev^+a and had gone back to her life as a nun and art teacher, and asked her if she would reconstitute *Faces* and allow LCGA to acquire it. She agreed. After Cecil King's death, Oliver Dowling, his executor, loaned and then generously gave the work to the Gallery in King's memory. So this whole exhibition, too, is now part of the LCGA collection.

VR: Did you buy much student work?

PMO'R: I made a practice of going to all the art colleges for the end of year exhibitions. The strongest stuff was often in ceramics and design. I bought jewellery, ceramics, teapots and so forth. This was a way of stretching the boundaries of the collection into design as well as art. In this way, two or three examples could help to strengthen the collection as a whole. In the case of the late Sarah Ryan, for instance, there are nine of her ceramic pieces now gracing the collection.

VR: Would you often buy from the exhibitions in LCGA?

PMO'R: Only sometimes when this could be afforded. The acquisitions budget was never very large; for a long time never more than £5,000. For instance, LCGA acquired a Richard Gorman, *Sojer* (1992), out of his major touring exhibition that came to Limerick. I felt the collection needed a good example of this kind of abstraction. We worked out a deal whereby he was paid in increments so that I could pay it in amounts of less than £1,000 and so not have to seek special permission. It hangs now next to the Robert Carver *Landscape* of 1754; they are family and share a similar gracefulness.

VR: You had an enormous number of exhibitions each year.

PMO'R: Yes, eventually the number reached 40 in 1996, only one of which lasted less than three weeks; and with a few such as ev^+a lasting more than three weeks. This was possibly due to the fact that two, three and four exhibitions could run at the same time, given the pattern of how the nine various galleries were set in a cluster around a centre space. The reason why so many exhibitions were mounted grew from the fact that so many artists were in need of audiences, and audiences, I felt, were in need of contact with what artists were doing; this seemed to be the proper role that LCGA should play. Years earlier while working for ev^+a on tour in Kilkenny, I learned that it seemed to take a lot of people a long time to put up and take down an exhibition. There is always a gap between when a show comes down and the next one goes up. I learned in LCGA that I could close a show at 1pm on Saturday afternoon and often have the next show up and ready for the audience by 10am on Monday, if I was willing to work weekends. I didn't mind that at all. I had a mattress and a blanket so I could, if need be, sleep there on the floor in the Gallery. In doing this I learned something very important about works of art. When it was dark the Gallery was like a graveyard. I was surrounded by the dead. I realised then that artworks only come to life when people deal with them. I worked hard so that the Gallery would never have to be closed

to the public; there was always one or more exhibition available on a regular basis.

I had the responsibility for all that had to be done: wrap, store, hang, repaint the walls, collect the work and return the work by truck. But to tell the truth I often had precious volunteer help in doing all this work. Only when the budget started to increase in the 1990s could I afford to call in Tony Magennis of Fine Art Transport to handle transport of the work. In the long run some of this hard work wasn't a very smart thing to do; I couldn't buy labour-saving equipment; I carried plinths up and down the stairs for years. The wear and tear has given me osteo-arthritis and a present need for new hips and knees. Only in more recent years has the Gallery acquired a handcart, piano wheels and a lift.

Administrating ev^+a meant doing all sorts of busy work, and I had years of experience doing it. So when I went into LCGA I just transferred those approaches and skills to the demands of the Gallery. I had learned a great deal about hanging exhibitions from following the examples the ev^+a adjudicators set in the way they would lay out their ev^+a's. I learned to trust my intuition.

I would move things around in a right brain trance without talking to anyone. If someone was there and asked me to verbalise and discuss my decisions it would all slow down and tighten up. You start to pay more attention to talking about your ideas than you do to the works you are hanging. If I met a persistent problem, going away for a while or sleeping overnight on it usually solved it.

What this means is that if you go about it correctly curating becomes a deeply creative activity. That fits in very well with the philosophy I've adopted from R.G. Collingwood:[2] the audience is as creative as the artist. The person we call the artist takes the initiative in presenting the work of art to the audience; but the audience is just as much an artist in that they have to make their meanings based on what the artist has done. The

adjudicator/curator is, of course, part of the audience and, he or she has great responsibilities. In all, ev^+a gave me the experience and the confidence that I could do the work set before me at LCGA. I had the right grasp. And the Gallery experience soon began to help me do the work of ev^+a better. Over the years I must have dealt with thousands of artists and many thousands of works, listened to them and handled them and hopefully did both the art and the artists justice.

VR: *Let's talk more about* ev$^+$a, *considered by many to be the foremost contemporary annual exhibition in Ireland.*

PMO'R: The nature of ev^+a is that it's intimate and modest; the way it fits into Limerick city is tender. It's not a blockbuster. So far it's never had the intention to blow people away. Yet it has brought into Ireland some of the best curators and artists in the world and it's produced some of the best shows. It doesn't behave like *Rosc* did; it doesn't have the same intention to impress an audience. *Rosc* was a successful attempt and, rightfully so, to be Big. I don't think anyone can take credit for the intimate, modest character of ev^+a. It may just be a function of the budget, which doesn't allow for a blockbuster approach. But I think it has as much to do with the people who year after year support it, especially the artists.

VR: ev$^+$a*'s nature has evolved.*

PMO'R: Yes. There was a step up in the whole profile and importance of ev^+a when in 1994 the adjudicators were asked to bring in invited artists every other year.

VR: *Before that it was open submission only?*

PMO'R: Yes, it's open and invited every other year. This year, 2002, it's open and invited. Next year it will be open only. As the years go by more and more artists apply to open ev^+a, even though an open submission can be considered by some to be a very old-fashioned idea. The Royal Hibernian Academy still runs a part of their annual exhibition by open submission.

VR: *Do you limit the number of artists?*

PMO'R: No. The committee doesn't dictate restrictions. Once the

adjudicator is brought in and agrees to do the job it's hands off. Nobody interferes with what he or she wants to do. The limits of available space and money and time are there but as much as possible everyone co-operates; no one interferes. No one says to the adjudicator you can't select that person or you should select that one. Sometimes there are worries; almost every year there's a risk taken of one type or other. But it's better to accept risks than hamper the curator. Each curator's ev^+a is fully hers or his. Invariably the curators tune in to Limerick. They select the work, tell us where to hang it; they can, if they choose, determine the style of the catalogue, and they write the catalogue essay or statement. They know the money situation and they spend it as they want. They know, for instance, that there are, unfortunately, no funds for artist's fees and they have to negotiate around that problem if they are doing the invited section and bringing in international high-flyers. A great generous spirit characterises the way these people do their job.

VR: *What is the budget?*

PMO'R: It's 140,000 this year – that's cash. The Arts Council, the Limerick City Council, Shannon Development and some local supporters provide this cash. The committee has yet to secure a major corporate sponsor; it's a difficult thing to do for an art exhibition, especially outside of Dublin. As well, ev^+a receives the value of another 50,000 in support, given in kind. Phillips has for years made equipment available without charge; Sisk & Sons Ltd. have given massive technical support; for years Walsh Western helped with storage and transport all over Europe. Then there is on-the-ground support given by people, the citizens of Limerick, to the artists who come to Limerick. This particular year Paul Lynam, a committee member, arranged to find host families who agreed to host visiting artists. Hugh Murray, ev^+a chairman since 1987, of the architectural firm Murray O'Laoire Architects and his wife Brenda hosted visiting artists/curators in their home in Clare. Some years ago ev^+a used to store artworks in Hugh's house when he lived opposite LCGA, on Pery Square.

Over the years committee members drawn from all walks of Limerick's life have, by their devotion to ev^+a, kept it alive.

VR: *What would you compare* ev$^+$a *to?*

PMO'R: The more I learn about the Wexford Opera Festival the more I realise that it sets an example that ev^+a with profit could follow. It's modest in size, enjoys massive local and corporate support and it has a very high international standing. ev^+a is going in that direction already. Of course, there are great differences between what they do and how they do it compared to ev^+a but that combination of size, support and standing is there to be emulated.

VR: *Are the adjudicators/curators always from outside Ireland?*

PMO'R: The first two years, 1977 and 1978, the show was chosen by a committee of Irish artists. In 1977: John Kelly, Barrie Cooke, and Brian King. The artists – Ursula Brick, Tom Fitzgerald, Charles Harper, Kate Hennessy, Bob Hobby, Terence Leahy, Willem Minjon and Dieter Blodau – who founded ev^+a, asked these three artists to do the adjudication. In 1978 the selection panel consisted of Charles Harper, Theo McNab, Cóilín Murray and Adrian Hall. Everyone knew everyone. In 1979 the committee made a big change. They invited a total outsider who knew little or nothing about contemporary Irish art; Sandy Nairne, who is prominent now at Tate Modern. The following year it was Brian O'Doherty, Irish born but, for decades, a New Yorker. With these two very successful ev^+a's in hand the pattern of a single adjudicator was continued.

There was only one year, 1988, when there were two adjudicators. It was a successful approach but hasn't been repeated as yet, though it will be some day. The pattern in this case was as follows: the first one, Flor Bex from Antwerp, arrived; he picked a show, told us where to hang it, awarded prizes, wrote an essay and left. The next week the second adjudicator, Alexander Roshin from Moscow, came in and did the same thing. So we had two ev^+a's back to back for four weeks each. Each worked completely independently of the other. Only 25 per

cent of the work selected was included in both exhibitions. It was unbelievable. They were quite different but both beautiful exhibitions. It was a great lesson in the nature of curation.

VR: *How are adjudicators now selected?*

PMO'R: Each year's adjudicator is asked to recommend to the committee adjudicators for future ev^+a's. The list of these curators includes many who are in the forefront of contemporary international curation. As the list continues to grow the committee tries to keep a mix of men and women and a mix of ethnic background, so that the choices broaden well beyond Europe and North America. Last year's adjudicator was from Africa; this year's was from Thailand; next year it's a woman from Costa Rica. Though the African and Thai curators were educated in England and the States, their understanding of contemporary art is not the same as someone from England, the States, Sweden or Holland. We've had three adjudicators from the Netherlands, two each from Spain, Italy and England. All these people know or know of each other. In this way ev^+a has a guarantee of excellence. The curators also let each other know that Limerick is a great place to do their work. The city is small, coherent and it's on the edge, on the periphery of Europe. All these curators are convinced that the periphery is as important as the mainstream in contemporary art. In ev^+a 1994 the adjudicator, Jan Hoet, the first to do an invited ev^+a, gave a talk expressly calling attention to that idea. These curators work out their ideas and philosophies in ev^+a and put into practice the things that are of most concern to them. They are without exception very generous in the way they work; as a rule they don't receive big fees. Their time in Limerick can be fairly described as a committed, friendly and intimate experience.

VR: *Much of* ev$^+$a *centres around LCGA, although it can spread all over the city.*

PMO'R: LCGA is the home base of ev^+a. As the administrator of ev^+a and director/curator of LCGA from 1985-2000 this idea of an ev^+a home base took on definitive shape but it can't be taken for

granted that LCGA will always provide such a major support for *ev⁺a*, but let's hope it will. The connection is not yet fully structural.

VR: *Were you flattered to be asked to be the* ev⁺a *adjudicator for 1998? Invited* ev⁺a *was in its third year then.*

PMO'R: I was terrified, really. I was blackmailed into it; it was an offer I couldn't refuse. At the initial *ev⁺a* colloquies on contemporary art and culture in 1997, which is now a biennial *ev⁺a* event, Flor Bex (*ev⁺a* 1988), Jan Hoet (*ev⁺a* 1994), and Guy Tortosa (*ev⁺a* 1996), convinced the *ev⁺a* committee that they all thought it was time for an Irish-based curator (they meant me) to take on the job of the *ev⁺a* adjudication for 1998. At the time, for *ev⁺a* 1998, LCGA was closed for renovations and expansion, so there was a scramble for alternative sites. *ev⁺a* 1998 had the work of 41 invited artists and 108 open artists, all selected and hung by myself. Hans Martens came from Ghent to help hang the work on loan from Stedelijk Museum voor Actuele Kunst (SMAK) in the Hunt Museum. He said to me, 'What you have is a *Documenta*'; what he meant was it was a take-over exhibition – it was literally all over the city of Limerick and beyond, to the University of Limerick. It became, by intuition not by intention, a survey of the reigning styles that had featured in open *ev⁺a* over the previous twenty years. It served as a resumé, a recapitulation, in recently made work, of the art styles that came and went in all those *ev⁺a*'s.

VR: *You were saying that you often bought work for the LCGA's permanent collection from* ev⁺a.

PMO'R: Well, not very often; the LCGA budget was never very large. But in the early years sales were common in *ev⁺a*. The desire to own contemporary art was strong then for part of a small, but devoted audience. Today it's not a selling show; increasingly the work is not easily saleable; it's now dominated by installation, video and photography. LCGA itself never took commissions from sales. I never wanted the Corporation to know there could be income from such commissions; they might well have said

'your budget is going to be based to such and such a degree on expected sales'; this would have made me into a seller of works. No thank you.

VR: And it's not a commercial gallery, it's municipal.

PMO'R: No. It's not a commercial gallery. ev^+a does take a 25 per cent commission on sales, but it goes to ev^+a, not to LCGA. But I did try to buy from ev^+a. I wouldn't hesitate if the money was there and the work augmented the Gallery policy of keeping faith with the existing collection and yet pushing and broadening its range in art and design.

VR: Do many people attend ev^+a?

PMO'R: ev^+a is the most popular contemporary exhibition in Limerick, if not in Ireland, and yet it still feels like too few visit ev^+a. It faces the same problem as LCGA. Supposedly it's an accepted adage that if you want to develop an audience you should be prepared to spend 30 per cent of your budget on promotional advertising. Throwing money at the problem is one (successful) way but there must be others. The ev^+a committee continually faces this problem. Based on recent experiences and rather than adopting a broadcast approach, we try to set aside evening visits for specially selected groups. The plan involves inviting ten businesses, one each week of the ev^+a exhibition and offering a company their own special event: a talk, gift catalogues and a tour by hired bus to some of the alternative ev^+a venues. Hopefully if this continues to succeed the approach will build up a confident, interested audience. But it will take time.

VR: There is young ev^+a as well.

PMO'R: Yes. Young ev^+a has depended on the art teachers and students in the secondary schools in the catchment areas of Limerick. As it has developed, young ev^+a has gone through many variations. The basic idea is to foster strong, prolonged contact with young people and put them in close encounter with contemporary artists, ev^+a artists, in a ten-week series of workshops leading to the young ev^+a exhibition, an annual event. Personal contact like that with people works very well. What

ev⁺a hopes to do is to eventually gain their parents' interest as well.

VR: Maybe the language of contemporary art is basically incomprehensible to audiences.

PMO'R: If this is so there are reasons. What I understand is that everyone who walks into a gallery has been trained in a school. They all tend to expect meaning to be available as it was given to them in school. When the teacher in school poses a question, the answer already exists; the students may not know the answer but they know that the teacher knows, or the textbook holds the answer. Answers, therefore, are readily available. Answers are also singular: one right answer goes with each question. School is also devoted to weeding out any doubts, paradoxes or ambiguities. So when people come up against contemporary art they tend to expect that a singular, clear and readily available meaning should be there for them. If it isn't there they either fault the artist or themselves and cease to listen.

Now in life, on the other hand, there are few if any ready-made answers to most of the questions or problems people face. There can certainly be many different answers to any one question; meaning can be various; and sometimes for prolonged periods there is no answer at all. In life we have to put up with paradoxes, doubts, contradictions, and ambiguities. So in dealing with contemporary art people should really apply the criteria for meaning found in life not the ones found in school. Contemporary art fully witnesses to how we actually live. School and its ways have little to do with art or the way we live. Art, especially modern and contemporary art, is based on mosaic patterns of organisation. The school model favours a linear, sequential, connected and narrative pattern. Sometimes you may need that particular technique in life, but mostly life and art are committed to the mosaic pattern.

In a gallery you try to encourage the audience to listen to the works of art. You try not to do anything that might diminish their chance to listen. Sense or meaning in a work of art is

not readymade; there's no guarantee that the audience will copy or acquire the same meaning as the artist has. Once people realise that the meaning of an artwork is for them to make, that there's not some secret readymade meaning available for them, they can come to the work just as they are and who they are; then the meaning they make is their meaning and if they have listened to the art work, their meaning will have a strong rapport with the artist's meaning.

VR: Are you working with a particular idea of what art is here?

PMO'R: R.G. Collingwood[3] claims that art is (as he puts it) the activity of consciously expressing emotion. This means that art is the basic human activity that everyone of us is engaged in at any time. The normal humdrum everyday result of this activity may not deserve to be considered worthy of being in a museum but the activity is the same for all, even if the results greatly differ.

VR: Do people know they are potentially artists, and is the gallery where they learn it?

PMO'R: I'd say most people have some idea that they engage in this kind of activity but only a few would dare to call it art. The art gallery is an artificial place. The Enlightenment tore art out of the churches in the eighteenth century and now art is detached for the most part from any sacred or spiritual space. The gallery can serve art as an oasis, a place of meditation, like a chapel. Some people can sense the artificiality of the gallery, its elitist claim, and that's why the gallery is sometimes spurned today; it is so greatly detached from normal life.

There is a small but curious thing that can deeply affect people's idea of a gallery. All works of art say, 'Touch me'. They appeal to all the senses. But a gallery can't allow people to actually touch the works of art. The way I dealt with this problem was to simply change the labels from DO NOT TOUCH to PLEASE DO NOT HANDLE. You can't stop people from touching works of art imaginatively, but you reasonably can expect them not to handle the works.

VR: Might the art gallery become dispensable?

PMO'R: For us it's indispensable, if only because many if not most works of art have nowhere else to go, they are literally homeless once they leave the artist's studio and if they fail to find a collector's home to live in.

VR: *The concept of the gallery as a kind of foundling hospital is interesting. Or a store room?*

PMO'R: Lots of artists today make work that's meant to belong outside the gallery. They want their work to be embedded in ordinary life. That's a healthy, intelligent attitude towards the artificiality of the gallery. The gallery remains a haven, an oasis, a temple, a storeroom, a treasure house, even a laboratory. Presently in Malmo, Sweden, there's an attempt on the part of the new director of the Rooseum, Charles Esche, an Englishman, to have the Swedish Government formally accept the gallery as The National Laboratory of Culture. He wants to phase out the mounting of ready-made exhibitions and turn the place over to studios where artists can pursue a wide variety of experiments in culture. What they won't necessarily have to do is end up producing works of art aimed at exhibitions.

VR: *Is that an isolationist approach to culture?*

PMO'R: Esche has latched onto a possible way of escaping the artificiality of the gallery. But at the same time, if you reserve the word culture for high quality, elitist productions by experts, you're recycling the nineteenth-century academic idea of fine art culture. The way the anthropologists use the word culture seems more proper. Culture is a cover word for all the ways people behave. It's an inclusive term for all our behaviour, from how we choose to live to how we arrange to die. What relates to this issue is what Collingwood says about art, the art activity, that it is always present, at stake, in everything we do.[4]

VR: *So did Duchamp, more or less.*

PMO'R: Yes as did Kurt Schwitters. Collingwood didn't claim to originate such ideas. He recognised them as already under discussion in his time. His work, *The Principles of Art* was published in 1938 and he died in 1943. The pity of it is that

the Second World War intervened and circumstances have effectively prevented any continuity of his ideas from developing ever since.

VR: You're concerned about what you call the visual bias of western culture and its influences on how we make and respond to art.

PMO'R: Western culture is visually biased. That's been the secret of its enormous power and influence throughout the world over the last centuries. The visual basis holds that the sense of sight is the most important sense; a myriad of western technologies, telescopes, maps, microscopes, radar, etc., all demonstrate that bias. Sight and its extensions maintain this dominant visual bias in western culture and in those cultures that come under western influence.

VR: That's a big theme in Rebecca Horn's work.

PMO'R: A lot of artists try to work against or out from under this visual bias. In Mexico 30 years ago I studied with a psychologist, Dr Douglas Carmichael, one of whose recommended texts was Arnheim's *Art & Visual Perception*.[5] While attending his course – one of the numerous post-graduate courses I spoke about – I bought a paperback of Marshal McLuhan's *The Medium is the Massage*[6] in a supermarket in Mexico City. McLuhan aptly complemented what Carmichael said: that there were many more senses than five; but that people are still convinced today that perception is as the Greeks said it was, based on five separate senses with sight of primary and hearing of secondary and the others of little or no importance. At the time psychologists didn't have names for all of these eleven senses that Carmichael discussed. Many of them were internally rather than externally orientated. The truth about perception is that you 'see' with your whole body, with all the senses in action; 'seeing' is a fully perceptual activity; all the senses are integrated, mutually involved, always present to each other in behaviour.[7]

More and more it seems to me that the lens/screen based art practice of today is re-asserting and deepening the visual bias. The materiality of artworks seems less and less important

in what the artist sets out to do. The photograph rejects or represses the sense of touch. Physical reality seems bypassed by the speed and character of chemical and electronic processes. In many cases the photographs on exhibition are not developed by the artist, they are produced by technically expert photographic processors, and the intimacy basic to fabrication seems lost.

The academic criteria of nineteenth-century art emphasised sight over all the other senses. It waged a systematic programme to suppress the other senses in favour of sight. You have to relive the experience of being deeply conditioned to academic criteria to realise the inherent disadvantage of this visual bias. Those artists we know of as modern in any of the various ways modern movements happened, were artists who were able in one way or another to throw off the bias, to work against it; to their and our great advantage when we consider what they accomplished.

VR: *Drawing from casts of antique sculptures, or sections of sculptures, was not a fully perceptual experience, certainly.*

PMO'R: Some artists realised that they had to retrain themselves, retrain their perceptions in order to fully express themselves. Impressionism was one way of dealing with the world afresh and it brought back the intuitive perceptual act of painting, put touch back into play. The fauves broke free of academic constraints but for all their innovative use of colour they kept it subservient to emotional licence, the role the academic system had long imposed on colour. The cubists brought back intuitive play in structure and composition but still relied on line and tone as they retrained themselves and only let full colour into play after several years spent recycling the severe constraints of line and tone that marked the academic system's attitude to colour. Surrealism, for all its breakthrough innovations, still favoured the tight academic emphasis on the representation of literal-visual detail. Even today the visual bias continues to perpetuate itself through all the radical or revolutionary attempts contemporary artists make to negate or escape it.

VR: How does contemporary architecture help to encourage dialogue between artwork and audience?

PMO'R: It seems to me that what we find happening in architecture today supports Collingwood's contention that everyone of us is an artist. At the National Sculpture Factory symposium on public art in the RHA Gallagher Gallery last year the architect Ian Ritchie, the designer of Dublin's 'needle' said, 'I hope you artists realise that architects are artists too'. What he was doing was underlining the sense he had of his own discipline as a fully-fledged art activity or process. This conviction is demonstrated by the way architects work today. They have taken over total responsibility for what a building becomes, often to the exclusion of what the building is actually for. This situation is exemplified by lots of high profile galleries, which often end up as awkward places in which to show other artists' art. They are really designed to enhance or express the role of the architect as artist. Every surface, every material inside and outside, is fixed in place by the architect's will to over-design. No neutral walls or floors are left for works of art. When the artworks are forced to compete with the design sense of the architect they invariably lose. Over-designed ceilings become muscle-beach features. This new architecture often contradicts the very purpose that the space is dedicated to. The problem lies in the fact that the architect does not trust the artist and vice versa. It's a distrust that's based on a lack of understanding, one of the other. The root of this is in the academic tradition that started in the sixteenth century, where responsibility for fostering various art forms was taken from the guilds and the patrons such as the Church and given over to separate schools of study. Previously architects were often also sculptors and painters. All worked in partnership. Once they specialised into separate schools of art, painting, sculpture and architecture, they began to lose the understanding, the rapport, with what the others did or could do.

VR: Does the percent for art scheme bring them back together?

PMO'R: That scheme seems to recognise that they should work together. But it's flawed partly by the fact that in the scheme art is considered to be worth only one per cent of the value of the architecture. In any case artists have lost the ability to think or want to think like architects and vice versa. Why should the architect trust the artist? The artist not only doesn't know about architecture but doesn't care. We sense something is wrong but we haven't the solution. The solutions we've tried to adopt so far have been flawed. If anyone had a comprehensive attitude to architecture it was Frank Lloyd Wright. He was sensitive to this breakdown between architecture and art. In the 1930s he formally invited José Clemente Orozco, the master Mexican muralist, to work with him in collaboration. The story goes that Orozco refused because he distrusted Wright, who was an architect with a reputation for being authoritarian. The artist is an endangered species in this situation and the architects are, knowingly or not, co-operating in the eradication of the species. A recent exhibition in Limerick by the artist, Gerard Byrne, had a single photograph, a large-scale one, pinned to the wall, all by itself, in one of the galleries. It depicted a man walking a New York city footpath with a placard saying 'The End of Architecture is Nigh'; wishful thinking on the part of the artist. The thinking behind the Limerick City Council's *Strategy for the Arts*, just published, is that the artist is a stakeholder in the city's future ventures. That's the vocabulary. The artist might well end up holding the stake that has pierced his heart. One of the ironies is that there are more and more people studying art and there's seemingly more and more money for the arts, yet artists as artists are an endangered species.

But maybe it's a good thing that the inherited idea of artists as special, exceptional people is in danger of disappearing. Maybe the word artist will no longer be used to describe special, elite, creative people and Collingwood's idea that everyone is an artist will become widely accepted.

The more advantages we seem to be getting as artists, the

more attention that is paid to us as artists, the more insecure we feel. The threat that business ethics might take over the administration of the arts is there to worry about. 'Clean up your act and follow a business model of efficiency' is now an attitude that is being foisted on arts organisations and artists in the name of professionalism. Does all this really foster art? I wonder.

The enormous increase in the market value of works of art also unsettles anyone who gives thought to what is happening to art. We hear about art sales through news items, such as the amount a Rubens painting makes as the second most expensive painting ever sold. These issues and these events point to a need that attention be paid to them.

VR: *Finally Paul, can we just recap? What is your sense of how modern and contemporary art happened in Ireland?*

PMO'R: I have great admiration for Jellett and Yeats and all those modernists we recognise as innovators in the story of modern Irish art. We do recognise, of course, that they were peripheral to what was going on in Europe. Yet they felt a need for radical basic change and they sought it in Europe, years after the innovations they were interested in were already well established. All that they did is still admirable. I have great time for people like Paul Henry and his wife Grace. They are not world shakers. They are very modest. Perhaps even Yeats is not a world shaker, although Kokoshka seemed to think he was. *Living Art* was nearly 35 years old when I came to live here in 1977. It was one of the major ways in which Ireland listened to and incorporated those modern changes.

That pattern of artists being on the periphery and then deliberately moving into the mainstream for the sake of change continues into today's contemporary experience. But the example set for artists today in the mainstream is a lot different. Artists still have the ability to adapt, to change, and to bring home the results of those changes. Artists in Ireland are still motivated to do that. But today you don't have the same high regard for materials, for colour, composition, and structure that

characterised the Irish modernists who followed the examples set by Matisse and the cubists. Today lens/screen-based work dominates contemporary attention. Generally what you have today is all the different styles un-peaceably co-existing. It's a turbulent mosaic of everything that has happened in the last hundred years. A supermarket of styles, a consumer's dream and for some people a nightmare from which we may one day all awake – not a moment too soon.

Interviewed 11 June and 24 July 2002

1. O'Reilly, P.M. (ed.), *Kingdom of Heaven, Selected Juxtapositions, Old and New, Drawn From The Permanent Collection of Limerick City Gallery of Art*, Oysterhaven, Gandon Edition, 1999.
2. Collingwood, R.G., *Principles of Art,* London, Oxford University Press, 1938, pp 321-324.
3. *Ibid.* p. 273-275.
4. *Ibid.* p. 285.
5. Arnheim, R., *Art and Visual Perception*, California, Berkeley, 1954.
6. McLuhan, M. with Fiore Q. and Agel J., *The Medium is the Massage*, New York, Bantam, 1967.
7. Collingwood, *op cit*; p. 144 ff.
 McLuhan E. and Zingrone F., (eds), *Essential McLuhan*, London, Routledge, 1995. pp 135-139.
 Nickolaides, K., *The Natural Way To Draw*, Boston, Houghton and Mifflin, 1938.
 Cayley, D., *Ivan Illich In Conversation*, Ontario, Anassai, Concord, 1992, p. 281.

*Dorothy Walker talking to Joseph Beuys
at the* Venice Biennale, *1980.*

Dorothy Walker

*Dorothy Walker, neé Cole, was born in 1929 in Dublin and was educated in
the Dominican Convent, Wicklow, and the École du Louvre, Paris. She and
her late husband, architect Robin Walker, had five children and six grand-
children. A freelance critic and curator, she served on many boards and
wrote three books. She lectured worldwide and lived in Dublin until her
death there on 8 December 2002.*

VR: *Dorothy, in the early 1970s you suggested to Joseph Beuys that he might apply for the job of director of the National College of Art and Design.*

DW: There was a dreadful tradition in art education up to the 1960s where the president of the RHA was professor of painting at the College of Art.

VR: *Yes, the RHA was very allied to the College in Kildare Street from the late 1930s to the late 1960s.*

DW: The academic tradition was built into the system. Finally students revolted and some staff revolted with them. Maurice MacGonigal, PRHA, resigned. The students sat in, and police came to get them out. Some staff were fired – people like Alice Hanratty and Paul Funge and some others who were protesting about the perpetuation of the academic tradition. The College was closed and when it was closed and they were advertising for a new director, I read an interview with Joseph Beuys in *Studio International.* He had been fired from his job in the Academy in Dusseldörf at that stage. I thought his general views on education were wonderful – free and open. I wrote to him out of the blue, without any authorisation, and asked him would he apply! I never heard another word. Eventually he came to Dublin in 1974 with the drawings, *The Secret Block for a Secret Person in Ireland.* Robin (Walker) had been ill, with double pleurisy, and so we went to the country and stayed. I went back for the opening at the Hugh Lane and everyone said 'where were you, Joseph Beuys is looking for you'. We started talking about his idea for the Free International University for Creativity and Interdisciplinary Research. He considered himself of Celtic origin – he came from Cleves on the German border and he was very interested in Celtic mythology. This drew him towards Ireland and Scotland. We started looking at venues for the University and for about three years we looked. We had a wonderful day up at the Royal Hospital in Kilmainham, which then had the folklore collection from the National Museum. He was fascinated with things like the mantraps. We sat out on the grass

and found wild sorrel and ate it. It was absolutely impossible to take on the RHK at that stage – it eventually cost £22,000,000.

VR: *What was the general response in Ireland to Beuys's idea of the Free University?*

DW: Some people in the universities were very enthusiastic. But George Dawson wrote a letter to me and Robin – Robin and Beuys got on very well – saying there was no way anyone would get a decent education. It was all amateur. I was particularly in favour of the interdisciplinary aspect – professions can be very specialised and blindfold. It's how you have this attitude to the arts among doctors and accountants, they are not exposed to the arts. Beuys's idea was that the whole thing would be based on projects, paid for by industry or the EEC. It was a time of terrible recession, it was after the oil crisis. People said 'are you mad' and ran away.

 The Marist fathers were closing a school – it was the birthplace of Robert Emmet. It was full of holy pictures. We could have had that. But Beuys, I think, was beginning to be afraid of being locked into staff issues and bureaucracy and it never happened.

 He thought he could solve the problems of Northern Ireland. He was working with a young man called Robert McDowell. They set up a community centre where people from both sides could come, and have coffee together. But some people just ended up spying on one another. He lectured in Dublin, Belfast, Limerick and Cork; they cleaned the blackboard with his drawing on it in Belfast, the same in Cork. Some of the blackboard drawings are now in the Ulster Museum; they have four, Hugh Lane has three.

VR: *You've been researching a book on Beuys in Ireland.*

DW: It's not widely known that he had a connection with Ireland. Ireland had a huge influence on him. In the piece, *Irish Energy 1*, 1974, in which he sandwiched two briquettes and a pound of butter we can see that. He was very interested in the changing properties of materials. After that Hugh Lane opening he came

over here the next morning, and the ashes were in the grate. He picked up the turf and said does that become that? He was fascinated.

He went to the Giant's Causeway. His project for his last *Documenta*, in Kassel, in 1982, was on the square. The sculptural part was the basalt columns. He filled the square with them. It was immediately obvious to me that it came from the Giant's Causeway in the North.

He was very interested in Irish literature. He wrote an extra chapter for Joyce's *Ulysses* on Joyce's instruction ...! And Beckett surfaces in works like the piece he did in Venice in 1976, *Tramstop*. It connects with *That Time*, there are parallels. Caroline Tisdall quoted Beckett in the catalogue note about the piece.

But he'd never heard of Flann O'Brien. I said he had to read *The Third Policeman*. His last performance before he died was *Is it about a bicycle?* – the first spoken words of *The Third Policeman*! There is a book by a French writer, it's called *Is it about a bicycle?* I found it in a library in Paris. I was rushing for my plane so I skimmed through it. It's a long interview with Beuys and it's very important.

VR: *Robin (Walker), your husband, was a partner in Scott Tallon Walker, the architectural firm, and you've written a book on Michael Scott,*[1] *the founder of* Rosc.

DW: We started doing tape recordings ages ago – I can't remember the exact date. We did lots of tapes. Then Michael lost the tapes for ten years. The housekeeper found them eventually. I happened to mention this to the publisher John O'Regan and he got very excited. We started editing them. John was very helpful and they did a beautiful job on the book. Michael had written nothing himself. It's an overall view of the man, but there is serious architectural stuff in it.

I started working for Michael Scott in 1961. I ran the design firm Signa in the same building that the architectural firm was in, in Merrion Square, designing all sorts of things, like

the trains which have Patrick Scott's colours; black and tan and white. Signa was set up by Michael Scott and Louis (le Brocquy). Louis designed the original logo for RTÉ; it was a St Bridget's Cross. Michael Scott had included art works in the buildings from

Left to right, Patrick Scott, Dorothy Walker, Richard Svaarre, Morris Graves and Patrick McLarnon, Henrietta Street, Dublin, circa 1961.

the very beginning – the Irish Pavilion in New York is the obvious example – he commissioned Keating of all people, and Herkner, professor of sculpture at the College of Art; for a short time I did some night classes in sculpture with him. Ronnie Tallon bought the whole series of Ballagh's *Figures Looking At* for the Bank of Ireland headquarters in Baggot Street. Between Robin being an architect and me writing about art it meshed very easily. He commissioned a lot. He gave Patrick Ireland his first commission, in UCD. It's called *Newman's Razor* and it's in the sunken courtyard of the restaurant building. It's a homage to Newman, founder of the university, and it quotes Ockham's 'it is vain to do with more what can be done with less'. That was known as 'Ockham's razor'. It's a precursor of Mies van der Rohe's 'less is more', in a way.

VR: *Robin designed this house, so close to Baggot Street bridge, yet*

it seems an oasis of green.

DW: We bought the end of Dr John Larchet's garden. Robin was very keen on orientation. He was obsessed with getting light. We get every possible bit of sun. It's a corner site which is a double site but it's small - the size of a council house – 1,400 square feet.

 Robin was totally convinced by Mies van der Rohe. We built it in 1964. Before that we lived in my flat in Fitzwilliam Square. The house certainly corresponds to my taste – I love it. Ronnie (Tallon) built his own home too, it's in Foxrock and very grand. Michael (Scott)'s house is wonderful.

VR: *Wasn't Michael Scott on the Arts Council?*

DW: Yes. Fr Donal O'Sullivan S.J., director of the Arts Council, married us – Robin converted when we married – and baptised all the children. He was a very close friend of Michael Scott's. Michael Scott's best friends were Fr Donal and Monsignor de Brún,[2] who had been a professor at Maynooth and was then sent to Galway as president of the university. Seán O Faoláin was director[3] before that. Inevitably he was interested in literature. Fr Donal was totally interested in the visual arts. On the Council he had Michael Scott, George Dawson and Sir Basil Goulding.[4] They were the three visual arts heavyweights; also James White.

VR: *Fr Cyril Barrett S.J. was quite a visual arts heavyweight too.*

DW: Yes. He organised two very influential shows in the Hendriks Gallery, the kinetic exhibition and the Italian Arte Povera show.

VR: *Quite a few clergy supported modern art then. Had you a social life that overlapped with your artistic interests?*

DW: I always loved having people coming to the house. There's nothing I like better than cooking for friends, not big groups, maybe six. I love cooking.

VR: *You sometimes lent your summer house in west Cork to artists.*

DW: Clement Greenberg stayed with us at Bothar Buí. The first artist we lent it to was Eilís O'Connell, but she found it lonely. Michael Mulcahy wintered there for five years. I suppose it gave him a boost. We were hardly ever there in the winter and there was the

big studio, so it was ideal.

VR: *Have you been friendly with many artists over the years?*

DW: I've always tried to stay in touch with expatriate Irish artists. People like Brian O'Doherty and Sean Scully.

VR: *Did you see the performance in the Project in 1972, in which Brian O'Doherty changed his name to Patrick Ireland? Like Beuys, believing then that art could influence politics.*

DW: Yes, he has stayed with the name change. It was a response to Bloody Sunday. In a way I felt partly responsible; I wrote him a passionate letter about Bloody Sunday. That was January, he did the piece in November. It was part of *The Irish Exhibition of Living Art* at the Project. Les Levine had a video piece on the British army in it.

Brian King and Robert Ballagh carried Brian (O'Doherty) into the space. Brian (O'Doherty) was wearing Robin's white pyjamas and a white overall/coat of Gordon Lambert's. Robin always wore white pyjamas from Brookes Brothers in New York. Brian came over to the house to borrow them. For the performance he lay on a dais and Brian King and Robert Ballagh started painting the pyjamas, green on one end, orange on the other, and the white of the pyjamas created the tricolour in the middle. But they continued painting until green and orange merged symbolically. He made a legal change to his name, it was drawn up by a solicitor, and witnessed by Brian King and Robert Ballagh; he would stay as Patrick Ireland the artist, until the British Army left the North and all citizens had civil rights. The *Living Art* committee was very good in 1972. They were all male, they were good artists like Robert Ballagh and Brian King, but *Living Art* had always been women, it had had women presidents, and the men weren't as good at the committee work.

VR: *Were you interested in performance art and new media from the beginning?*

DW: I was always on the look out for more adventurous thinking in art practice. I liked being challenged to see new things. I still do. Nigel (Rolfe) did some very early performance pieces. I remember

bringing William Scott to one. Nigel covered himself with red pigment, which fascinated William Scott.

In the early 1980s in Lyons, in France, they had a performance festival and I was invited to speak. They published the proceedings. I did quite a lot of work in France, I'd been a student in Paris so it was easy for me to take part in conferences and to write in French. I was commissioner for the Paris *Biennale* in 1980 and 1982. Cecil King had been commissioner for it in the 1960s.

VR: *You'd known Louis le Brocquy well before you wrote the book[5] on him.*

DW: I was commissioned to do the book. I thought I would reiterate his way of doing multiple view portraits by getting multiple views on his art from a variety of writers. It wasn't just a straightforward book. There were very good pieces, like John Montague's and Seamus Heaney's, and Louis himself wrote. So I was as much an editor as a writer. Louis was very helpful. That was 1981, we did it in six months.

Louis had gone to London after the war, in 1947. He did become quite successful in London, with paintings like *A Family*. The white relief torsos and spines were based on Anne's spine, she'd had this horrendous riding accident. When they married in 1958 they moved to France. He was coming and going to Ireland all the time. He was very close to Francis Bacon but Louis's work is not as violent as Bacon's. He always said that Bacon's influence was responsible for the exhibition of the 100 heads of Yeats which he exhibited at the Musée d'Art Moderne (de la Ville de Paris). He had a very good gallery in Paris and had a wonderful exhibition in Galerie Maeght in the South of France. In spite of the fact that he lived in France, he sold more here than in France. He has concentrated on father figures like Yeats and Joyce. People can relate to that very easily. He's an indefatigable worker. He had his studio in France until he moved back here two years ago. He did the watercolours here.

VR: *Which other expatriate artists have you kept up with?*

DW: Scully, Sean Scully. He's a close friend. He had an early show in the Douglas Hyde Gallery and I didn't agree with the catalogue essay. So I wrote to *The Irish Times* saying so and we became friendly from then on.

VR: *His proposed donation of his own work seems not to be coming to Dublin?*

DW: Yes, we're missing the Scully donation. He offered 30 major paintings, including the *Catherine* paintings, 30 works on paper – pastels, prints, watercolours, drawings, plus his archive. It was to go to Stack A on the Quays, at North Wall.

The Department of Arts, Culture and the Gaeltacht wanted Stack A to be a transport museum. Had they ever heard of Sean Scully? One-third of the museum at Stack A was to be for the Scullys.

The only people who showed real interest in the Scullys were the OPW; that was Barry Murphy. They got their solicitor to draw up a deed of trust to donate the work to the people of Ireland and Sean came to meet them. But it didn't happen. It's a major scandal. The things that are turned down!

VR: *Was there trouble earlier over a work of his to be acquired for the Hugh Lane?*

DW: There was a scandal over a Scully called *Field*. It was costing £20,000 or £30,000, roughly. The curator Ethna Waldron wanted to buy it. The Advisory Committee was mostly composed of city councillors, but they turned it down. She propped it against the wall, and didn't take the polythene off or make any plea for it. There was a donor lurking whom I thought might buy it and present it. But we couldn't do it. So a museum in Denmark snatched it up immediately.

VR: *You were on the Advisory Committee to the Hugh Lane for some time.*

DW: I was on it for eight or nine years. That was before it had a proper director. It was just a curator in charge. James White made that Gallery. He opened it up. Before he came it was like it was after he left. A mausoleum. Barbara (Dawson) has made

such a difference too. The City Council run it. I remember Gordon Lambert, Mary Mooney, some Fianna Fáil councillors and myself buying a Tom Fitzgerald sculpture.

We were interested in buying a James Coleman. In those days, they weren't that expensive, I think that was the early 1980s. He always wanted to change the piece, and to have a say in how it was shown. *Clara and Dario* was a video and installation piece that had been shown in Milan in a different format. It was wall-sized photos of Clara and Dario holding very typical James Coleman conversations about their childhood memories. He reduced it right down. It was shown in the Douglas Hyde retrospective of Coleman (in 1982). It is a lovely piece. It was early days in video, there is still a problem in showing it.

We did buy a Patrick Ireland piece of sculpture which is there.

The Advisory Committee had all these councillors from the City Council. There was one notorious fellow. We were offered a Rabinowitch floor piece, it was steel and slate. This fellow said he wouldn't put it outside his door as a doormat. They thought art should be paintings of the west of Ireland and a few portraits of bishops. All they really wanted was Seán Keating and Maurice MacGonigal. Academic painting. Seán Keating hated modern art, he influenced a whole generation. The Hugh Lane had turned down Rouault's *Christ and the Soldier*.[6] Some said it was an insult to religion. It was taken into sanctuary in Maynooth, and eventually made its way back to the Hugh Lane.

We got a better committee going; for a while; I think it was seven feisty women. We bought the Agnes Martin from *Rosc '80*. Gay Byrne held up a black and white newspaper reproduction on the Late Late Show, saying 'can you imagine paying public money for this blank canvas?' He was the arbiter of everything in Irish life then. He was dismissive of contemporary art. Would they ever actually look? Did he ever go and see the Agnes Martin? Probably not.

VR: *Do you remember many donations of important modern paintings*

– as good say as the Beit collection of old masters at the National Gallery or the Hunt collection in Limerick – coming into Irish museums and galleries in those days?

DW: Evie Hone left wonderful paintings to the National Gallery. The Cézanne, the big Picasso, the Juan Gris.

Through Stanley Mosse, Basil Goulding set up the Contemporary Irish Art Society, to buy for the Hugh Lane, when it had no purchasing fund. Basil gave a lot.

Basil had a wonderful Tàpies painting, but his widow sold the best pieces in London when he died, and I remember seeing the Tàpies in Scotland. It broke my heart that it wasn't in an Irish collection. Basil and Gordon (Lambert) were the first real collectors, but there wasn't such a person as a 'collector' then really.

Now there's Lochlann Quinn, and the Fergusons, and Patrick Murphy and Maurice Foley and Paul McGuinness, and the Donnellys.

VR: Do you see yourself as a collector?

DW: No, sometimes I do buy; almost always impulsively.

VR: When did you start writing about Irish art?

DW: I started writing in *Hibernia* in 1967 and wrote there for ten years. I had started before that on radio. We used to have critics' programmes. All through the 1960s I was pregnant with one child after another, and radio was a great medium for a pregnant woman.

More and more art criticism has been taken over by people writing for colleagues. I was writing for the public. I wrote in a very unacademic way, but I hope with clarity. People were afraid of going into art galleries. I wanted to get them in there. I wrote in *Studio International*. I was contributing editor for a few years. I wrote in *Flash Art* and *Art in America*. One of the people I really pushed in the beginning was Aidan Dunne. I'd asked to do things and I'd pass them on to Aidan. Likewise with Caomhín Mac Giolla Léith. He's a real academic and very widely read and widely travelled. It was Ryszard Stanislawski who suggested that I join AICA, the association of international critics of

art. Bruce Arnold and myself set it up again in Ireland in the 1970s. James White had set it up here in the 1950s, but it had faded. I ran for president in 1980. I was opposed by the Russians, who were putting forward a Romanian guy, the French backed the Romanians.

AICA was a good way of publicising Irish art.

VR: *You wrote for exhibition catalogues, and are associated with several major exhibitions.*

DW: I did all the dog work for the first *Rosc*. Typing the letters and so on. I was quite determined it would go ahead, so I gave maximum support. It was mainly Michael Scott and James Johnson Sweeney. James was belligerent, an emperor. Anne Crookshank had just moved from the Ulster Museum to Dublin that year and was on the first committee. She didn't get on with Sweeney.

Rosc '67 made such an impact, it really affected people. There were wonderful Soulages paintings. Soulages came over to Ireland – I've stayed in touch with him ever since. His show of all black paintings in the 1990s, *Noir Lumiere* was wonderful. I love the paradox of black light. There were Lichtensteins and Rauschenbergs and a big Barnett Newman, *Who's afraid of Red, Yellow and Blue II*, later bought by the Stedelijk, in Amsterdam.

When he came over to our house Barnett Newman was fascinated by a portrait of my father, done by his son from his first marriage, which had a mirror behind his head acting like a halo.

There was such an air of opportunity and optimism in the 1960s. The Picassos in the first *Rosc* were late, and very much derided at the time. There was a nude and a big profile head of a woman. He was still alive then. *Rosc* was to have 50 living artists from all over the world showing three pieces of recent work. They had very international juries. Sweeney, of course, travelled all over the world. *Rosc '67* was painting only. In 1971 they added sculpture.

The three jurors were taken to see the gold in the National Museum and were bowled over. They said 'why don't we show

the old with the new'. People didn't want the treasures taken out of the museum and brought over to the RDS. The Irish Countrywoman's Association did a sit-in in Carndonagh in County Donegal to stop the OPW moving the Cross. The Tau Stone cross from County Clare was temporarily 'stolen', so that it wouldn't be in *Rosc*, and the owner 'stole' it back again and put it in the car and brought it up to Dublin himself. *Rosc* was a household word before the exhibition opened. It made people aware of their antiquities. There was great excitement at the opening night. As soon as people saw the modern art all the fuss about the antiquities was forgotten.

They were stirring times. Charlie Haughey opened *Rosc '67* and made a very positive, almost aggressive speech about people obstructing the progress of art. He was very supportive of *Rosc*. Cultural tourism was a pretty revolutionary concept then, but Tim O'Driscoll at Bord Fáilte was very strong on it and helped a lot.

Poor Michael Scott had a heart attack and so he wasn't at the opening. He had a really bad one a few years earlier. He started thinking about *Rosc* when he was convalescing in Lord Killanin's house in Galway. James Johnson Sweeney had a house near Newport in County Mayo, and Michael went to stay with him. They were great buddies, and they started plotting *Rosc*. Our son Corban was born in June of 1967. *Rosc* was in the autumn and James Johnson Sweeney was his godfather.

VR: *Corban is an artist.*

DW: He's currently in Japan, making a major art work.

VR: Rosc '71 *was not just in Dublin.*

DW: Yes. For *Rosc '71* we had exhibitions all over the country, in Limerick, Kildare, Sligo, Galway, Cork. In Galway we had nowhere to put the exhibition so we hired a marquee. That was young Irish artists. People like Micheal Farrell, Roy Johnston, Robert Ballagh. We had people like Mary Boydell organising the glass and tapestry exhibition in Limerick, and Pat Hickey doing an exhibition of blue and white eighteenth-century porcelain in

Picnicing at Adare in the late 1970s en route to Bothar Buí:
Dorothy Walker, Pierre Restany and Roderic Knowles.

Castletown House. There was a Yeats family exhibition in Sligo. Cyril Barrett did Irish art in the nineteenth century in Cork. It was an eye opener. There was that wonderful Roderic O'Conor of a woman knitting. Years later I was asked by a newspaper to nominate ten of the best Irish paintings and I nominated it. The man who owned it was in London, and he rang and invited me to come and see it. I tried to persuade him that it should be in the National Gallery of Ireland. His mother had bought it from the studio sale when O'Conor's widow died.

There was *The Irish Imagination* in the Hugh Lane. Brian O'Doherty selected it.

There had been rows about their being no Irish artists in the first *Rosc*.

At the opening of *Rosc '71* the students from NCAD set up a protest about the College. They were quite taken aback when

Jack Lynch handed them the microphone. He was opening it. He had just fired Charlie Haughey. 1970 was the arms crisis, and Charlie was out in the cold. He had been President of *Rosc* and Michael Scott had to remove him when Jack Lynch fired him. I got the task of bringing him around *Rosc '71*, at the opening, while the rest of them were grogging whiskeys in the hospitality room; it was not the easiest occasion.

VR: *You were involved in* A Sense of Ireland, *the major multi-disciplinary exhibition presenting Irish arts in London in 1980.*

DW: It was set up to counteract the violent image of Ireland in England. My exhibition[7] was in the ICA in London. There were three main visual art exhibitions. One was *The Delighted Eye*, curated by Frances Ruane. It was mainly good landscape painters and it was very popular. Then there was *The International Connection* which was curated by Cyril Barrett. It had mostly abstract work. Sean Scully, Cecil King, Patrick Scott, Charlie Tyrrell, people like that, and Theo McNab who seems to have vanished.

John Stephenson, who organised the main event, asked me would I do an exhibition different to those.

I selected nine artists. We had Nigel Rolfe, Brian King, John Aiken, James Coleman, Noel Sheridan – another of these expatriate artists I wanted to keep in touch with, he was still in Australia at the time – Michael O'Sullivan, Felim Egan, Ciarán Lennon and Alannah O'Kelly. That was before she was doing performance art. She had a lovely sculptural piece made from New Zealand flax. The lads gave her a terrible time, actually. I had to stick up for her. She was the only woman.

VR: *Despite the unequal opportunities Irish women generally have had up to recently, do you think women artists in Ireland have been and are a strong force?*

DW: Irish women artists have always been leaders in the twentieth century, from Sarah Purser on, and particularly in the last twenty years, where the women artists have been at the cutting edge. Alannah, Dorothy Cross, Pauline Cummins, Kathy Prendergast,

Eilís O'Connell, there are loads of them, they've been so adventurous. There is Willie Doherty working in new media and some younger photographers like Gerard Byrne, but mainly it's the women who have been out there. They're so good. It's not just that they have been experimenters in new media. They are good in the traditional media as well, there are good sculptors and painters. Many of the women don't want to be ghettoised as women artists, Dorothy (Cross), for example, just wants to be known as an artist.

I haven't made a platform of including women artists but I have always tried to.

Back to *A Sense of Ireland*. I called my exhibition *Without the Walls*, referring to the church in Rome that was outside the walls, and to the kind of art in the exhibition, which wasn't that acceptable. There was only one piece on the wall! I gave the artists complete carte blanche. I didn't know what I was getting, which was unheard of at the time. The response was magnificent. I was really delighted with every single one of them. They were ahead of their time, they were ahead of London at the time.

VR: *Was it reviewed well?*

DW: It hardly got reviewed at all. *The Delighted Eye* got several reviews because it was pleasant.

VR: *Was* Without the Walls *shown in Ireland?*

DW: No, *The Delighted Eye* was.

James Coleman's piece was *The Ploughman's Party*. He never repeated it. It was a white felt room – ceiling, walls, floor, all white felt. It had a projected image of a stylised plough, and a bilingual French and English commentary. It was about an Irish countryman, and a sophisticated young man going to a party. It had that Coleman ambiguity. I guess I was the first person in the English speaking world to write about his art. I wrote about him in the international edition of *Flash Art* in 1977. I wrote about the 'Strongbow' piece in *Art Monthly* in 1978. I was always fascinated by his work. In Lavitt's Quay in Cork he had two separate rooms with an identical image of a seagull flying

in each one. It was projected. Since you could never see the two together you didn't know if it was the same one. It was so simple, he was mostly using projected slides then. He still does project. His first video piece was the marvellous one *So Different and Yet*. It made history as a video piece. It was a 45-minute take, nobody had ever done that. Olwen Fouére was dressed in a green sequined dress, telling a story, an ambiguous story. Roger Doyle played the piano in the background. The three of them worked together for a number of years, and called themselves 'The Operating Theatre'.

VR: *Was Coleman back and forth to Ireland?*

DW: He was coming and going from Milan. They did the retrospective of his work in TCD, the Hyde, but it didn't show a lot of the pieces. Now his work is restricted by his gallery in New York. He did a wonderful piece in Galway a few years ago. It was called *Ochón*. It was an image of the Irish flag with loudspeakers under it, and a child's voice calling for her mother, saying she'd soiled herself. It was fairly straightforwardly symbolic of mother Ireland and the mess we've made of it.

VR: *Have we?*

DW: We haven't made enough of it.

I travelled the country to see his work. I went to Derry to see the first version of *Living Presumed Dead* in the Orchard. They were light drawings projected onto the wall. Noel Purcell did the voice over, once again a very ambiguous story. Coleman completely changed that subsequently. He completely changed the whole image, so that he had a cast of actors dressed in operatic costume, lined up on a stage, as against the previous one which was just the light drawings on the dark wall in which there were never more than two or three figures in it. The piece he did in *Rosc '77* he did show again; *Returnabout*. It was about a boxing match between Tunney and Dempsey in 1927. He used the film clips of the original boxing match split into strobe lighting rhythm. There was an interior monologue from the champion – who was still the champion – but might not be a champion

at the end of the match. It's about being a hero, and not being a hero. It was probably the best thing in that *Rosc*. James Coleman and Patrick Ireland were the only two Irish artists who had been selected by the international jury. Well-known Irish artists were outraged that two 'outsiders' were selected.

I wasn't on the *Rosc '84* committee but Richard Serra told me they were going to show the Irish artists separately. I burst in and said they mustn't. 'Here be savages' would be the message.

Rosc '80 had seven Irish artists, including Louis (le Brocquy) and Robert Ballagh, among the 50 living artists, not separate. We had fourteen invited artists, the others had their work selected. That photo of me and Beuys was taken in Venice when I was selecting Magdalena Abakanowicz for *Rosc* from the *Biennale*. We had a lot of performance and installation, so again it was breaking new ground.

The last piece of Coleman's that I saw in Ireland was about ten years ago in Galway. It was a wonderful piece called *Guaire,* after the tower house Dún Guaire, in the sea. Very few people saw it. You had to go and see it, it was a live piece. It was Olwen Fouére who played the King. It was on the top floor of the castle, and the wind was howling. The sea was lashing. It had a backdrop of mirrors by Dan Graham, the American artist, these reflected the damp walls of the castle. She was superb, she told the story of the King. It played for a few nights, it wasn't just a one off.

VR: *In a way he explores issues of Irish identity just as much as Keating did.*

DW: Yes, he does it in a universal sense.

VR: *Do you keep notebooks at art events like that?*

DW: Yes. I have mountains of notebooks. They are very spontaneous. They are often not very complimentary. I like reading and re-reading them. I'm a terrible squirrel. I have given quite a lot to NIVAL (The National Irish Visual Arts Library).

VR: *Tell me about writing* Modern Art in Ireland.[8]

DW: When I started it we were talking about the whole of the

twentieth century, including architecture. The publisher decided that it would be better to limit it to starting with the *Living Art.* There was Brian Kennedy's book[9] on the earlier part of the century. It's very academic to read, but there's a lot in there.

The Lilliput Press did a beautiful job on *Modern Art in Ireland.* It was the first time they'd done an art book. One of the workers in Betaprint, the printers, had worked on Louis's book. Gandon are doing a lot, but a lot of what they do are booklets. Bruce (Arnold) has done books with Yale – the Mainie Jellett[9] and the Yeats book.[10]

VR: *You were involved in the GPA (Guinness Peat Aviation) awards for emerging artists.*

DW: It was after GPA sponsored *Rosc '80* that they got quite hooked on sponsoring the arts, all the arts. They became major sponsors. They got such feedback from sponsoring that *Rosc.* I was so exhausted after everything that year that Robin took me to Florence for a week to recover.

The first GPA award for emerging artists was in 1981. It was small, with good artists like Eilís O'Connell and Felim Egan.

I selected in 1986 and 1988 and I opened it up quite a bit. It had been restricted in numbers. Only the east wing at the RHK was restored at that stage and it was held there. I refused and still refuse to judge from slides. They can be very misleading. I travelled the country. Quite often what the artist thought I wanted wasn't as good as something else in the studio. It was through GPA that Willie Doherty became known.

VR: *Being a GPA prizewinner and exhibitor in 1990 was probably important for Alice Maher also.*

DW: Yes. GPA was really important for young Irish artists. The second one I selected was in the Douglas Hyde. I announced that I was retiring from the art world. But the next day I was asked to sit on an advisory committee for the proposed Irish Museum of Modern Art. There was no way I was going to turn that down. The museum was something I was campaigning for for years. We had a committee to advise the Taoiseach. I think it was Tony

Cronin who persuaded the Government that the RHK should be the museum of modern art. Some of the committee were against it, and some were for it, and it happened. Some of us were appointed to the first Board. I've been on the Board since the start, but I resigned in the new year of 2002 and they asked me to go on the International Council for The Irish Museum of Modern Art, which I did.

Interviewed 9 July, 30 July and 21 August 2002

1. Walker, D., *Michael Scott architect in (casual) conversation with Dorothy Walker*, Oysterhaven, Gandon Editions, 1995.
2. Monsignor Pádraig de Brún was a member of the first Arts Council, from 1951 to 1956, and director from 1959 to 1960.
3. Dr Seán O Faoláin was director from 1956 to 1959.
4. Michael Scott was a member of the Arts Council from 1959 to 1973 and 1978 to 1983. Professor George Dawson was a member from 1968 to 1973, and Sir Basil Goulding was a member from 1957 to 1973.
5. Walker, D., *Louis le Brocquy*, Dublin, Ward River, 1981.
6. In 1942. Róisín Kennedy, 'The Rouault Controversy, An Insight into the Politics of Irish Art', Dublin, *UCD Faculty of Arts Postgraduate Research in Progress* Vol. 8, 2001.
7. Walker, D., *Without the Walls*, London, ICA, 1980.
8. Walker, D., *Modern Art in Ireland*, Dublin, Lilliput Press, 1997.
9. Kennedy S.B., *Irish Art and Modernism*, Belfast, Institute of Irish Studies, 1991.
10. Arnold, B., *Mainie Jellett and The Modern Movement in Ireland*, London and New Haven, Yale University Press, 1991; Arnold B., *Jack Yeats*, London and New Haven, Yale University Press, 1998.

Minister for Arts, Culture and the Gaeltacht, Michael D. Higgins talks to Dorothy Cross.

Michael D. Higgins

The politician and poet Michael D. Higgins was born in Limerick in 1941, educated in St Flannan's College, Ennis, at UCG and the Universities of Indiana and Manchester. He is married to Sabina Coyne, they have four children and live in Galway. Since 1970 he lectured in political science in UCG and in many American universities. He first became a member of Seanad Éireann in 1973 and has been involved in Irish political life for over 30 years, as Labour Party representative for Galway West in Dáil Éireann and as Minister for Arts, Culture and the Gaeltacht from 1993-1997.

VR: What was it like to become the full first Minister at cabinet table for Arts, Culture and the Gaeltacht, in 1993?[1]

MDH: I was very challenged by it, and very pleased that such a Ministry was about to be created. It was going to be a very big undertaking, removing the arts from their Cinderella existence in the Department of the Taoiseach into a full Ministry that would give the arts a centrality and a place at the cabinet table.

But if I was, I was even more appalled at the beginning of the destruction of the Department after I left, and the completion of that destruction just now. You know when the title 'Culture' was taken from the Department in 1997, it meant that no longer would there be a full ministry with the title, 'Culture'.

So I suppose the fact that I was the first and last is as disappointing to me as it was a privilege to be the first Minister.

The idea of a department was contained in the Labour Party manifesto of 1992. I had many discussions with people in the Labour Party, including with people who had worked on the original proposal. I was as convinced as they were that the only way of assuring a proper recognition for the role of creativity and culture in our lives was to have a full Ministry to be represented at the cabinet table. This proved to be crucial, for example, when we were negotiating the first round of EU Structural Funding.

VR: Yes. Ireland received a lot of European money for the arts when you were Minister.

MDH: The programme headings had been agreed. My first wish and inclination was to have separate headings.

The Department of Finance was never likely to agree, they had agreed the headings. I think that in the first proposal for the total activities of the new Department there was £247,000,000. We moved back from that. EU funding had to be match funded on a 75 per cent/25 per cent basis if it was a public project, and 50 per cent/50 per cent if it was private. Most applications for funding were public.

With the state of the economy at the time, the difficulty

was finding the 25 per cent. That required a person at the cabinet table.

Equally at the EU level, for example, there was an immense debate about film as an art form or film as commodity – at the GATT talks in Geneva. Again if one wanted to influence anything, you needed a Minister for Culture. Without being negative, it was foolish to lose all of that capacity, to abolish Culture.

VR: *It was difficult to set up such a department?*

MDH: I think in the early days one of the biggest difficulties I had was to take Arts from the Department of the Taoiseach, I had to take Heritage from the OPW, and Broadcasting had to come from the Department of Communications.

Gaeltacht was where I started. Gaeltacht had less than 50 civil servants and one of the ugliest buildings in Dublin on Lower Grand Canal Street. It looked like a bunker with railings. They were on the fifth floor. The main Department was in Connemara.

Because I was Minister for the Gaeltacht and the Minister for Broadcasting I was able to advance the proposal for Telefís na Gaeilge. Had I not been Minister with both functions I could not have advanced the project. The concept had public support, but sustained hostility from certain sources, particularly the independent newspapers. It had administrative opposition, particularly in the Department of Finance, on the narrowest of grounds: cost.

The cultural space had to be defined. I suppose an advantage I had was that I had been around the art scene for a very long time. I had been chairperson of the Galway Mayo Regional Arts Committee for twelve years. I know playwrights and actors. My partner Sabina was a founder of the Focus Theatre in Dublin in the 1960s. I was coming to it with 30 years of awareness. I knew many people in the visual arts too. Robert Ballagh, Tim Goulding, Mick Mulcahy. Dorothy Walker's book came out as I left office. She has assembled powerful evidence of contemporary artistic achievement.

The administrative shifts were very difficult.

Michael D. Higgins and his wife Sabina plot their campaign for the west Galway election, 1975 (photograph Jimmy Walsh).

VR: Did it take long to get going?

MDH: I worked very quickly – I had most of the institutional arrangements in place within the first hundred days, the first three months. Most of the initiatives in film were established by May 1993. I was appointed in February.

Sections of the OPW were the longest and most protracted to deal with. They were ideologically committed to some grandiose projects, including the interpretative centres.

I brought in a broadcasting bill by May. The longest and most protracted difficulty was with Section 7.

I worked very quickly on the European front as well. People came with a different grace to it. After the successful first six months people were enthusiastic.

I faced other difficulties as well as the acceptance of the speed of action. The acceptance of the role of my personal advisers was questioned. I brought just three people with me: I appointed Colm Ó Briain as my adviser, and Kevin O'Driscoll as programme manager. I brought Eileen Hayes as personal assistant – she was my secretary in my constituency. I never had a PR person. I wasn't interested in spinning anything. The programme justified itself.

I was in two governments, 1993 to 1994, and 1994 to 1997.

There is a deep strain of anti-intellectualism in Ireland and that served as an obstacle. It's not confined to elected public representatives. It's quite deeply ingrained. It reflects itself in the contemporary world as a very narrow functionalism and a very crude materialism. I think that the materialism of Irish political thinking affected some politicians.

I found Albert Reynolds sympathetic to film. Of course, I had the support of my own colleagues in cabinet. The logic of the time was very utilitarian.

That meant that in trying to negotiate significant capital funding for the Department I had to ride two horses, I had to make the case for the arts in their own right, but also for their employment potential in the cultural industry.

VR: *You yourself are passionately committed to having film-making in Ireland, despite the huge cultural domination by American film.*

MDH: We were making two to three feature films in 1992. The gross expenditure was in the order of £11,000,000 I think.

Before I left it was more than £146,000,000 and we were making twenty to forty feature films for general release and films for television. I think it created 3,000 to 4,000 full-time job equivalents. The first major film I certified was *Braveheart* and *Saving Private Ryan* was the last. There was a great energy in this new space for film-making.

VR: *Do you feel happy with what you achieved in those four years?*

MDH: I had to move very quick-
ly with some of the big pro-
jects. For example, Collins
Barracks was up for sale. I
had to intervene to make
sure that we made a bid for
it. We bought it. I immedi-
ately began the negotiations
for the Chester Beatty
Library transferring from
Shrewsbury Road. Chairman
of the Trustees, the late
Brian Walsh, was very help-
ful.

I set in train the first
community incentive pro-
grammes.

I was asked in an
interview on RTÉ – I think
it was Seán O'Rourke – was
I building white elephants?

We built something like
seventeen theatres/art cen-
tres. In Mullingar, in
Letterkenny, in Galway, in
Portlaoise, in Tallaght, in

Ministers Michael D. Higgins and
Minister Charles McCreevy at
Leinster House, 1994,
© The Irish Times.

Blanchardstown. The Kino Cinema in Cork. They are all there.

Curiously, contrary to much popular speculation, Cork was
the area where we spent the most money. I have no regrets
about that.

VR: *Toddy O'Sullivan, then a Labour Minister for State for Tourism,*
worked very hard to bring European funding to the arts in Cork.
Cultural money was coming through Tourism, wasn't it?

MDH: Yes, he'd been chairman of the Crawford Gallery.

VR: *The processes by which you allocated European money were*

quite strict.

MDH: I had an evaluation process, by which people sent in proposals for capital projects. We had criteria that they had to satisfy. They had to satisfy the validating body, the Arts Council or whoever was appropriate, about the artistic integrity. There had to be commitment financially at a local level, and the projects had to fit into a regional structure.

I had a rough principle in my own head that there should be two of everything; no one should be far from a place with commitment to excellence in the arts.

That was the basis for my giving the go ahead for Turlough House, the musuem of country life [in Castlebar]. It was a matter of having balance. Colm [Ó Briain] and myself wanted to ensure excellence. I decided to have a second corridor of film in Connemara. Udarás na Gaeltachta having invested in the televisual, the basis was there. I wanted to have state of the art employment, high technology employment rather than the more traditional knitwear, for example, in the Gaeltacht.

VR: *Once your department came into being, it allocated funding to the Arts Council. What were your relations with the Arts Council like? You appointed Professor Ciarán Benson as chair, and asked the Arts Council to publish plans for the arts in Ireland.*

MDH: I appointed Ciarán Benson very deliberately. I wanted to see implemented the core principle of the 1979 Benson Report, *The Place of the Arts in Irish Education*,[2] which was that creativity was socially based. Creativity, while personal, is primarily social. From that flowed his emphasis on access and access could, I believe, be achieved without sacrificing any commitment to excellence.

In Europe at this time I was developing a concept of the cultural space. Put bluntly, what I meant was that your rights of a cultural kind as a member of society were wider than the economic or employment possibilities within the economy.

1993-1994 was a period of economic recession. Europe had

gone to the right. The old thinking would be 'we'll fund projects when the economy recovers'. My point was that it was precisely at times of unemployment that we should invest more in the arts.

If you're losing your economic space why should you lose your cultural space also?[3]

VR: *Was there a difficulty with politicians' understanding of the process of cultural formation?*

MDH: Most people abroad could not understand how a country with such a reputation for artistic achievement as Ireland did not have a Ministry of Culture until I was appointed. The practice up to that in Brussels was that whatever Minister was around, usually a Minister for State, would fit in when arts and cultural issues came up.

My view about arts in the Department of the Taoiseach under Mr O h-Uigínn – he was the person I took over staff from – was that they were miserly in what they released. He agreed to release four people – maybe four – including Chris O'Grady, who was superb with film; he had much more than the competence of a public servant. He had vision. Four people I think came from Communications.

I would say, without putting a tooth in it, that the arts in the Department of the Taoiseach was very much a case of the arts being patronised rather than being promoted or assisted or funded. I have an impression that while some useful initiatives were taken it was more like a vanity exercise than policy making.

VR: *The Aosdána initiative in the early 1980s was a major initiative, surely?*

MDH: Yes. I think the Arts Council owed a very great deal to the hard work of Tony Cronin and Colm Ó Briain. The Arts Council was very lucky to have someone of Colm Ó Briain's insight and stature. I think there is a problem about Aosdána, in terms of definition. Is it fully representative of Irish arts and letters or is it an academy of letters, or is it representative of Irish life at the

time?

VR: *Do you believe things are better now, for artists, than they were?*

MDH: If I have a disappointment in relation to all of these people – concert pianists, performers, artists – I think it's that the public and those they elect to power have been having a free lunch for a long time on such people's lives. I wanted and I had begun gathering material on Scandinavian models for artists' incomes and pensions. What I had in mind was that you could construct a scheme – of crediting public exhibitions, work in schools and so on – so as to generate pension entitlements for artists.

One of my earliest memories is my admiration for Charles Lynch, in Galway, when there was hardly a piano, long before the Steinway arrived. I remember him almost needing the train fare sent to him to enable him to come and play as wonderfully as he did. This was quite scandalous. I remember poets contacting me about ESB bills, and their electricity being cut off, or about being evicted. That's the Ireland we're in. Sadly it hasn't enormously changed.

VR: *The Arts Council's* Arts Plan 1995-1997 *stated that there were between 30 and 50 visual artists making a living from their work and a survey[4] of 90 visual artists reported that 86 earned under £15,000 per annum in 1997.*

MDH: In relation to actors we have lots of actors who are asked what is their real job. Acting is not acceptable as a real job to this day, in the Department of Family and Social Affairs.

The country has an ugly side in terms of its perception of the concept of play. Homo Ludens has no space in Ireland, neither has the concept of creative work.

There are improvements. For example, in relation to hospitals, there are some senior citizens with someone working in the arts with them here in St Francis's Home in Galway. Some hospitals have paintings. I would like to think that would become normal.

If I had a second term I could have finished up some projects. I kept producing ideas. I had noted that most parents were

interested in music being available for their children. 'The piano will stand to her.' A number of people had bought instruments for their children, these are the good parents. The instruments were later abandoned and were often in the attics. I was envisaging asking for them, for all the dead instruments, and establishing an Instrument Bank, and after two years the people who lent the instruments would get them back, with a recording of what had been played on them. I envisaged going on the Gay Byrne Show and asking for them. I went as far as putting £10,000 into a pilot scheme.

We had awful opposition. First of all we had questions from the Department of Education. 'This is something our department not yours should be doing.' 'He's operating ultra vires,' said Finance. Even some of my own most senior people said, 'Are you sure this is something you should be doing?'

I felt it was my responsibility as the first Minister for Culture to produce ideas.

VR: *You had brought in people with ideas and you wanted cultural participation to be a citizen's right.*

MDH: Lelia Doolan I appointed as chairperson of the Film Board. The cinema mobile eventually came in with Lelia. We looked at the model in France. Lelia was part of a generation almost excluded from public space. I appointed Bob Quinn to the RTÉ authority. These were people who were excluded because they had a creative dissident intelligence. I don't know anyone else who would have appointed Niall Stokes to Broadcasting. As Albert Reynolds put it 'He wouldn't be one of our own'.

And there was Ciarán (Benson), who was just wonderful. Fourteen years after that major report on the arts in Irish education the author was chair of the Arts Council.

What all this was was a validation, a valorisation of expression from the heart of the arts community.

VR: *How can the arts become more central in our culture? Can you achieve a cultural democracy?*

MDH: The most important change that has to take place is at the

level of education. I deeply regret myself that I didn't have access to the various art forms when I was a child. I don't want to go into it all. My mother played the piano and the violin and we had neither a piano nor a violin. When I gave the 'Open Mind'[5] lecture I said then that I was very much impressed by the theories of the Eastern Europeans. If you played music at the beginning of the school day and the end of the school day you improved not only the music but you improved the whole atmosphere of the school, the range of creativity, the function of the brain in the narrow sense and the fulfilment of the teacher and the pupil. Maybe it's idealistic but it's such a good way to teach.

When I think back on the eleven or twelve years I was chairman of the Galway Mayo Region Arts Committee, and teachers telling me that they hadn't appropriate paper for the children to do their Junior Cert! The materials were missing. Wonderful teachers were assembling the basic materials for youngsters to do their basic exam. That isn't entirely eliminated. Everyone is forever saying what they've done in Ireland. Maybe it's my own weakness: I always compared anything we did with what needed to be done, rather than saying I spent this much, and so and so spent that much. If you're going to free young people who will be citizens from domination by trash in the audio visual area, you need to have film appreciation. How an image is handled in the visual arts, materials, the grammar of the thing – if you dispense that widely the whole level rises. That's where significant change has to take place. It's directly related to the commodification of culture.

If you actually empower the citizen in relation to the arts, you get something that isn't only more democratic, you get something that is more critically aware, and the dross of the thing is eliminated. You're able to force the standard higher. If you don't do that then there's a real danger that you have a comprehensive commodification of experience, in which for example, as has happened now, film is no longer valued as an art medium but is,

in fact, regarded as part of the entertainment industry.

I can't tell you how I groan when I hear of thousands of youngsters wanting to become pop stars for a year. This travesty of music is going on. Some of them are wonderful young people. They would just as easily have fitted into a dignified version of the culture. I think we are in real danger.

The other thing is we have this idea that everything we do of a contemporary kind is for the market place and anything we hold for ourselves for the kitchen on a winter's evening is a kind of a nostalgic version of the past. That's a recipe for disaster. I'm sure wonderful musicians like Noel Hill and Tony McMahon and others don't want to be treated like a fossil retrieved from the bog. There's a lot of the bog in relation to some of the things we're doing. The dead and the past is a safe area for someone with no vision of the contemporary and is used as an escape route from crucial decisions in relation to the contemporary. There's nothing wrong with a person not liking, for example, Michael Mulcahy's work but it's entirely reasonable that they should be able to say why.

In relation to painting, I would have early on had a liking for a certain kind of work in oils, done with the brush, shall we say, rather than the trowel. It's a matter of orientation and how much critical facility one has. The reality is that as I got an opportunity of knowing more I widened my own abilities to appreciate work.

There are other areas of neglect, and one is most obvious – dance. I still think to this day that the decision to withdraw support[6] for Joan Denise Moriarty's work in dance was disastrous. You must remember the political thinking in relation to the arts. If it's not working as we see it, abolish it. Ballet was abolished. They abolished the Film Board in the 1980s on the same premises. I must be technically accurate; they didn't abolish it, they removed funding and left one civil servant, Michael Grant, in charge of it, with no money.

VR: *Creative groups can be very vulnerable to systematic assessment.*

MDH: I stress immediately that when I was Minister, inflation rates and interest rates were in double figures. There wasn't money on the scale I would have liked; we had to agree with the tax amnesty, some of the money was used to fund projects. But there were more things we could have done. When there were surpluses of between £1,000,000 and £3,000,000, what is there to show for it, in reality?

I pay tribute to my successor Síle de Valera. I doubled the Arts Funding (to the Arts Council) in my period. She went on to give the arts even more money. I applaud her for that. I appreciate that.

VR: *Yes. The Arts Council has received greatly increased funding from her.*

MDH: Maybe the single biggest problem now is the lack of vision.

Maybe the form that embraces everything is the opera. I would have positively discriminated in favour of opera. It would have been a great achievement to have built an opera house on the Docklands site in Dublin, on the basis of an architectural competition. You'd never get it through the Department of Finance. They opposed electricity – the Shannon Scheme – on the basis that it would never work.

On the theatre side I feel that despite all the controversy, Patrick Mason's paper on the role of the National Theatre was very good. When the offer of the new site on the Docklands came, the thing to do was to upgrade the existing building in Abbey Street as the home of the National Theatre on Tour. It could be used to provide a venue for the smaller theatre groups in Dublin. Remember there are seventeen new regional theatres now. They could initiate a tour and come. Companies from the regions could come. You build the new theatre on the docks. And the people singing hymns to a diluted commerce could use the building for whatever they wanted. The debate about the new Abbey is a very narrow one – whether it should be on the north of the river or the south. The option I put forward is a proposal, not a decision, but you don't sit there and not come in

with a proposal.

I should say that any Minister has to operate from a principle of autonomy with responsibility. You must be at arm's length from the institution for which you have responsibility, and you must allow autonomous expression. Equally it can be required of you and it should be required of you, that you indicate the shape of your own thinking in terms of policy. What this means is that people can vote on the issue. Is this the attitude of the person who holds the Ministry and is it enriching the cultural process or is it purchasing access on an entertainment model? These are inescapable choices.

VR: You established the Heritage Council on a statutory basis. How did you envisage it and the Arts Council, two bodies you saw as funded by you but autonomous, operating to complement one another?

MDH: That is for them to decide. What is now being proposed in the *Arts Bill* is a travesty of the Arts Council, abandoning all principles of autonomy, by creating subcommittees within it, appointed by the Minister. What I sought was autonomy for both Councils. There's the built heritage and the living heritage. The purpose of the 1994 legislation I put through was to avoid heritage destruction. With the impact of the new roads it's important that in the legislation – it's stated – that if there is a conflict between the Minister for Transport and the Minister with responsibility for heritage it must come to the Dáil for debate. At the moment, the Minister for the Environment has responsibility, in one case, in Dun Laoghaire Rathdown, for development and is also the Minister with responsibility for heritage!

VR: You're currently debating the Arts Bill 2002, *brought in by Síle de Valera at the very end of her ministerial tenure, in April 2002.*

MDH: The ghettoisation of the traditional arts is one of the worst things in the new bill. As a piece of legislation it's quite crazy. The Minister appoints all the chairs for all the new subcommittees in Section 21 but the subcommittee on traditional arts can make recommendations to the Arts Council with regard to money and

the others can't. That's an inconsistency in the legislation. The subcommittees create a ghetto within the Arts Council. One may question where this proposal comes from. It separates out the traditional and the contemporary. The views of the general community of Irish music would be interesting to hear. In all of these matters it would be helpful if there was much more public discussion and agitation from groups themselves. This is not a proposal that has come from traditional Irish musicians. It has come from one particular source within that community. Do those who love traditional music, those who perform it want it? If not, let's hear from them.

VR: *And music isn't the only traditional art form. How do we define stone carving for example? You find this arts bill disappointing?*

MDH: It's a poor bill, promised for years. It suggests many thing that are contradictory and backward.

This bill reflects the worst thinking of the arts having been separated from culture. The issues are cultural. There are two reports on culture that are the definitive ones internationally. *In From the Margins* is a report of the Council of Europe. That was, as it were, the regional contribution to the UNESCO document on Creative Diversity. After I left office I was invited by the Swedish writers' union to their seminar on their contribution to *In From the Margins.* Later when UNESCO had a conference on creative development I went there and read another paper, and was part of the workshop.

Both reports have a broad anthropological definition of culture as 'the way we are'. It accommodates not only particular artistic expression but inherited culture and something I argued very strongly for, which of course isn't reflected in the new legislation at all, the integrity of the imagination.

There are two principles that you have to satisfy. One is what you might call choices made within the politics of memory, which I mean in terms of Paul Ricoeur's[7] use of that word. Paul Ricouer is very interesting in terms of Northern Ireland. It's insulting to say you should have amnesia, that you should be amnesiac

about what has happened. It's appropriate to say you might have an amnesty on versions of heritage and culture to enable you to move on. The second thing is a kind of freedom of the imagination. You must be able to make space, for not just the contemporary expression in an aesthetic sense. I also think that there is a prophetic role in the cultural sphere.

Raymond Williams's[8] work has hugely influenced me. You need to be able to envisage the world as it has not yet become. You must be able to envisage communities and people as they have not yet managed to be. That is not something that needs to be invented. That is something that is at the core of the European humanist tradition. The history of Greek tragedy and the evolution of the Greek theatre very much provides a metaphor for the society and the way that we are. All that is exciting to me.

VR: *When you were Minister did you develop cultural policies and projects to try to contribute to better relations with the North?*

MDH: Way before the Good Friday Agreement we did it. We did it quietly.

The directors of the institutions had been having meetings for a long time. I visited the institutions in Northern Ireland. The Minister I had most rapport with was Peter Brooke. He was a bibliophile. His great aunt Charlotte Brooke was the last gatherer of Gaelic poetry in Ulster and published pamphlets on it. He was a lovely man.

The situation in Northern Ireland is a microcosm of the bigger problem. Culture doesn't exist as a term in the Treaty of Rome. Culture as a term only arrives in Maastricht 128 Chapter 6. There it says culture shall be taken into account. There are a number of reasons for this. Culture had been abused with the rise of fascism. I have a sense that in relation to some of the locations in Northern Ireland it had been seized and abused. The project would be to try to investigate that thoroughly and accept the fact that there are divisions there. Field Day on one side, Edna Longley on the other.

There are art forms that have capacities to get beyond that.

My daughter Mary Alice did her M. Litt. thesis in Trinity on the humour of the oppressed, the laughter of the victim. She talked to different theatre groups operating out of different models of experience. There's an issue in it that travels outside her work. Minorities under pressure, because they have to cope, have an ability to laugh at themselves, and view themselves ironically more than a group who have a hegemony. Is it a case that nationalists can laugh at themselves more easily, because they are a minority, than unionists?

VR: *A concept of the term culture as broad is very critical to your beliefs, isn't it?*

MDH: Culture includes things like fashion, and cookery and movement and the grace of living. We are in grave danger of becoming an island of neurotically unhappy consumers. The evidence is there. After what the present Taoiseach (and past) described as the five golden years, the unhappiness is tangible. It's not only those who have previously been excluded by way of right in areas of health, education, housing, but those who have been consuming as well as those excluded who have found their lives wrecked. It's no longer possible for one income to purchase a house. Both parties have to work. Leaving in daylight, getting home as darkness falls, having collected the children from the childminders', where's the space for theatre, the library, dance, music – for anything communal?

The abolition of the Minister for Culture, of the title even, in 1997, was the beginning of a powerful gesture of the loss of national self respect. There was a sheer vindictiveness in removing the word Culture from the title of the Ministry. Anything that had the imprint of the previous Minister had to be abolished. Everything I did was reversed. Broadcasting has been sent back to Communications. Heritage has been sent back to Environment. People aren't quite sure where film is. It's probably sent to Arts, Sports and Tourism. My moving of Broadcasting from Communications was an affirmation that a

piece of Broadcasting was more than a commodity. Its image and its impact on the community was part of national identity. It's now buried as a technical matter in Communications. Hence the shambles about sports coverage.

VR: *You believe in the core importance of the Irish language to Irish culture?*

MDH: Very much so. I see it as something not merely symbolic. I see it as to do with memory and the imagination. It's a key resource. At a time when the Hollywood model dominates, we have imaginative short films coming out of Telefís na Gaeilge. When I was establishing Telefís na Gaeilge, what was interesting was the people who were opposed to it. There were two groups. One I had sympathy with; those who had a bad experience learning Irish. The other group consisted of those who believed the highest point of creativity would be a good imitation of work from the dominant country, America, or the mother country, as England is often referred to. There has always been a second rank of creative expression in Ireland that is totally imitative. Telefís na Gaeilge is a decision I've never regretted. The Irish language is of ourselves. It is immensely creative.

The idea of making films in Irish is of interest, by the way, to the Maoris!

VR: *In the last decade and more, local authorities have been taking more and more responsibility for developing the arts in their own areas. Do you see this as progress?*

MDH: It really is quite encouraging that small local authorities in Ireland have collections of visual art. It's even more disappointing that some haven't even begun to put together a collection. It's quite outrageous that many have, in fact, built expensive new headquarters with no provision for the proper display of art. Galway County Council have a huge site at the city centre. At the very beginning I said they should have final year students from Galway Mayo Institute of Technology showing their end of year work, and purchase some of it. They buy some work to my knowledge, but they made no provision in the architectural

design for the building for space in which to hang work. To do that you need to structure your space. Irish architecture from an initial hostility to the concept of the atrium decided that every public building should have one. So even if we're not getting the weather we have hectares of glass and we haven't walls on which to put a picture.

VR: *How do you read the role of local authorities in the new arts bill?*

MDH: Some local authorities in their Plan have said they will create only the capacity to consider how they might plan for the arts. That's effectively what the *Arts Bill* says. So that at the end of the next ten years there may be a rough idea about what they might do, but there isn't a commitment to do anything. The bill makes them take it into account, but if you want an example, look at the Galway City Development Plan which says it will create the capacity to envisage what is needed. It's not at one remove, it's at three removes from doing anything. The bill facilitates that kind of long fingering exercise.

VR: *The local authorities may say that if they are not funded by central government how can they do it?*

MDH: Why don't they enter into a dialogue with their arts communities? A proper dialogue.

It's not a matter of calling in all the arts groups and telling them you're going to make provision for them. It's a matter of engaging them. I question the capacity for that dialogue.

There is an assumption that what the arts community needed and what Ireland needed was the tranference of management expertise into the area. While good practice might have been welcome, the transmission of the most mediocre conceptual thinking and the most barren of languages into this area is a disaster.

When you find arts administrators saying to you that they are 'running it past you', 'bouncing if off you', 'upending your proposals', 'on stream', 'in the pipeline', 'being front loaded' or 'back loaded', my head sinks into my hands. Instead of there

being a confident administrative language coming into being, or some kind of creativity in the structures, you're just getting something that is the second hand of a fourth-rate version. That's why I call it a disaster. I think this is upsetting the creative people.

VR: *Creative people sometimes seem to despair of communicating with officialdom without using that kind of language, without sacrificing an authenticity of voice.*

MDH: Take a radical concept of public performance, which maybe has the most controversy at the heart of it, writing like that of Bakhtin[9] on the function of carnival. In the public space you have performances in which people can raise important issues behind the mask, as it were.

If you have art in the streets, is the test how many visitors it entertained? Or is the test the aesthetic, social or cultural questions it promotes? We're not even close to asking the second question.

We have indicated our preferences through such legislation as the Public Order legislation. More than three people gathering together and drinking together must move on, and if they give cheek to the gardaí they may spend the night in the cells. We'll build more prisons for them and so on. It's depressing. We have a public order mentality more than a public celebration mentality.

If you take the Galway Arts Festival; the media and Bord Fáilte talk about how much it is worth to the city in terms of visitors. What is more important is what does it release for the people of Galway and its visitors?

VR: *Brendan Kennelly has written that 'the politician is the poet, the poet the politician'.*[10]

MDH: My first book was *The Betrayal*.[11] I wasn't free to have readings of *The Season of Fire* because I was Minister. I couldn't use the radio. *The Betrayal* went into three editions.

My third collection will be called *An Arid Season*. Mick Mulcahy finished sixteen new drawings for it two years ago. It

has many black poems. It deals with the death of language, not only in a Lacanian way. I've tried to put other dimensions to it. It's influenced by the politics of memory. It draws on reconstructed memories from County Clare and asks why are these being reconsidered? There are 38 poems in it, twelve or fourteen have already been published. It deals with sound. I had read Rilke who has images of the forest and the well and sounds of buckets hitting the well. It deals with the inevitable desolation of the aging process. Perhaps it is a tougher book. It doesn't make much concession to sentiment. It investigates the ethical requirements of friendship. It's quite revelatory. I'm reading a book on the prophetic image. It acknowledges the positive side of grieving. The author writes about the raising of Lazarus. Jesus arrives but doesn't perform the trick of raising the man, he grieves. One shouldn't grieve for what has been but for what has not yet managed to be. It's beyond humanism. It valorises the role of the spiritual. The humanist tradition is dangerous. I don't agree that you get on with the real stuff when you transcend the human. Life is a diminished or enriched celebration – that's what life is.

Interviewed on 30 July 2002

1. There was a Department of Fine Arts in the Second Dáil Éireann (26 August 1921 – 9 January 1922) and the Minister of Fine Arts was George Noble, Count Plunkett. It was a non-cabinet post.

2. Benson, C., *The Place of the Arts in Irish Education*, Dublin, the Arts Council, 1979.

3. Kelly, A., 'Interview with Michael D. Higgins, Minister for Arts, Culture and Gaeltacht, Ireland', *European Journal of Cultural Policy*, 1.1, 1995, p. 75.

4. 'Visual Artists and The Celtic Tiger' in *Art Bulletin, Journal of the Representative Body for Professional Artists in Ireland*, 86:15, 1998/99.

5. Higgins, M.D., 'Education for Freedom', in Quinn, J., (ed.), *The Open*

Mind Guest Lectures 1989-98. Dublin I.P.A. p. 10.

6. 'In 1972 Joan Denise Moriarty founded the Irish National Ballet. Productions such as the dance version of Synge's *Playboy* were acclaimed in New York (1979) and London. Arts Council funding for this professional company was abruptly withdrawn. Returning to Cork by train in August 1985, Miss Moriarty opened the newspaper to see the headline "Ballet Chief Axed" over her photograph. That was the first she ever heard of it.' Patrick Murray, letter to the author, 20 June 2003.

7. Ricoeur, P., *The Conflict of Interpretation*, Chicago, Northwestern University, 1974.

8. Higgins, M.D., 'Raymond Williams: The Migrant's Return', *Critical Quarterly*, 39/4, London 1997.

9. Bakhtin, M., *Rabelais and his World*, Cambridge, Mass. Cambridge University Press, 1968.

10. Higgins, M.D., *Season of Fire*. Dingle, Brandon 1993.

11. Higgins, M.D., *Betrayal*. Galway, Salmon Press 1990.

Brian Fallon in Tony O'Malley's studio in Callan.

Brian Fallon

Brian Fallon was born in County Cavan in 1933, the second of six sons of the poet Padraic Fallon. He was educated in St Peter's College, Wexford and Trinity College, Dublin. In 1963 he married journalist and broadcaster Marion Fitzgerald and they have seven children and three grandchildren. They have lived near Blessington, County Wicklow, since 1969. Art critic in The Irish Times *from 1963 to 1998, and literary editor from 1977 to 1988, he won an A.T. Cross National Media Award for arts coverage. In 2002 the Royal Hibernian Academy awarded him its gold medal for outstanding service to art. He has written and edited several books, and reguarly reviews books.*

VR: *Brian, in* Irish Art 1830-1990[1] *you link our tardy absorption of modernism to England's.*

BF: The greater number of our leading artists have lived abroad for a long time. Yeats and Orpen were English-trained. When I was young, the fashion was for everyone to go to Paris. Now it's New York. It's inevitable that people would want to get out and see the world, from an island country like ours. If you think of Scandinavian artists in the nineteenth century, they were on the periphery like ourselves, and went to mainland Europe, studied art there, and applied what they learnt to their own ambience. Most Irish painters who made it earlier rapidly distanced themselves from here. Roderic O'Conor sold his family estate in Roscommon under the 1903 Wyndham Act, and stayed in France.

But going to Paris doesn't exist as a phenomenon anymore. Beckett is the last Irish modernist of any stature who made Paris his home. My impression is that New York is well past its zenith as an art capital too. Art has become decentralised. There are art markets in places like New York and London, but no major schools of painting. Artists perhaps don't need cities anymore. You can discover a painter through reproduction, and then go and see the art.

Dublin at the moment is in a period of self-infatuation, regarding itself as a swinging metropolis. To my mind it is what it always was, a provincial capital. New York is a very special place, a world capital. For us to ape it is silly, a futility. Dublin is still a very local place.

VR: *Being informed at first hand is so important to artists, isn't it?*

BF: An awful lot of onus falls on the art educators. The art colleges must have the best people. I think they are going through a bad phase at the moment. They are bound by fashion, political correctness and a dozen other factors which don't relate to purely aesthetic ones.

They are often staffed by young careerists who are second-rate artists and harden very quickly. They remain at a certain

decade and never move beyond it. When the reaction came here in the National College against the old brigade, about a generation ago, it was exciting for about a decade. A lot of interesting people came out – people like Michael Mulcahy, and Charlie Tyrrell, and Brian Maguire. That was a very good generation. My impression nowadays is that what is being done in NCAD is a provincial version of what is being done in the UK.

VR: *Teaching people to be artists is so complex.*

BF: There is a lot to be said for the old studio system.

VR: *Which still operates, in the sense that Irish art students still have studio spaces where they work. But you're referring to the teachers being artists who have studios in the college and that's gone.*

BF: I meant more the painters like Jacques-Louis David, who ran studios of their own.

VR: *Away from the art colleges, with students as assistants or apprentices, often modelling for the artist?*

BF: People like Francis Bacon were self-trained. He broke up the bland international abstraction that prevailed then and gave painting a new urgent existentialist content, with recognisably personal stresses. The work has a feeling of nervous immediacy to it. That doesn't come out of art-college work.

VR: *A number of Irish artists of that generation and later didn't go to art college.*

BF: Gerard Dillon and Tony O'Malley were never in art college. That generation would have faced academic stultification in the art colleges under the old regime. This generation, by contrast, faces 'liberationist' stultification. Historical factors enter into this. Our broken history didn't give us an opportunity to break into fine art. It produced poets and passionate patriots who made speeches. It needs a settled social class with a hereditary assurance to have fine art. We had very little real middle class for a long time and we didn't have much of a cultured middle class. Most of the middle class were emerging out of peasantdom and shopkeeping and were almost entirely philistine. We

had the remnants of a Protestant middle class who were cultured but confined. It was largely mercantile in character.

VR: *Is it the middle class who buy art though? I suppose modernist art was, to an extent, bought by the haute bourgeoisie?*

BF: Nowadays it's the new rich who buy. There was no new rich in Ireland until recently. Art has now become a fashionable snob product. It isn't always accompanied by culture, and it is sometimes undiscriminating. But it is marvellous for the artist. And there is a streak of enthusiasm there. Corporate buying is quite a new phenomenon too. But I wish AIB and the Bank of Ireland and the others would make their collections more visible. Corporate buying by its nature is diffuse and they tend to hang their art where most people don't see it.

VR: *AIB toured their collection a few years ago.*

BF: Yes, that's true.

VR: *How big a role have the dealers in creating a climate that fosters fine art production?*

BF: Not much in this country, I think. The professional galleries make a decent living but they don't try to mould public opinion. Places like IMMA do, perhaps. The *Rosc* exhibitions tried to inform, if not shape, public opinion. They were a big breakthrough. The work was probably familiar to the artists, at least in reproduction, but not to the public. My impression is that the local committee had the idea, but without the prestige and international contacts of James Johnson Sweeney it would not have succeeded as it did. I think the 1971 exhibition was the high point. '67 had all the names but I suspect that the dealers were a bit cautious and didn't send the best. '71 was the best ever international exhibition in this country. Apart possibly from *Art USA Now* shown at the Hugh Lane in 1964, when James White was director. People have forgotten that. It had all the big names – Hopper, de Kooning, Avery, Guston, Kline, Motherwell. All except Pollock and Rothko. The whole Gallery was taken over.

VR: *Was it a travelling exhibition?*

BF: Yes. With a two-volume catalogue, which I still have. It's a

handicap being out of the track of the international exhibition circuit as Dublin is. It's costly and difficult to bring exhibitions here, and to sell enough catalogues to the small art-going public.

James White's role in the Hugh Lane was at least as important as his role in the National Gallery, where he was later the director.

There were three things that helped modernist art to emerge here during and after the war. *The Irish Exhibition of Living Art* gave artists a platform. Then there was the lecturing and enthusiasm of people like James White. And thirdly, there were powerful people like Waddington who sold artists' work.

VR: *You remember Victor Waddington? The Waddingtons did a lot to promote Irish art outside Ireland, even after Victor Waddington left.*

BF: He was gone before my period as a critic, though I met him in London. Without Waddington any form of modernism, even the kind of tame second-generation modernism which had a validity here, would not have been on the map. He had an eye for painting, and a kind of sixth sense. He took O'Neill, Campbell and Middleton under his wing, among others.

VR: *And Yeats.*

BF: Yes, of course, Yeats. I saw a very good, very big Middleton exhibition in Waddington's in 1954-1955. You could hardly overestimate the role of Waddington in the 1940s. In the immediate post-war era, *The Irish Exhibition of Living Art* committee tended to be a coterie which gave art snob value and newspaper value. The exhibitions were held in the old College of Art in Kildare Street, a very decrepit venue. Waddington created a public for our limited form of modernism. He didn't go as far as abstract art, but curiously he put the St Ives artists on the map some years later. He left in 1957 or 1958, he went to London, where he was unknown, and within a very few years he made himself a power in the land. He created a whole dynasty of dealers. He dominated Cork Street where there were two or three

The first Aosdána assembly meet, April, 1983, at the Bank of Ireland, formerly the House of Lords, Dublin © The Irish Times.

Waddington Galleries, up to the end of the 1960s.

He was personally very impressive. He had the looks of a Renaissance senator in Florence.

Artists have to sell. Waddington was in South Anne Street, one of those side streets running into Grafton Street. There was no Aosdána in those days. People like George Campbell, at one stage, had to sell their work on the street, while living in London. State recognition still went to the moribund RHA, where the politicians went for their portraits and took their womenfolk along.

VR: *Who took the lead after Waddington?*

BF: Basically, Leo Smith of the Dawson Gallery who had worked with him at one stage. And David Hendriks who started the Ritchie Hendriks Gallery in Stephen's Green – I think in 1955 or 1956. He named it after his uncle, who put up the money. David and his cousin Vivette ran it. She was a former opera singer and eventually went back to Jamaica where she and David came

from. David was consciously international. He tried to get in artists from abroad. He showed a lot of op and kinetic art. He was a kind of an international homosexual, elegant and well spoken. Hendriks was the fashionable place for a good while – maybe until the late 1970s. When he died in 1983, Vincent Ferguson took it over for a while.

The Taylor Gallery came after Leo Smith died, about 1977, I think. John Taylor had been Leo's apprentice and the understanding was that John would take over, but Leo died intestate, and John didn't even get the goodwill of the gallery name. John then set up on his own. People like Louis le Brocquy, who had been with Leo Smith, went with Taylor.

There was more of a Northern emphasis in the Kerlin when it opened. They also showed a number of Germans, new expressionists, such as Penck, and they showed the art of the 1980s and 1990s, and minimalism, and a few conceptionalists. They regularly show people like Stephen McKenna, who is a kind of a cosmopolitan figure.

VR: *Talking about the politicians going for their portraits, Edward McGuire, on whom you've written a monograph,[2] was emerging as a really fine portrait painter in the late 1950s.*

BF: Edward was the first portrait painter since John B. Yeats to make portraiture respectable. He painted the intelligentsia of Dublin. He was sufficiently a modernist to meet the challenges of the time. He produced a novel type of portraiture, with a lot of psychological insight. He painted the inner man. He used very frontal and very rigid poses which gave the portraits a hieratic aura. He used a limited colour scheme, which gave its own tension. They wouldn't have worked in strong colour.

He'd seen Freud under whom he had studied briefly at the Slade but I'd never mistake his work for Freud's. Edward is painting other people when he paints, not just his own world. You can see that in the Seamus Heaney portrait. Freud's work is always about himself.

I thought that Patrick Swift was an interesting painter,

though a little before my time. Like Edward, he painted the intelligentsia, the poets, mostly the English poets in his case. The portraits are important documents of their era. Swift and Edward weren't entirely dissimilar people. They were nervous, highly strung men, more at home with writers than with painters. They weren't primarily craftsmen. I think Edward learnt the craft of painting very hard. It didn't come naturally to him. I don't think he had any special facility as a draughtsman. Edward was totally representative of the Irish intelligentsia of the time, the McDaid's intelligentsia, the disinherited Dublin bohemianism of people like Patrick Kavanagh and Tony Cronin. He represented the anti-establishment of the time. I don't know if Swift's painting of Patrick Kavanagh is a masterpiece as a painting, but it's a considerable psychological document.

Edward had a following. But he was a fractious person. The Academy diehards regarded him with great suspicion. Edward didn't show much in public. He showed at the Academy, much as he reviled it. He called it the Royal Horse Artillery.

He was never given any teaching post. The National College had largely become a club for untalented people who did their own work. They sat on any independence. People like James McKenna, and Michael Kane, and Brian Bourke came out as angry people, in some cases technically immature. It took them seven or eight years to learn to handle their materials. Maurice MacGonigal was an exception to all that. He really did try to teach.

Edward's respectability came late, certainly too late for him, because he was by then an alcoholic. By the time he started painting Terry Keane (in 1977) and other social figures his style had coarsened. By nature he was a slow worker. Once he had to speed up, his style lost its edge.

There are greater painters than Edward, but he is the only important Irish portrait painter since John Yeats. He is to the culture of his age what the elder Yeats is to the Literary Revival.

He painted all its leading figures.

VR: *Tony O'Malley, on whom you've also written,[3] showed in the gallery in Edward McGuire's father's department store, Brown Thomas.*

BF: Yes, he did, about 1957. Edward's father was very wealthy and an Irish senator as well.

VR: *Was Tony an influence on developing your interest in art?*

BF: When I met Tony, I was eighteen and just out of school. So my opportunities for seeing art before that were limited. But I collected reproductions in a scrapbook. A lot were black and white. People like Herbert Read were in my father's library. Of course, Tony had a huge influence on me personally – and still has.

VR: *Your father was the poet Padraic Fallon – you've edited his work[4] – and you're currently doing a book on the painter Nancy Wynne-Jones, who is your sister-in-law.*

BF: That book is now finished, I hope. I think Nancy has a unique colour sense. She lays stress on warm colours, yet it's never an overheated palette. It's a very un-English palette and a very un-Irish palette too.

Tony (O'Malley) like a lot of St Ives painters is marvellous in the lower colour range. Nancy can control high tones without being gaudy. She found her wholly original style relatively late in life. But anything she did before has the touch of a painter, it always has her own original touch. She's not an uneven painter. She keeps a good average. There's an awful lot of work in a smaller format, and it's very good. So many of the St Ives painters ran out of gas, while she gets better. There's the question of whether or not you can put her in that school. She was there for quite a long time, from 1957 to 1972.

VR: *And knew Tony there.*

BF: Yes, she did. Tony did a lot to shape my sensibility. He was the first person I heard talking about Jackson Pollock. That was the mid-1950s in Wexford. When he came back from St Ives in 1955 he mentioned 'this great painter Lanyon'. We'd never heard of him. He had a sense of who counted. Good artists always do. My

father was the same, even though he lived very sedately in Wexford.

VR: *We had and have many good women artists.*

BF: Nano Reid is underrated now. The Irish don't like low-toned colours. They don't like brownish colours in painting, which is odd. It's the colour of their landscape in autumn and winter. She always had a following and was never short of a gallery. I only knew her very slightly but we got on well. The generation that came after Yeats was a very gifted one.

VR: *We did have good modernists. Is modernism now dead?*

BF: It's dead for quite some time, I think. It had a good innings. Modernism had an innings of 60, 70 years. It's as much as anything can hope for.

 When I started writing for *The Irish Times*, nineteenth-century art was under a cloud. For modernism, nothing except French and English art was accepted, and a little later American art began to be accepted. Expressionism was under a ban, almost. It was regarded as Germanic bad taste. There was still a sort of neo-Fry aesthetic which had people talking endlessly about formal values, without seeming to know what formal values were a lot of the time. The modern movement had been formalised into tameness. Abstract expressionism was a big thing for us. It had guts and immediacy. While some of it looks flabby now, it took things head on. They painted out of their own world. English art had gone antiseptic. Ben Nicholson had a bad influence, great painter though he was. Even though they wouldn't admit it, French painting was played out by then.

VR: *When you started writing art criticism for* The Irish Times *modernism was the dominant style, in parallel here with the prevailing academicism.*

BF: Yes, it was. There is a crisis here now, and everywhere else too. It's a vacuum. Post-modernism is a trough. It describes not so much a style as a lack of style. One of the proofs of that is that most of the acclaimed movements of the past 30 years have been revivalist or pastiche movements. Pop was based on people like

Duchamp, who was right in the centre of New York. Hard edge abstraction was a revival of Mondrian and Malevich. Happenings and performance had been covered by dada.

VR: *You wrote for* The Times *for 35 years. When did you start?*

BF: In 1963. On Terence de Vere White's advice to the editor, Douglas Gageby, I was appointed art critic for *The Irish Times*. Before that, Tony Gray was critic for a long time, James White for a few years. There was Christopher Salvesen, who went to England. I'd written very little at that stage. Terence and I had talked a lot. He was a collector and had a very good eye for painting. I wasn't, I suppose, the best qualified person at the time. Hilary Pyle would have been a good choice. I never studied art history, though I read a lot of it. I never tried to paint. But I had an enormous interest.

VR: *There weren't any art history degree courses available in Ireland when you were a student. Julian Campbell did a lot to take nineteenth-century Irish art in France from under a cloud. And Hilary Pyle's work on Yeats is massive. She also wrote for the* Cork Examiner *for years; it must be quite an archive.*

BF: Yes, probably a valuable one. Hilary has a lifetime of writing and scholarship.

VR: *Given that you also covered literature for* The Times, *the pressure must have been intense, particularly as the number of art college graduates and art venues increased.*

BF: Yes, it was often quite intense. My editor nearly always stood behind me, luckily. The great thing was that you got art books and were able to travel, though not as an end in itself. I used every opportunity to travel. I've passed more hours in obscure European galleries than I care to think about. I would not recommend the job of professional art critic to anyone. You achieve relatively little and make a great number of enemies. If I had my life over again I'd be something else. As you grow older and acquire more knowledge, you learn to distrust your first impressions a good deal more than before. Your enthusiasm also lessens, but I should like to think that your powers of

judgement increase. I have no certainty that they do. I'm very glad that I no longer have to put them to the proof on a daily or even weekly basis since I retired.

Paddy Collins was going through a bad phase when I started writing. I greatly regret that I didn't appreciate his importance then. I now think Collins looks better and better. Alcohol, to be blunt, and the frustrating atmosphere of the time militated against him. There were many white hopes who faded. Doreen Vanston had a very hard life. She could barely afford materials. She was the last of the good French-inspired Irish painters, and the most neglected. She was difficult. She often scraped one painting out and painted over it through sheer poverty. She didn't have a gallery and sold almost nothing.

Camille (Souter) I liked. I always stood up for Nano Reid, she thanked me. I loved Barrie Cooke's early work. I still admire him. He was first seen, to my knowledge, in the *Independent Artists* exhibition in Lower Baggot Street, I think in 1960, at the Building Centre. Hendriks took up Cooke. Charlie Brady was heavily involved in setting up the *Independents*, a role which is often forgotten. He was outmanoeuvred and sidelined by fellow-artists. Charlie was an interesting arrival - I met him in the very early 1960s.

VR: *Charlie (Brady) was American, a fine artist of still lifes.*

BF: Yes, and Barrie Cooke is originally English, with American training. Camille is English by birth. There are others. Without that influx we would have been very much poorer.

Some good Irish artists went abroad. William Scott and F.E. McWilliam worked in an English context, which their northern roots allowed them to do easily. But they kept a certain footing at home too.

Tony (O'Malley) was abroad in St Ives, which was a very sealed-off context. He never had any success in London. Very few had. Shaw is right when he says that no two races in Europe are more different than the Irish and the English. They simply do not understand one another. Shaw lived twenty years in Ireland

and 70 in England, and said there was no country in the world in which an Irishman felt more foreign than England. He didn't mean that the English were unfriendly or unsympathetic. They were simply uncomprehending. It's not so much a history of English oppression as of mutual incomprehension. There was a kind of dual citizenship, of course, which Yeats, for example, took advantage of. He went to London when he could not trouble about the small dogs biting at his heels back in Dublin. Seamus Heaney is perhaps the last writer to benefit from this dual citizenship. He belongs partly to an Anglo-American tradition, the pastoral tradition of Robert Frost and Edward Thomas.

Alexandra Wejchert's *Freedom* in the AIB headquarters is the best piece of public abstract sculpture in Ireland. I think it's the best of its time – 1985 – in the entire British Isles.

It is as good as anything by Hepworth. Hepworth, of course, is a carver. Robert Adams did some great metal abstract pieces. Alexandra isn't as good as him, overall. She didn't have his consistent output. Adams discovered his own style earlier. When she hit metal sculpture, late in life, she did work as good as anyone's. She's a product of that very pure Eastern European style; Gabo, Pevsner, Malevich had it.

Gerda Frömel was another central European artist working here. She again almost stumbled in here. There's a lot of Lehmbruck and Giacometti in her work, she's stylish and eclectic, but a beautiful craftsman with a poetic sensibility. She was a very beautiful woman, a very striking personality. I always respected her and her death put me into depression for weeks. Luckily she had a few patrons like George Dawson and Basil Goulding. They kept her going.

I think George is a very underrated figure. He did an awful lot in his work in TCD with the old Library Gallery, and then the Douglas Hyde, its successor. He brought people like Lurçat in, there was a wonderful tapestry exhibition of his in the Hyde early on. He had people like Picasso. He had Pop art. He provided some of the most exciting exhibitions of the 1970s. He

had an enthusiastic committee of students under him. He was a collector, and had Braque lithographs. He was one of the men who adroitly managed to prevent TCD from being absorbed into the NUI, which would have been disastrous for both. He took Trinity as his field.

VR: Individual personalities made such a difference. Sculpture has a different story to painting, in Irish art, hasn't it?

BF: Sculpture has its own line of development. Between the wars you had Irish-American figures like Jerome Connor and Andrew O'Connor, working in a post-Rodinesque way. They never had much public patronage in Ireland, they were largely ignored or passed over in favour of local artists or mediocre local statuary.

Without the foreigners moving in, we might have been in a bad way. There was always Oisín Kelly, whose work was good but not international. He wasn't original or forceful enough to establish a school. He was a sensitive, intellectual eclectic. He didn't have the personality which created a following.

Alexandra (Wejchert), Gerda (Frömel), Imogen (Stuart),[5] none of them have established a tradition. They remain figures apart. There wasn't a dominant figure in sculpture in the 1960s that I could see. Gerda was probably the finest. I think her private work is her best. When she got public commissions, the result seemed like everyone else's. She was an intimate sculptor, not a public one.

I think Seamus Murphy was probably a good stonecarver. He was a charming man, an essential figure in cultural Cork. I think that for bread-and-butter reasons he had to rely very much on portraiture in bronze, and in that field his work is virtually indistinguishable from a dozen others. He's a carver, not a modeller.

VR: How do you rate the metal sculpture that emerged in the 1970s?

BF: I thought it was all right, but it wasn't any better than what it was based on in England – Brian Kneale and Philip King, and so on. John Bourke is easily the best. Eilís O'Connell took it further. They took up a style rather than formed one, so it seems to

Brian Fallon and Sarah Finlay, Dublin, circa 1992.

me. They did it with great energy and efficiency, but not with much originality. They are excellent professionals, and carry out any commission well. But I didn't see any core of personality that makes the work stand out from a number of others' work. Alexandra had a flame of imagination always there, a spirituality. She was a master of form but never a formalist. Eastern European abstraction always had that dimension to it. I can't see it in people like Caro, who for me is a modernist academic.

VR: *What does public art in Ireland represent to you now?*

BF: Its potential for good and bad is great. If you start putting up sculptures in public you're stuck with them. By its nature, unfortunately, very few people have the ability to carry it out. If you fill the country with mediocre sculptures the result is going to be painful rather than inspiring. We should learn from England before it's too late. There's a Henry Moore in nearly every park in England, and the result is boredom.

Public sculpture should have some roots in local or national history or myth. Some connection with the landscape in which it's placed. When you're dealing with public art you're talking about popular art. You have to address the ordinary man, who has to pass it every day and look at it, to live with it. Oisín Kelly was a private and fastidious man but he had a pipeline to the public. At County Hall in Cork, his two bronze

figures look rooted, look as though they belong in this setting. He was most successful with single figures. *The Children of Lir* in the Garden of Remembrance is an ambitious mess, he could not cope with complex, baroque-style compositions. Michael Quane's stone man facing the Blasket Islands works well, for the same reason as Kelly's bronze figures in Cork.

Imogen Stuart could do it in her religious work. She did it in the church at Burt in Donegal, she worked very efficiently with Liam McCormick, a great architect, a very original one. Some of Imogen's doors, like the ones at Newcastle in County Dublin, work very well too. Although I say it myself, my brother Conor has done some very effective work. The bronze horses he has done for Tony O'Reilly at Independent House are major achievements. Certain other pieces of his are too. Things like those show that relatively traditional imagery is never obsolete. What is needed is a new language to renew them.

VR: How important an art patron was the Church in later twentieth-century Ireland?

BF: If you think in terms of the Church patronage of the Middle Ages it's not comparable. But the Church was an important patron for certain artists – Imogen, Oisín Kelly, Patrick Pye, for example. Maybe a handful of others.

VR: Vatican II stimulated quite a lot of change in church interiors, creating potential opportunities for art patronage.

BF: There's too much of a divorce between the language of modern art and traditional religious imagery. It's very hard to bring them together. The greatest religious artist of the twentieth century was surely Chagall and he can't be reckoned an orthodox religious artist; Judaism doesn't allow figures and he frequently has images of God. Harry Clarke is the most obvious case of an Irish artist patronised by the Church, but I find his work wholly irreligious. It's very Nineties and decadent, in the best sense of the word.

VR: There's James Scanlon's work. I really like his crypt chapel in Glenstal and the windows in Galway cathedral.

BF: Yes. And abstract art can be moving emotionally. Evie Hone is a lesser artist than Harry Clarke. She can be a little academic, but at its best her glass is good. Glass and architecture were the mediums that benefitted most from church patronage after Vatican II.

VR: *If a lot of the post-war generation involved themselves in organising exhibitions –* Living Art, Independent Artists, Rosc *– the late 1970s saw artists getting together to acquire more permanent spaces in which to make work.*

BF: I think it's very important that artists should stick together and establish codes for professional behaviour. They've always done this. That was the purpose of medieval guilds and the Academy. The danger is that they became dominated by cliques and it's hard for the individual artist to flourish if he is outside it. Any group activity tends to encourage conformity and often drives the original artist outside it. This happened in the Academy in the nineteenth century in France.

It's a very delicate balance. It's very important that artists should have a degree of solidarity. They need corporate strength. For centuries they were artisans, or perhaps more than artisans, but that upheld standards of technical reliability, standards that would apply to good craftsmen or tradesmen, to plumbers and to artists in equal measure.

Unfortunately the modern movement smashed that. It was necessary to do so, but we are left with a bad legacy.

VR: *It's a shame that AAI (Association of Artists in Ireland) can no longer operate.*[6] *But there's solidarity in groups like SSI (Sculptors' Society of Ireland).*

BF: The SSI doesn't seem to me to have set very high standards. Things like that tend to become protection societies, and second-rate talents seek safety in numbers. While I respect solidarity among artists, I find that sooner or later they nearly always fall out. Artists are often highly strung, rather paranoid people, and it's difficult to hold them together. Except when they are under pressure.

VR: *One of the results of the expansion of numbers in the art col-*
leges since the 1970s has been that artists have been involved in
a lot of related activities. Circa *magazine, for example, was*
founded about twenty years ago, by artists. Do you read it?

BF: I don't often read it, I'm afraid. It's couched in language which
I find very opaque and I don't read it with any pleasure. It main-
ly deals with areas of art I don't have much sympathy with. I'm
not hostile to conceptual art but most conceptual art I find, in
practice, very tedious. Performance art I've learned to dread. It's
like bad amateur theatricals. For most performances I attended,
I've wished earnestly that I was somewhere else. I find some of
them are simply embarrassing. *Circa* obviously speaks for a cer-
tain number of people. It should be there. It's a legitimate pub-
lication. I'd be sorry to see it fold. I don't know to what extent
it speaks for the art-going population of Ireland. But if it has
even a large minority following, that makes it worthwhile.

VR: *Were you encouraged to see the co-operative studios emerge in*
the late 1970s and early 1980s?

BF: I think co-operative studios are an excellent thing for young
artists. But at a certain stage, I think these people will go their
own way. I still think it's very important that the Arts Council
and others should provide cheap studios. It can make such a dif-
ference to an artist starting out to know he doesn't have to pay
an exorbitant rent. Young artists need the feeling that they are
in the same boat. At a certain stage, communal activity is very
important. Temple Bar Studios and Buckingham Street Studios
are very important, in that sense.

I saw an interview on TV once with Stravinsky. He was
asked what form the musical masterpieces of the future would
take. He said 'nothing is ever certain about masterpieces, least
of all that there will be any.' You can legislate for a lot of things
but not genius. They can't even produce it genetically. On the
other hand, you must legislate for the exceptional as well as the
typical. It's nice, if and when they come along, that the struc-
tures are there for them in advance.

VR: *You must have visited a lot of artists' studios. Do you have any outstanding memories?*

BF: I think probably the greatest discovery for me was when I was on a cultural trip to Germany in December 1968. It was arranged through the Goëthe Institute in Dublin. A very respected German art critic of the older generation, Dr Karl Gustav Geröld, was stationed here and he arranged the trip. It was an illumination in lots of ways. I saw a great deal of German art. I saw a huge Beckmann exhibition in Munich, and I saw the Blue Rider in various museums. I discovered nineteenth-century German art, of which I had known almost nothing except Friedrich. I saw the wonderful treasure house of late Gothic painting, mostly anonymous masters.

Dr Geröld knew all the great German Expressionists personally and asked me would I like to meet them. I mentioned Heckel and Schmidt-Rottluff, both of whom I knew were still alive. He said yes, but Heckel's work had 'lost its force', and Schmidt-Rottluff was not a friendly man. I fell silent. He asked me would I like to visit the studio of Alexander Camaro. It meant nothing to me. But we arranged it, and the day finally came in Berlin. A bitter wind blew across the square as I made my way to the Hochschule. Camaro was expecting me and my interpreter – a student – in his private studio there. His personality was tremendous. He'd been a dancer and a cabaret artist. He had even less English than I had German. His studio was full of abstract paintings which seemed to me to be in the Rothko class. He asked me, through the interpreter, would I like to see the Wooden Theatre. I'd never heard of it. Like most German artists of his generation, he'd lost nearly all his work in the war. He'd been born in 1901. Twenty years' work was largely gone. He'd saved a series of gouaches, which he'd painted in an old castle where there was an eighteenth-century wooden theatre. Appropriately they were in a wooden box with a sliding top. They were marvellous things, different to what he was doing when I met him.

Later I heard that William Scott, who had been in Germany at that time, was asked in public whom he thought was the best living German artist and when he said 'Alexander Camaro' there was a stunned silence. Camaro was very isolated because Berlin was just an island in the Communist East. He couldn't sell his work. His fame never travelled outside Germany. But fame did come and he got a State funeral.

At one stage during the visit Camaro was bustling around, he was very graceful in his movements. All of a sudden some big pictures fell on top of him, then more and he fell around laughing. We all ran round pushing these big canvases upright again, while others kept falling. I said to my guide, 'this is like something out of a Marx Brothers film'. The guide said, 'Did you hear what Herr Camaro said?' I didn't. He said, 'He's just said the exact same thing". He told the guide he thought his teacher's ghost had walked into the room when I entered. The teacher had been 'Gypsy' Müller, one of Die Brücke group. It was a tremendous experience; the personal electricity was there. We corresponded later but we had to get the letters translated. There is no book on him.

VR: *Apart from your journalism, you've published quite a lot on Irish art.*

BF: It doesn't seem so, in retrospect. I had demanding jobs in journalism. I have a large family and I have a very supportive wife. But the sheer career demands were very heavy. I was not only a journalist *per se*, I was also an executive who had to oversee certain sections of my paper. I succeeded Terence de Vere White as literary editor in 1977 and continued until 1988 – for eleven years – until John Banville succeeded me. I had a very good relationship with John Banville, as I have with his successor Caroline Walsh. I continue to review books. I read very compulsively, on the bus, everywhere. I don't drive – I can, but I don't. *An Age of Innocence*[7] seems to have made the biggest impact of my work. It was a book which was needed at the time, as historical redress. Revisionism had run into a blind alley and

needed to be revised in its turn. I did begin to feel indignant that a whole epoch had become distorted, sometimes wilfully. It's not as if we're living in an age of enlightenment. We're living in an age of crass materialism, which won't last.

My other books were nearly all monographs on individual artists. Apart from *Irish Art 1830-1990,* in which I'd like to rewrite certain sections, because I'm not satisfied with them. Now I'm attempting to fulfil a number of projects that I've put on the long finger for years. I think it's fortunate I didn't do some of them earlier. I feel more qualified to attempt them now than I did in the past. The problem will be to find publishers. It's always a problem in Ireland.

VR: *Do critics make reputations in Ireland?*

BF: I could never judge the power of criticism. In a limited area inside New York, yes, it's clearly important. Here people don't necessarily believe the critic. I sometimes think art criticism is a futile activity, but if it was abolished you'd miss it. Artists always give out about it. But it has to be there, wrong-headed or erratic though it often is.

Nowadays in *The Irish Times,* Aidan Dunne does a survey rather than the individual exhibition reviews I did. This is inevitable, because of the much greater number of exhibitions. I sometimes think you need two or three art critics specialising in different areas, just as you have music critics specialising in pop, classical, folk music.

Art has got enormously varied. It's a pluralistic world. I don't think any critic alive could claim equal sympathy with all art forms.

I'm not very interested in conceptual art myself. I find a lot of it boring and intellectually respectable. Sometimes people take some visual conceit and laboriously illustrate it in a whole room, when the concept could be better dealt with in a 4'x2' format.

VR: *Was it possible for you to be aware of what was going on in the visual arts around the country?*

BF: In recent years papers have had regional art critics. Even then

it's arbitrary. You cover one thing and not another. Art coverage is cost-intensive and only appeals to a small readership. I know that from my own experiences, as arts editor in my paper from 1970 to 1977. Many people will read theatre notices but not exhibition notices. Newspapers here do a good job, but it's always a catching-up job. Even the allocation of space in the newspaper is to some extent arbitrary.

I think the Butler Gallery in Kilkenny played a very important role. It probably was, at one stage, the best modern gallery in the country. The presence of a major artist like Barrie Cooke in the area probably had a lot of do with that. It doesn't lessen the fact that Kilkenny has had a very good, far-seeing committee that took chances. Seán McSweeney in Sligo had a definite influence. Now you have *Éigse* in Carlow which is doing a good job. These are all lifeblood coursing through certain areas. It would be a disaster if Dublin dominated everything. French art was dominated by Paris and suffered by it, there was no regional vitality after the mid-nineteenth century.

VR: *With all the creative activity in new media, like video, since the Second World War, what have you found most interesting?*

BF: I think the most significant thing is so-called land art, or earth art. I think it's been greatly abused, especially in America, where as one critic said, it simply became an excuse for digging holes in Utah. Used judiciously and in the right hands it can have a beneficial effect on the environment, akin to creative landscaping. It can be very effectively used around our cities. After all people tend to forget that a great deal of our landscape was shaped by the eighteenth-century aristocracy. It's a man-made landscape. There's an obligation on us to shape our landscape while keeping in touch with the natural environment. This is especially so since a kind of subtopian development creates a kind of wilderness for ten or fifteen miles around every city or large town.

I think video is potentially a marvellous medium. But nineteen out of twenty times I'm very disappointed with the result.

It often seems like a badly-made home movie. Firstly people don't seem to have adequate technique, they don't seem to have the mastery of the medium, and secondly they follow the conceptualists by getting a very banal idea and running it into the ground. The result is generally pretentious piffle.

VR: *Was the big art event of the 1990s the opening of IMMA? You were on the Board for a while.*

BF: I was, yes. I'm afraid I wasn't very effectual. I'm not, I think, very good on boards. But I was slightly unhappy with the heavy stress on a conceptualist programme.

On the other hand IMMA had to establish its own territory, it had to pin its colours to the mast as it were. Its main achievement was that Declan McGonagle, starting with nothing, built it up as an institution. He began with virtually a blank cheque and when he left IMMA it was a well-run and well-administered institution with a competent staff. His taste in art was not mine, but then I was not the director.

I think the way in which he was virtually pushed out was a clumsy and badly handled affair which reflects no credit on anybody. It has left a bad taste and makes things difficult for any successor.

VR: *Indeed. How do you perceive the role of a newspaper art critic?*

BF: Fashion is always to be distrusted, but not to be despised. Three-quarters of so-called art movements are simply fads, engineered by dealers, media or museum organisers. But there's nearly always a core of validity and it's the critic's job to find it. He should look at the individual artist and the individual art work, above all. It's his job to find the trees among the wood.

His job is to alert the public to what is happening in his field. He should have opinions but he should write with his eye on the target and not about himself. He should always go on learning and looking, and try to get a sense of areas where he doesn't belong and perhaps realise at a certain stage that he is out of step with a generation, as I feel myself to be. His job is sometimes to take up major and neglected talents. He should

discover worthwhile people, be lenient with young artists and be totally ruthless towards establishment phonies. He may have a certain educational role, but he needs an exceptional knowledge and breadth if he's to take on that role. Art criticism is written for tomorrow's newspaper, not posterity. The art critic is like a war correspondent. He's in the middle of the smoke of battle and finds it very hard to see the battlefield overall, and even less the grand strategy behind it. So his wisdom, if he has any, is likely to be in hindsight. But he should stick his neck out, nevertheless. Else he shouldn't write; better be wrong for the right reasons than right for the wrong reasons. There's no point in neutralised opinions. Silence is preferable.

Interviewed 22 August 2002

1. Fallon, B., *Irish Art 1830-1990*, Belfast, Appletree Press, 1994, p. 189.
2. Fallon, B., *Edward McGuire*. Dublin, IAP, 1991. Edward McGuire painted Brian Fallon's portrait in 1983.
3. Fallon, B., *Tony O'Malley, Painter in Exile*, Dublin, the Arts Councils, 1984.
 Fallon, B., 'The St Ives Period' in Lynch, B., (ed.), *Tony O'Malley*, Aldershot, Scolar Press, in association with the Butler Gallery, Kilkenny, 1996.
4. Fallon, B., (ed.), *Padraic Fallon Poems and Versions*, Manchester, Carcanet New Press & Dublin, Raven Arts Press, 1983.
5. Fallon, B., *Imogen Stuart, Sculptor,* Dublin, Four Courts Press, 2002.
6. 'The Association of Artists in Ireland was founded in 1981 by artists including Robert Ballagh, to improve the status of visual artists. It had 1,200 members prior to its ceasing trading in March 2002, when the Arts Council discontinued funding.' Stella Coffey in conversation with the author, 20 June 2003.
7. Fallon, B., *An Age of Innocence, Irish Culture 1930-1960*, Dublin, Gill & Macmillan, 1998

Colm Ó Briain talks to An Taoiseach Jack Lynch, 1978.

Colm Ó Briain

Colm Ó Briain was born in 1943 and educated in Belvedere College, Dublin, UCD and the King's Inns. He is married to Muireann McHugh SC and they have two daughters. He has been a producer and director for RTÉ Television, Head of Training at the Abbey Theatre, director of An Chomhairle Ealaíon/the Arts Council and general secretary of the Labour Party. He was adviser to the Minister for Arts, Culture and the Gaeltacht from 1993-1997. He was appointed director of the National College of Art and Design in 2002.

VR: *Colm, did you have long hair when you started up the Project Arts Centre in 1967?*

C.ÓB: Yes, being a member of The Beatles generation long hair was de rigueur. I was always considered a bit of an outsider when I was in college, I suppose. I was doing law and neither my hairstyle nor my apparel were appropriate to the seriousness that a law student should project.

VR: *Did you ever practise law?*

C.ÓB: No. The Project came after I did my LLB and passed the Bar exams. When I was in college I decided my career would not be in the legal profession but out of respect for my father who paid my fees, I felt it was my duty to a least finish what I started. I was focused on theatre; I was active in the Drama Society from the very beginning. But during my second year my ideas began to crystallise and I felt I would be trying to make my career in the theatre. Theatre and music had been part of my family life. My mother was a musician. Theatre and music were present at home though, which the visual arts were not. My earliest memory of theatre was sitting in the back row of the Gate Theatre with my father and brothers watching a Lord Longford production of *The Importance of Being Earnest.*

In the visual arts, I remember that I was really taken with Evie Hone's work in the Great Hall in UCD. It was a retrospective with her windows, a most impressive installation. I was in secondary school, maybe it was 1958 or 1959.

VR: *Did you think of the Project as a place where all the arts would unite? What was your vision?*

CÓB: It didn't start as a vision, it started as a piece of pragmatism. There was an exhibition in the Hugh Lane called *Art USA Now,* the Johnson & Johnson Collection. The diversity of the work there was really an eye opener for me. An interest in the visual arts had begun to awaken in me after I left college and was starting to focus on a career in theatre. I was introduced to John Behan who was suggested as a designer of sets and he agreed to come on board and design sets for what was later called Project

67, in the Gate Theatre. Through John I met other painters, like John Kelly and Michael Kane. We did Project '67 because we were paying rent on the Gate for three weeks and it was at our disposal, so we had an exhibition in the foyer. We had seminars, we had teach-ins. We had a massive Sunday night seminar on censorship in Ireland and Edna O'Brien travelled over from London to be a guest speaker. It was the first time the queue for the Gate was longer than the queue for the Ambassador cinema next door. She had declared her books at the Customs and they were seized because they were banned.

After that venture we came out with a small deficit, not enough to disenable me. I asked my father, who was storing hosepipes on the second floor of a building in Lower Abbey Street, could he store them elsewhere and could I use the space. John Behan, Michael Kane and John Kelly all said it would make a terrific gallery. Around this time I would have met Paul Funge. I became more and more involved with artists and realised their predicament was very similar to my own. How do you break in? For visual artists and for theatre people it was very hard to break into the established order. There were only two real commercial galleries, the Hendriks and the Dawson, and if you weren't a stable artist you had no exhibition opportunities. There was the RHA and *Living Art*. The Project artists had been involved in something called Rising Ground with James McKenna. They hired a space in *The Irish Times*, then in Westmoreland Street, not d'Olier Street where it is now, and they had an exhibition in the front lobby. There was total impermanence for visual artists, other than for those who were very established. So the Project Gallery became the third gallery on a continual exhibition basis. It was an alternative in every sense because it was a co-operative. It had difficulty meeting overheads but it was connecting with the rising generation of painters. The *Independent Artists* continued as an annual exhibition whereas the Project was open six days a week, every week.

VR: *The Project was opened by Donogh O'Malley, the Minister for Education who brought in free secondary education at that time?*

CÓB: James McKenna, God be good to him, he's dead now, always maintained my recollection was not correct in regard to this. It was the first major row in the Project. My recollection is that we decided we would invite the Minister for Education, but James objected and disassociated himself from the committee in the wake of the invitation. But James came back later when we moved to Project No. 2 in the basement of the YMCA in Lower Abbey Street. He was involved with his plays and having his work shown in the Project.

In spite of all the obstacles there was a spirit of 'can do'. Donogh O'Malley was charismatic but was to die very young. We were full of our own importance and wouldn't have been phased by asking a government minister to open two rooms on the second floor of an engineering shop in Lower Abbey Street.

VR: *You were part of a group of artists who were not in favour of the* Rosc *exhibitions.*

CÓB: Yes. The artists I was pals with were very antagonistic because they saw it as a quasi-imperial gesture – the Irish are so ignorant, the only way for them to learn is by looking at other artists and all that. The realities for living artists were pretty severe and this blockbuster was something people resented. It had to do with our own sense of ourselves, of the visual tradition in Ireland, and a feeling that if it was Irish it was second rate and why should it be? Why should we be second-class citizens? There were complex identity, cultural and political issues all mixed up. So without knowing a great deal about it I would have found myself in the anti-*Rosc* lobby.

VR: *You were, in effect, anti-establishment?*

CÓB: I suppose so. At this time the perception was that the Arts Council was exclusively visual arts.

Mervyn Wall, the novelist who was then secretary of the Arts Council, would contradict me, but that was the general perception. Of course, its statute of 1951 didn't confine it to visual

arts. There was a perception that there were other institutions dealing with theatre – the Abbey – or music – the Royal Irish Academy of Music and RTÉ, but only the Arts Council to support the visual arts. Mervyn Wall was later keen to disabuse me of this single dimension perception. The Arts Council actually gave significant amounts of its tiny budget to opera. Anyway, the Arts Council was a focus of resentment among visual artists at the time.

Around that time Michael Scott had an exhibition of his drawings in the Dawson Gallery and the Arts Council, of which he was a member, bought two. That enflamed artists who perceived themselves on the outside. The Project was very much a structure around which the disenfranchised were gathering.

VR: *Was it difficult to run the gallery well?*

CÓB: Because there was a committee approach to work, the strains of running the gallery on a week-in, week-out basis were huge. The administration was almost completely amateur. I do remember huge arguments about sustaining quality and about whether it would be better to close than to exhibit sub-standard work.

VR: *Did you have any exhibitions policy?*

CÓB: Basically we were trying to extend our circle. We realised we couldn't sustain a gallery on an inner circle.

VR: *Which exhibitions do you particularly remember?*

CÓB: I remember John Behan's early exhibitions, particularly his lithographs. Those images have remained with me. I still see them in John's work, even in his most recent exhibition. I remember very strong exhibitions by Paul Funge. Also Jonathan Wade who was a very important influence in the early years of the Project. He was very down to earth. When we would have furious rows on the committee, Jonathan was the great pragmatist. He was killed in a motorbike accident in his twenties. It was very tragic. I was very attracted to his work. I found his urban landscapes, these works which were neither figurative nor realistic, spoke very strongly to me, coming from an entirely urban background as I did.

VR: Did you build up a collection?

CÓB: I bought John Kelly and Michael Byrne on the painting side initially, John Behan and John Bourke on the sculpture side. I have several Mary Farl Powers. She was an artist with whom, much later on, I had a very confrontational relationship over the Graphic Studio. I suppose the works I have represent different phases of my own visual awareness and career and people I was meeting and exhibitions I was going to. I bought works by Tony O'Malley and Eamonn O'Doherty in later years.

I developed a very clear idea about the difference between purchasing work for myself and for an institution when I went into the Arts Council. The Arts Council had a very strong purchasing policy which started in the 1960s or earlier.

VR: There was/is the Joint Purchase Scheme.

CÓB: In its early days, the early 1960s, it was called the Hotels Purchase Scheme. The purpose of it was to put work by Irish artists into public places. With the founding of Bórd Fáilte in the mid 1950s I suppose hotel foyers were very conspicuous public spaces. Getting work that was bought by the State and the private purchaser together into hotel spaces was the impetus for the Joint Purchase Scheme.

VR: What was Ciste Cholmcille?

CÓB: It is a fund set up by the Arts Council at the suggestion of Cearbhaill Ó Dalaigh and Eilís Dillon to give grants to individual artists who might be in financial difficulties. It depends entirely on donations from private individuals. Before 1976 it was the only way by which individual artists could receive money from the Arts Council, as its policy until then was only to fund organisations or groups.

VR: You did a famous interview with Seán Keating visiting Rosc.

CÓB: It was Ted Dolan who was the producer of *Aurora* (I was working in Current Affairs in RTÉ, on the *Seven Days* programme) who asked me if I would present the programme. There was controversy about the College of Art, and the old guard and the new guard, and scorn was being heaped on the traditional,

regimented approach to drawing. As far as I remember Seán Keating wrote, as former professor of the college, a letter to the paper which prompted Ted to do an interview with him. The part of the interview that's never, or rarely, repeated in the 30 years since I did it is with Keating in his studio and around his house. He lived out in Rathfarnhan. It was very interesting to encounter him. He had extreme views about all forms of art but he wasn't in any office and didn't influence any policy or institution at that stage. We were really talking to an old reactionary. The debate about art and art education was in the public eye. Ted asked him could we visit *Rosc*, so without any real preparation Seán Keating, camera crew, the producer and I arrived in the RDS. I had no agenda, I wasn't trying to expose him. I really was enjoying my conversation with him. Because we had done the interview in his studio beforehand he and I were chatting, for want of a better word. I wasn't antagonistic and he didn't feel I was asking him questions to show him up as a foolish old man. He felt he could be straight and very honest. I wouldn't say it happened completely by accident but accident played a part in how the interview came about. It is now in RTÉ's archives.

VR: *Had you finished working in the Project at that stage, surely not?*

CÓB: The one thing I insisted on with my contracts with RTÉ, which were full time, was a specific clause that I could continue my work for the Project.

VR: *Were you interested in the events at the College of Art?*

CÓB: The first time I was ever in the National College of Art in Kildare Street was as a trespasser. The students conspired to get myself and a film crew in there. So we were filming part of the protest and the occupation.

VR: *Was that for* Aurora *or* Seven Days?

CÓB: Current Affairs. *Seven Days.*

VR: *You were very young when you became director of the Art Council.*

a cost of £11,600 out of a total expenditure on purchases of art of £92,300. That's reasonable support.

CÓB: Purchasing was, at one stage, the only visible form of state support for contemporary artists.

VR: *It's odd, though, that places like the Crawford Municipal Art Gallery had huge empty spaces, and hardly any purchasing budget, and the Arts Council had very little space and a rather ample purchasing budget.*

CÓB: The intention originally was that the first floor of Merrion Square would be a gallery. That was before my time, it would have been when Seán O Faoláin moved the Arts Council from Stephen's Green to Merrion Square in the late 1950s. The Arts Council of Northern Ireland had its own gallery. The Welsh Arts Council had its own gallery. The Arts Council of Scotland had its own gallery. So it was perceived here that what an Arts Council had to do was have its own gallery. Any reformation of the Arts Council in the 1960s and early 1970s would have included focusing on a gallery.

VR: *Your own first report to the Arts Council was about the necessity of supporting individual artists. Were you the innovator there, advocating giving grants to artists?*

CÓB: I would say that it was a collective energy, good ideas were discussed. There was a vigorous relationship between a small executive and a very committed Council. This was the furnace out of which a lot of good ideas came. The commitment to grant writers was the first to move off the block. The writers on the Council were well disposed to this as an essential strategy for the support of writers in Ireland. The visual arts people would have been more reticent, conscious of the criticism of the Arts Council in earlier years. This could be seen as a slush fund for favourites. It needed far more examination to ensure that this initiative wasn't just the old regime in a different guise. So the bursaries and grants for visual artists (and composers) followed the initiative in relation to writers.

VR: *Do you think that the individual artist is adequately supported?*

So much money gets absorbed in arts administration.
CÓB: The individual artist never gets enough.

But I've never believed it was the role of the Arts Council to run a tape measure across its grants. In the 1980s when there were huge cutbacks, a Minister of State who was dealing with representations from her own constituents about Arts Council cutbacks actually said that if the Arts Council has a cut of four per cent it was its duty to apply an equal level of misery across the sector. Therefore, the only role of the Arts Council was to pass on cuts or increases. This is a very mechanistic approach. People like Seán Ó Tuama were very clear that if a Council was going to be driven by quality and by policy initiatives that were meaningful, a percentage of resources was not a measure of success.

VR: *Do you see your interest in supporting the individual artist through grants and bursaries as one of the great advances made during your time as director?*

CÓB: That and breaking the hegemony of Dublin.

VR: *Beginning to break it? And you brought in the 'Big Five', the Abbey, the Gate, the Irish Ballet Company, The Irish Theatre Company and the Dublin Theatre Festival. They had been under the Department of Finance. But let's stick to visual arts issues.*

CÓB: Yes, indeed, a beginning. It is a process that is still ongoing. But the beginning of a recognition that you didn't parachute art from Dublin into the regions, and that you had to encourage creation and exhibitions generated within the regions and of the regions, rather than the paternalist attitude that Dublin knew best; that was an important advance. Aosdána was the other advance. It was motivated by the mutual interest of the individual artist and society at large – the taxpayers, the public. It wasn't to suggest that artists are an élite apart. The whole objective was to develop a strategy for the support of the arts which was multi-faceted rather than single dimensional. From my work with artists I realised how arts institutions and organisations couldn't function without artists, individual artists, and if

these institutions were to be properly supported there would also have to be a régime of support for individual artists. The view that gained acceptance at the time was that Aosdána was a gain for everybody. The Council had commissioned a survey[2] on the living and working conditions of artists. All the people around the table at Council knew what the reality was. The survey, however, showed in brutal figures how small an income artists had in Ireland, and how many of them had none, and how they were excluded from Social Welfare as well. There were no pension rights available to them. So the general economic and social conditions under which artists had to exist were a concern for the Arts Council. The bursaries and grants were support in the short-term, on an annual basis; and they were project based. The Arts Council had developed its own thinking considerably when the possibility of doing something more permanent and longer term was introduced by Tony Cronin, after he was appointed as the Taoiseach's arts adviser. There was a momentum developing. As soon as there was an indication that there was sympathy for the work that was being done by the Council, we went into overdrive and developed the Aosdána idea, which was accepted by the government of the day.

Aosdána was to be an affiliation of artists – writers, composers and visual artists – admitted to membership because of the excellence of their creative work. The number of members would be limited, initially to 150, and it would be first and foremost a recognition of artistic achievement. The initial membership was to be decided by the Arts Council, but once up and running, membership was to be by election of those already admitted to membership.

Where individual members were prevented by economic circumstances from devoting themselves on a full-time basis to their art, they were eligible for a five-year annuity (to be called *cnuas*), which would assist them to devote their time wholly to artistic work.

Members themselves would regulate the affairs of Aosdána,

discuss cultural issues in an annual assembly, and elect not more than five of their number at any time to the honour of *Saoi* in recognition of an outstanding contribution to the arts in Ireland. This honour would be conferred by Uachtarán na hÉireann.

The concern from the outset was, as it had been with the bursaries, to balance artistic freedom and independence with State support. The notion of a State artist was not what Aosdána was about at any stage, and that's why a member of Aosdána is a member for life – so that artists who fall foul of the establishment cannot be excluded.

VR: You seem to have asserted the independence of the Arts Council in the Bord na Móna controversy about knocking down buildings on Pembroke Street. That was really quite heroic, was it not?

CÓB: I suppose I was a bit of an upstart. I wouldn't like to use the word heroic. This was an issue about which members of the Arts Council felt very strongly. I felt that I was working with people whose views I respected. Therefore, the challenge was to devise concrete actions, to take matters into our hands and do something. Architecture was within the statutory remit of the Arts Council. The Arts Council was also a designated body under the Planning Acts, so to have walked away from it would have been shameful. Bord na Móna, as a state body, was obviously not pleased at being frustrated by another State agency.

VR: The architectural students occupied the buildings Bord na Móna wanted to demolish?

CÓB: The students occupied the building after the Arts Council took Bord na Móna to court and lost. The reason we lost was that we had, as a designated body under the Planning Acts, made no objection at the planning stage. The Bórd na Móna office development had gone through the planning process. We had no standing in court because we had missed the boat. It was said that the Arts Council had neglected to carry out its statutory duties. But the Arts Council was a small office. We were snowed under with planning applications and had no executive capacity

to address these additional responsibilities on a day-to-day basis.

The occupation bought time for negotiations. There were very complex discussions between Bord na Móna and the Arts Council, and between the various Ministers responsible and the Taoiseach. The Taoiseach was responsible for the Arts Council. Through these high-level negotiations – I'm guessing now – a member of the Arts Council may have had a role in identifying a purchaser for the Bord na Móna building in Pembroke Street. That let Bord na Móna off the hook. So they agreed to stand down. The Arts Council had got engineering advice that it was not necessary to demolish the façade whereas Bord na Móna had engineering advice that it was necessary to demolish the façade. There had been so many pastiche solutions to conservation problems that the Council felt that this was the time to take a stand. The buildings on Pembroke Street weren't that important in themselves. It was the streetscape, the environment, it was the proximity to Fitzwilliam Square, the integrity of the streetscape that was the issue. The Arts Council had previously been seen to have failed publicly in relation to the ESB offices, you know, the Arthur Gibney and Sam Stephenson designed office block in Fitzwilliam Street. All the Georgian buildings there were demolished and the Arts Council had concurred with the development.

VR: *And what role had it in the Wood Quay affair where a large number of derelict buildings acquired by the Corporation covered a major Viking site?*

CÓB: The Arts Council did discuss it deeply, and did engage with the Corporation, but was not involved in the campaign as it had no statutory remit for archaeology. It felt it would have been dishonourable to have been involved publicly, because in a meeting between senior officials of the Corporation and the Arts Council, background confidential information was made available to the Council.

VR: *Oh?*

CÓB: Agencies of the State must proceed on matters of principle, they are not stand alone single issue groups, who can tilt at whatever windmill happens to present itself. The Arts Council felt that it could only advance anything in Wood Quay on a negotiation basis. The Corporation agreed to enter discussions with the Council.

VR: *Was it dreadful to go ahead with the building the way they did, do you think? They could have kept the Viking site, one of the most important in Europe, and had the building, but some experts were saying the site was only a hole in the ground.*

CÓB: At the time of the campaign what had been done in York was greatly praised. I've seen York and there are modern buildings built over the site. Archaeologists would say 'you find something, you expose it forever'. That creates huge problems. Look at Carrickmines Castle and the route of the M50.

If there had been no excavation it would have been criminal. The difficulty concerned what the Museum had, and had not said, to the Corporation. The Council's query was in relation to the advice on which the Corporation made a number of legal and contractual commitments. It had not proceeded without advice. The National Museum was also an agency of the State. There were complex inter-state and civil issues involved. The main constraint on the Arts Council was, as I've said, that archaeology is not within its remit. The Arts Council did seek to use its influence. It rolled up its sleeves and did work on it privately.

I think if you are going to be principled but pragmatic you can engage. But if you sit on the fence or if you only argue from a highly inflexible 'we will not be moved' point of view, you will be ignored and marginalised.

VR: *You didn't remain as director of the Arts Council. Did you leave because there was a sense of completion with some projects like Aosdána? Do you just believe in moving on?*

CÓB: Well, there was a sense of completion with Aosdána, but I had been there for nearly eight and a half years. There are serious

issues for people who are engaged in cultural work and the point at which they must move on. I was on my second five-year contract when I resigned. Eight years was what I thought was my useful life with the Arts Council. I had to be released from my contract.

VR: *To follow another dream?*

CÓB: I moved to be general secretary of the Labour Party. If you believe in certain things in society, and you want to see them delivered, you get in there and do it. You try to do it.

VR: *That political involvement lasted a long time.*

CÓB: Well, the political involvement lasts till today, but my time as general secretary only two and a half years.

VR: *I was thinking about your work with Michael D. Higgins, first Minister for the Arts at cabinet table.*

CÓB: Well, that came much later. In 1993.

VR: *What did you do after being a general secretary?*

CÓB: I worked as a freelance director in theatre and television. I also set up the Arts Administration Studies programme in UCD. I set up Cothú, the group which promotes business support for the arts.

I used to say when I was with the Arts Council, the arts were my profession and politics were my hobby. When I went into the Labour Party, politics became my profession and the arts my hobby. I have always mixed the two. Mary Robinson would have been a catalyst, not when she stood for President, but much earlier when she stood for the Dáil, for which she wasn't successful. That would have been the first campaign for the Labour Party I was involved with. Many years later I was asked to contribute to the section on the arts in the Labour Party Manifesto in 1992 for the general election. Michael D. had been chairman of the Labour Party when I was general secretary. We had worked together closely on political issues. I would share a lot of his political values, and would have been very inspired by his political analysis.

VR: *As adviser to Michael D. when he became Minister for Arts,*

Colm Ó Briain, a friend, Michael D. Higgins,
his son Michael, and Derek Hill.

Culture and the Gaeltacht in 1993, did you value the work Ted
Nealon had done, as a Minister for State, before the first full
ministry was in operation?

CÓB: Ted Nealon is important in the scheme of things. Much of the
groundwork was laid by him in the Taoiseach's Department
when he gathered in the museums, the Film Board and other
agencies into the Department. There was also Lottery funding
for Arts and Culture. His preparatory work in terms of gather-
ing in the various elements of a cultural section in the
Taoiseach's Department was unexciting, non-public profile, but
necessary work. He made it possible for there to be a department
– it was an idea whose time had come by 1993.

VR: *There had been several efforts throughout the century to set up*

a full ministry for the arts.

CÓB: Several. It had been recommended in the mid-1960s.

VR: What opportunities did it represent to you?

CÓB: Opportunities for structural change and structural development. To address institutions that had suffered neglect and address them with a new energy and a political commitment to get things done. The most obvious one was Collins Barracks, securing it for the National Museum and then devising a strategy for the resources to do the construction work and then to man it. This was a huge development. The Museum had been promised the be-all and end-all for several years and the promises had never materialised. There was talk of it going to the Docks, to Kilmainham; it had a number of false starts. The engagement with the museum issues culminated then in the Cultural Institutions Act of 1997, where there is a whole new régime in relation to museums and libraries. The Act introduced a whole range of other designated institutions in regard to indemnities for major exhibitions. So developments as diverse as an indemnity for modern art in the Crawford Gallery, and Marsh's Library, the oldest public library in Ireland, were amongst the issues addressed on a statutory basis. The National Monuments Act 1994 implemented recommendations that had been around since the Hamilton Committee, in relation to securing artefacts, documents and paintings that were the heritage of the nation. Issues had arisen in relation to the Derrynaflan Chalice and in the Courts the judge said the law was inadequate. We corrected that.

The real achievement, however, was to build a new department. I would certainly be critical of what has now replaced it. We're back to pre-1990s fragmentation.

VR: In that there was EU money available, it was at least a good time, 1993-1997, to have a department for the arts.

CÓB: One of Michael D.'s achievements was that he fought successfully for EU money for the arts, at political level. EU money was not going to be spent on any cultural work, when the

Department (for Arts, Culture and the Gaeltacht) was set up. The previous government had negotiated a huge tranche of regional funding for that period but culture was not part of it. In fact Brussels was opposed to any heading called 'culture' at the time. But capital resources under the 'tourism' heading were targeted and secured.

VR: That money made such a difference to the arts in Ireland.

CÓB: So much needed to be done. There was a political commitment to have the *Arts Plan*, on the contemporary arts side.

VR: Did you seek that commitment?

CÓB: It was one of the features that I included in the manifesto for the general election in 1992. I felt there was no way forward without planning and so the Labour Party in 1992 committed itself to an arts plan and then negotiated with Fianna Fáil for it to be in the Programme for Government. Later, in 1993, for the first time, the Government asked the Arts Council on foot of that agreement, to prepare the first arts plan.

VR: Do you think there is good planning for the arts now?

CÓB: I know there are always and will always be resources issues, but I was impressed with the second *Arts Plan* and I am impressed with the third *Arts Plan*, the current *Arts Plan* although the present Government has seriously undermined it by its cuts in Arts Council funding. I think planning is the way forward. We will always be critical of aspects of any plan. Planning does not of itself bring us into a perfect world but in the early 1990s incrementalism was no longer a viable approach.

An issue that has largely fallen out of the public consciousness is how Michael D. dealt with it Section 31[3] – the censorship of broadcasting. There was censorship of broadcasting since the early 1970s, renewed every year by the Dáil. Michael D. had often spoken out against it but he was assailed in his first year as Minister for not moving immediately to secure its abolition. He bided his time, consulted with government colleagues and within a year the ban on RTÉ was lifted on his proposal. An interesting thing for me was that I was working on *Seven Days*

– the current affairs programme – when the ban was imposed and I was working with Michael D. when the ban was lifted. It's one of the small symmetries in my career that gives me particular satisfaction.

VR: Isn't it a neat symmetry that you first visited the College of Art in Kildare Street as a trespasser with Seven Days, *and now you're the director of the College? Censorship is odd, isn't it? What does it signify?*

CÓB: The ban came about because of the situation in Northern Ireland. There were fears down here that civil unrest would engulf the State. The Government turned its attention to RTÉ coverage. I was producing a television programme which invited the Government to participate, and we invited both Provisional and official Sinn Féin spokespersons to contribute. The Government refused to participate and banned spokesmen and members of certain organisations from appearing on television and radio, under Section 31 of the Broadcasting Act.

VR: Do you think the lifting of Section 31 was very important?

CÓB: I think it made its contribution. I wouldn't exaggerate it. In a sense it was a signal that we in the Republic were prepared to address the motes in our own eyes. The media and public discourse were again opened to people whose views might be rejected by most people. Michael D. argued very strongly that broadcasters were not above the criminal law. But what Section 31 did was single out broadcast journalists for separate and special treatment. Michael D. believed that as citizens in a modern democracy broadcasters should only be subject to the same restraints as the privately owned print media.

Equally, artists are not above the law, the struggle for the individual artist has not been for a special place. I always argue with people who say that Aosdána is an élitist institution which copper fastens the élitism of the arts. I say it was a necessary countermeasure to give artists equality as citizens within this economy and within this society.

VR: Did you say that you believed in ignoring the Border where the

arts were concerned?

CÓB: Collaboration between the Arts Council in Belfast and the Arts Council in Dublin predated my days with the Council, but we took it to a new level when the Arts Council, An Chomhairle Ealaíon, met in joint session with the Arts Council of Northern Ireland. This was unique, two cross-border State bodies having a joint session, that would have been 1978, I think. In fact it was directly out of that meeting that Annaghmakerrig became possible as a joint venture of the two Arts Councils. Since Tyrone Guthrie's death the house had been in the custody of the Department of Finance and it was following the joint meeting that the Government agreed to transfer the house to the custody of An Chomhairle Ealaíon. We had a joint management strategy with the Arts Council of Northern Ireland.

We were also able to establish what was called the Celtic Quartet with the directors of the Welsh, Scottish and the two Irish Arts Councils. Because of the scale of operations we had more in common than with the very large Arts Council of Great Britain. The four directors met frequently on a structured basis for discussion. Later I had the opportunity to meet the Secretary General of the Arts Council of Great Britain. We received an invitation to visit the Arts Council in London. We went to London when Christopher Ewart Biggs, the British Ambassador, who had been murdered here, was being buried. The invitation had been received prior to the murder. When the killing took place, of course we were in touch with the Arts Council of Great Britain, to see if they wished to defer, postpone or withdraw the invitation. They said no. Unless it was a problem for us. So as the British were burying their ambassador to Ireland, whom we in Ireland had killed, we were in Piccadilly at a plenary session of the Arts Council of Great Britain. I think we were the first people not associated with the Arts Council of Great Britain to have been invited to attend a meeting of the Council. Again it's a consequence of collaboration, getting involved, developing credibility.

VR: *That kind of experience must have been a help when you became Michael D.'s adviser.*

CÓB: We had hoped to build on that when we were setting up Telefís na Gaeilge. Michael D. had close relations with Peter Brooke, the Heritage Secretary of State, but it didn't prove possible. It was never represented as being a political problem, it was always represented as a technical transmission problem arising from the receipt of television signals from here into Northern Ireland. I was pleased in 1998 with the Belfast Agreement, that a commitment to assist the reception of the signal of Telifís na Gaelige throughout Northern Ireland was written into the Agreement.

VR: *Was your particular rapport with Michael D. a great help in getting a lot of work done when he was Minister?*

CÓB: My father used to say good luck is being in the right place at the right time but you have to do an awful lot of work to be in the right place at the right time. In a sense what happened in 1993 was the confluence of all the things I had been involved in. It was an extraordinarily unique opportunity. It was tense. Michael D. used to say in many of his speeches, 'I have inherited a bleak landscape'. The opportunities were incredible. I remember Mary Robinson saying when she was a senator and promoting women's rights within the Irish legal system that American feminists would come into her office and finish up saying, 'if only we had the causes you have'. The burden of responsibility for so many cultural causes is where the pressure came from. Within government we had the reputation of never being satisfied; 'you'll never give them enough, if you give them something they'll come back looking for more'. There was so much to be done; we were annoying our colleagues in other departments, principally Finance. 'You can have Telefís na Gaeilge or you can have the *Arts Plan*, you can't have both', was being said at civil service level. So the fact that we had both will, I think, in itself be testimony to the work done in those years and to Michael D.'s adroitness in securing funding. Michael D. was totally passionate about the primacy of culture

in State policy.

We developed a relationship which had started in the mid-1980s in an extraordinarily cohesive way. Every issue that came before us was addressed both in intellectual and practical terms.

The position of politically appointed advisers to Ministers is one which wouldn't be widely welcomed by the civil service. They regard it as a usurpation. Because it was a new department, because most people in the Department had come from other sections of the civil service, it was the civil servants who were coming to me looking for information and advice. I think there was a real opportunity for constructive engagement. Of course we had disagreements. I had rows with Michael D. and I had rows with civil servants, but by and large there was effective engagement between the political and administrative sectors. When we needed the support of other Labour ministers, without my connections in the Labour Party, we wouldn't have got it to the extent that we did.

VR: *You were terribly disappointed not to be in power again?*

CÓB: Well, it was a mixture of exhaustion and disappointment. I would have seriously questioned my own capacity to work at the same pace for a second term. So it was a huge disappointment but a relief, nevertheless. You need to recharge your energy, your convictions and your ideas. I think in the four and a half years I was working with Michael D. I probably had burnt myself out more than during the eight and a half years at the Arts Council. My own family remind me of what I said to them when I was appointed, 'The next few years are going to be very difficult for us as a family, because I feel I am going to have to give this job so much commitment that the family will take second place'.

VR: *And what stage was your family at? Had you married your college sweetheart?*

CÓB: No. I married a college classmate. She was not my college sweetheart. We had been friends and worked together at UCD on a number of projects but it was only four years after finishing

college that we met up again. My two daughters would have been in their late teens when I started working in the Department.

VR: *Is it possible to balance due commitment to personal life and a major commitment like advising the minister in a new department, for example?*

CÓB: Balance in the sense of giving equal time to both? No, not at the same time. You have to do it over a period. It's more difficult in

Colm Ó Briain and his wife Muireann McHugh, Dublin, June 1996.

political life. The demands on people in public life are horrendous, horrendous.

VR: *What did you think about the shredding of Brian P. Kennedy's book* Dreams and Responsibilities, The State and The Arts in Independent Ireland*?*

CÓB: I left the Arts Council and became overtly political in 1983. There was a change of government in 1987. The origins of Aosdána had been distorted in the intervening years. I would be the last person to deny the critical involvement of both Tony Cronin and the Taoiseach but I felt the role of the Arts Council and obviously by extension, my own role, was completely airbrushed out of the record. While I was in my early months in the Labour Party commentators referred to Aosdána as

Haughey's Aosdána. I tried many times to correct that, saying it was an Arts Council initiative which couldn't have been delivered without the support of the Taoiseach. Finally I gave up because I felt like a crank. When Brian Kennedy came to interview me for his book it was my first opportunity to set the record straight. I felt he represented my role fairly and truthfully. The book was commissioned by the Arts Council. Brian is a distinguished art historian, with a career in the civil service at that time. I was teaching in UCD on the Arts Administration course and I acquired some copies of the book from the Art Council's office where I was told it was being destroyed. It was alleged, and denied by Tony Cronin, that since *Dreams and Responsibilities* did not show him in a proper light that he had indicated his displeasure to the Arts Council and consequently books in storage were seen as a political liability, and were shredded. Anthony Cronin has always been a vocal critic of censorship and denied there was censorship involved. The Arts Council never conceded that censorship was behind the shredding and did make amends by reprinting the book.

VR: *You've just started working as director of the National College of Art and Design. Good luck. You may find things move a bit more slowly in education than in politics.*

CÓB: Thanks. I was genuinely surprised when I got this job because I didn't think that I had the kind of CV that was being looked for. I'm excited. I have six years to contribute. It's a great opportunity. The downturn in public finances you might say makes it a bad time, but I'm buoyed up with the opportunity to work with talented and creative people in the College – and, of course, with the next generation. Those who will help to shape the cultural life of the Ireland of the future, as artists, as teachers of art and as designers.

Interviewed on 4 October 2002

1. Kennedy, B.P., *Dreams and Responsibilities. The State and the Arts in Independent Ireland,* published by the Arts Council, p. 156.
2. *Ibid*, p. 197. The Survey of Living and Working Conditions of Artists, was carried out by Irish Marketing Surveys. Dublin 1980.
3. The Broadcasting Authority Act 1960.

Index